D0312263

THE ARTS TO-DAY

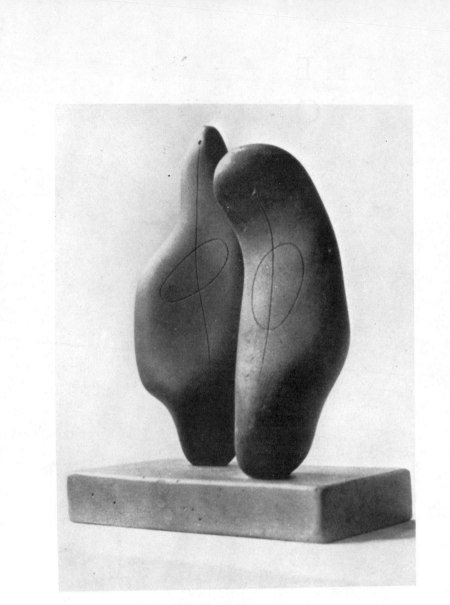

Henry Moore. TWO FORMS, carving in Iron Stone, 1934.

THE ARTS TO-DAY

Edited, with an Introduction, by
GEOFFREY GRIGSON

PSYCHOLOGY AND ART
W. H. Auden

POETRY
Louis MacNeice

PAINTING AND SCULPTURE
Geoffrey Grigson

FICTION
Arthur Calder-Marshall

MUSIC
Edward Crankshaw

THE THEATRE
Humphrey Jennings

THE CINEMA
John Grierson

ARCHITECTURE
John Summerson

KENNIKAT PRESS
Port Washington, N. Y./London

THE ARTS TO-DAY

First published in 1935
Reissued in 1970 by Kennikat Press
Library of Congress Catalog Card No: 78-111310
SBN 8046-0930-6

Manufactured by Taylor Publishing Company Dallas, Texas

ESSAY AND GENERAL LITERATURE INDEX REPRINT SERIES

CONTENTS

ILLUSTRATIONS

INTRODUCTION

THE eight essays in this book are eight individual statements. They are independent of each other, and of the editor, whose only business was to invite, and to collect. They are not in any way the united views, in eight compartments, of a clique in the arts, in criticism, in politics and social attitude, or in age. They have no specific design on the reader. They are meant to interpret, to make statements, to give information, rather than to persuade. Each writer may start from the same place, since the arts are a unity, and have the same destination; but there are as many ways of reaching the town as there are paths, roads, railways and airlines. Mr. Auden, for example, as a poet, and in the implications of his article, takes for some of the way a round-about political route. He adds a purpose to pure poetry: "There must always be two kinds of art, escape-art, for man needs escape as he needs food and deep sleep, and parable-art, that art which shall teach man to unlearn hatred and learn love"; and in his own verse, here and there, this purpose is made to include persuasive sympathy for a preliminary way of unlearning hatred which is political. Mr. MacNeice, (whom I would join with Mr. Auden as the best of the newer poets) emphasises critically, as Mr. Auden does with some self-contradiction in his own

poems, that poetry is not this or that, with one aim
or another, but a ratio; and as long as the necessity of
preserving a ratio in the arts is remembered, we shall not
be damaged by a new kind of artless Shavianism, or
bored by more art stripped to "art itself."

These articles may make clear some of the dangers
standing over the arts and some of the injuries which
have been done to them as well as some of the good
things which the best poets, painters, sculptors, archi-
tects, novelists etc. of our time have achieved. No one
will get much comfort from the essays which deal with
the arts more dependent than others on co-operation
between the artist and society. Mr. Grierson on the
cinema begins darkly that a movie camera costs a
thousand pounds, Mr. Jennings on the Theatre is
fundamentally and bitterly destructive. What film ever
comes far enough over the edge into the category of
art? Outside the new Russian Ballet (uneven itself),
what new thing do we ever see in a London theatre,
Mr. St. John Ervine and Mr. Agate notwithstanding,
which is written or produced within the terms of art?
Or are we ever given a revival which is more than
a "revival," a thing with its authentic life, and not
the bogus life put into it by the fancy of producers?
Answers to these questions need more honesty than they
usually get. In Valéry's dialogue *Eupalinos: or The
Architect*, Eupalinos asks Phaedrus if he has not noticed
"in walking about this city, that among the buildings
with which it is peopled, certain are *mute*; others *speak*;
and others, finally—and they are the most rare—*sing*?"

Only the buildings which sing are the edifices of art, and how many buildings which sing are there in all London? There are swell new buildings which speak of their purpose loudly, there are a very few with a quiet voice, there are millions with no voice at all. Architecture, though not so badly off as the theatre or as the cinema, which has never been able to grow into an art, seems at best permitted now only to build "magnificent" factories or "magnificent" blocks of flats in rehousing schemes. "Everything depends ultimately on the shifts of the social structure and its economic basis," writes Mr. Summerson, but in my view none of the shifts idealised and yearned for by Mr. G. D. H. Cole, Mr. Harry Pollitt, Major Douglas or Sir Oswald Mosley—or Mr. T. S. Eliot, could give *by themselves* the conditions for buildings which sing—or for a life without hatred. For some time the best arts will be those most individual, which will have the small but wider audience which Mr. MacNeice expects for poetry; and their good influence will spread in rings further and further among those who have never heard the painter's or the poet's name, and never felt the stone fall into the pond. If the world is unhealthy, these arts at least are healthier than they were, because we have recognised more sharply the things which hindered and degraded them in recent periods. The artist may disappear, but this will only happen when he is finally ignored and refused fulfilment by the masses into which men are being turned and are turning themselves; and I wish that in general in this book it had been more

emphasised that for introverted artists, fragmentary performance, art that puzzles the people and angers them, art for which society furiously blames the artist, society should by rights blame itself. It has degraded itself or been degraded in understanding below the level at which the artist is bound to remain; but I am risking every insult by saying that when democracy (as it is and should not be) tries to level all trees to the privet hedge.

As far as my own contribution to this book is concerned, I should like to thank the three English artists I most admire, Mr. Wyndham Lewis, Mr. Henry Moore, and Mr. Ben Nicholson, for the very great benefits of their conversation; and for leave to reproduce three of their new works. Mr. Paul Rotha must also be thanked for the cinema "stills" from his collection, and Miss Barbara Hepworth, M. Jean Hélion, Snr. Miró and Mr. Douglas Cooper, Herr Paul Klee (and Messrs. Kahnweiler, Paris, and Müller and Kiepenheuer, Berlin) for other illustrations.

GEOFFREY GRIGSON.

PSYCHOLOGY AND ART TO-DAY

W. H. Auden

PSYCHOLOGY AND ART TO-DAY

By W. H. AUDEN

Neither in my youth nor later was I able to detect
in myself any particular fondness for the position or
work of a doctor. I was, rather, spurred on by a sort
of itch for knowledge which concerned human relation-
ships far more than the data of natural science.—*Freud*.
Mutual forgiveness of each vice
Such are the gates of paradise.—*Blake*.

TO trace, in the manner of the textual critic, the
influence of Freud upon modern art, as one might
trace the influence of Plutarch upon Shakespeare, would
not only demand an erudition which few, if any, possess,
but would be of very doubtful utility. Certain writers,
notably Thomas Mann and D. H. Lawrence, have
actually written about Freud, certain critics, Robert
Graves in *Poetic Unreason* and Herbert Read in *Form in
Modern Poetry*, for example, have made use of Freudian
terminology, surrealism has adopted a technique
resembling the procedure in the analyst's consulting-
room;[1] but the importance of Freud in art is greater

[1]But not the first. The Elizabethans used madness, not as a subject for
clinical description but as opportunity for a particular kind of associational
writing (e.g., *Lear* or *The Duchess of Malfi*). Something of the kind occurs
even earlier in the nonsense passages in the mummer's play.

I

than his language, technique or the truth of theoretical details. He is the most typical but not the only representative of a certain attitude to life and living relationships, and to define that attitude and its importance to creative art must be the purpose of this essay.

The Artist in History

Of the earliest artists, the palæolithic rock-drawers, we can of course know nothing for certain, but it is generally agreed that their aim was a practical one, to gain power over objects by representing them; and it has been suggested that they were probably bachelors, i.e., those who, isolated from the social group, had leisure to objectify the phantasies of their group, and were tolerated for their power to do so. Be that as it may, the popular idea of the artist as socially ill adapted has been a constant one, and not unjustified. Homer may have been blind, Milton certainly was, Beethoven deaf, Villon a crook, Dante very difficult, Pope deformed, Swift impotent, Proust asthmatic, Van Gogh mental, and so on. Yet parallel with this has gone a belief in their social value. From the chiefs who kept a bard, down to the Shell-Mex exhibition, patronage, however undiscriminating, has never been wanting as a sign that art provides society with something for which it is worth paying. On both these beliefs, in the artist as neurotic, and in the social value of Art, psychology has thrown a good deal of light.

The Artist as Neurotic

There is a famous passage in Freud's introductory lectures which has infuriated artists, not altogether unjustly:

"Before you leave to-day I should like to direct your attention for a moment to a side of phantasy-life of very general interest. There is, in fact, a path from phantasy back again to reality, and that is—art. The artist has also an introverted disposition and has not far to go to become neurotic. He is one who is urged on by instinctive needs which are too clamorous; he longs to attain to honour, power, riches, fame, and the love of women; but he lacks the means of achieving these gratifications. So, like any other with an unsatisfied longing, he turns away from reality and transfers all his interest, and all his Libido, too, on to the creation of his wishes in life. There must be many factors in combination to prevent this becoming the whole outcome of his development; it is well known how often artists in particular suffer from partial inhibition of their capacities through neurosis. Probably their constitution is endowed with a powerful capacity for sublimation and with a certain flexibility in the repressions determining the conflict. But the way back to reality is found by the artist thus: He is not the only one who has a life of phantasy; the intermediate world of phantasy is sanctioned by general human consent, and every hungry soul looks to it for comfort and consolation. But to those who are not artists the

3

gratification that can be drawn from the springs of phantasy is very limited; their inexorable repressions prevent the enjoyment of all but the meagre day-dreams which can become conscious. A true artist has more at his disposal. First of all he understands how to elaborate his day-dreams, so that they lose that personal note which grates upon strange ears and become enjoyable to others; he knows too how to modify them sufficiently so that their origin in pro-hibited sources is not easily detected. Further, he possesses the mysterious ability to mould his particular material until it expresses the idea of his phantasy faithfully; and then he knows how to attach to this reflection of his phantasy-life so strong a stream of pleasure that, for a time at least, the repressions are out-balanced and dispelled by it. When he can do all this, he opens out to others the way back to the comfort and consolation of their own unconscious sources of pleasure, and so reaps their gratitude and admiration; then he has won—through his phantasy—what before he could only win in phantasy: honour, power, and the love of women."

Misleading though this may be, it draws attention to two facts, firstly that no artist, however "pure," is disinterested: he expects certain rewards for his activity, however much his opinion of their nature may change as he develops; and he starts from the same point as the neurotic and the day-dreamer, from emotional frustra-tion in early childhood.

The artist like every other kind of "highbrow" is self-conscious, i.e., he is all of the time what everyone

is some of the time, a man who is active rather than passive to his experience. A man struggling for life in the water, a schoolboy evading an imposition, or a cook getting her mistress out of the house is in the widest sense a highbrow. We only think when we are prevented from feeling or acting as we should like. Perfect satisfaction would be complete unconsciousness. Most people, however, fit into society too neatly for the stimulus to arise except in a crisis such as falling in love or losing their money.[1] The possible family situations which may produce the artist or intellectual are of course innumerable, but those in which one of the parents, usually the mother, seeks a conscious spiritual, in a sense, adult relationship with the child, are probably the commonest, i.e.,

(1) When the parents are not physically in love with each other. There are several varieties of this: the complete fiasco; the brother sister relationship on a basis of common mental interests; the invalid nurse relationship when one parent is a child to be maternally cared for; and the unpassionate relations of old parents.

(2) The only child. This alone is most likely to produce early life confidence which on meeting disappointment, ǀturns like the unwanted child, to illness and anti-social behaviour to secure attention.

(3) The youngest child. Not only are the parents old

[1] E.g., the sale of popular text-books on economics since 1929.

5

but the whole family field is one of mental stimulation.[1]

Early mental stimulation can interfere with physical development and intensify the conflict. It is a true intuition that makes the caricaturist provide the highbrow with a pair of spectacles. Myopia, deafness, delayed puberty, asthma—breathing is the first independent act of the child—are some of the attempts of the mentally awakened child to resist the demands of life.

To a situation of danger and difficulty there are five solutions:

(1) To sham dead: The idiot.
(2) To retire into a life of phantasy: The schyzophrene.
(3) To panic, i.e., to wreak one's grudge upon society: The criminal.
(4) To excite pity, to become ill: The invalid.
(5) To understand the mechanism of the trap: The scientist and the artist.

Art and Phantasy

In the passage of Freud quoted above, no distinction was drawn between art and phantasy, between—as Mr. Roger Fry once pointed out—*Madame Bovary* and a *Daily Mirror* serial about earls and housemaids.

[1] The success of the youngest son in folk tales is instructive. He is generally his mother's favourite as physically weaker and less assertive than his brothers. If he is often called stupid, his stupidity is physical. He is clumsy and lazy rather than dull. (Clumsiness being due to the interference of fancies with sense data.) He succeeds partly out of good nature and partly because confronted with a problem he overcomes it by understanding rather than with force.

6

The distinction is one which may perhaps be best illustrated by the difference between two kinds of dream. "A child has in the afternoon passed the window of a sweetshop, and would have liked to buy some chocolate it saw there, but its parents have refused the gift—so the child dreams of chocolate"—here is a simple wish fulfilment dream of the *Daily Mirror* kind, and all art, as the juvenile work of artists, starts from this level. But it does not remain there. For the following dream and its analysis I am indebted to Dr. Maurice Nicoll's *Dream Psychology*:

A young man who had begun to take morphia, but was not an addict, had the following dream:

"I was hanging by a rope a short way down a precipice. Above me on the top of the cliff was a small boy who held the rope. I was not alarmed because I knew I had only to tell the boy to pull and I would get to the top safely. The patient could give no associations."

The dream shows that the morphinist has gone a certain way from the top of the cliff—the position of normal safety—down the side of the precipice, but he is still in contact with that which remains on the top. That which remains on the top is now relatively small, but is not inanimate like a fort, but alive: it is a force operating from the level of normal safety. This force is holding the dreamer back from the gulf, but that is all. It is for the dreamer himself to say the word if he wants to be pulled up (i.e., the morphinist is *deliberately* a morphinist).

When the common phrase is used that a man's will is weakening as he goes along some path of self-indulgence, it implies that something is strengthening. What is strengthening is the attractive power of vice. But in the dream, the attractive power of morphia is represented by the force of gravitation, and the force of gravitation is constant.

But there are certain variable elements in the dream. The position of the figure over the cliff can vary and with it the length of the rope. The size of the figure at the top of the cliff might also vary without in any way violating the spirit of the dream. If then, we examine the length of the rope and the size of the figure on the cliff top in the light of relatively variable factors, the explanation of the *smallness* of the figure on the cliff top may be found to lie in the length of the rope, as if the rope drew itself out of the figure, and so caused it to shrink.

Now the figure at the top of the cliff is on firm ground and may there symbolise the forces of some habit and custom that exist in the morphinist and from which he has departed over the edge of the cliff, but which still hold him back from disaster although they are now shrunken. The attractive power of the morphia is not increasing, but *the interest the morphinist takes in morphia* is increasing.

A picture of the balance of interest in the morphinist is thus given, and the dream shows that the part of interest situated in the cliff top is now being drawn increasingly over the precipice.

In this dream, we have something which resembles art much more closely. Not only has the censor transformed the latent content of the dream into symbols but the dream itself is no longer a simple wish fulfilment, it has become constructive, and, if you like, moral. "A picture of the balance of interest"—that is a good description of a work of art. To use a phrase of Blake's "It's like a lawyer serving a writ."

Craftsmanship

There have always been two views of the poetic process, as an inspiration and as a craft, of the poet as the Possessed and as the Maker, e.g.,

"All good poets, epic as well as lyric, compose their beautiful poems not by art, but because they are inspired and possessed."—*Socrates.*

"That talk of inspiration is sheer nonsense: there is no such thing; it is a matter of craftsmanship."— *William Morris*

And corresponding to this, two theories of imagination:

"Natural objects always weaken, deaden, and obliterate imagination in me."—*Blake.*

"Time and education beget experience: experience begets memory; memory begets judgment and fancy. . . . Imagination is nothing else but sense decaying or weakened by the absence of the object."—*Hobbes.*

The public, fond of marvels and envious of success without trouble, has favoured the first (see any film of

artists at work); but the poets themselves, painfully aware of the labour involved, on the whole have inclined towards the second. Psycho-analysis, naturally enough, first turned its attention to those works where the workings of the unconscious were easiest to follow. Romantic literature like *Peer Gynt*, "queer" plays like *Hamlet*, or fairy tales like *Alice in Wonderland*. I should doubt if Pope's name occurs in any text-book. The poet is inclined to retort that a great deal of literature is not of this kind, that even in a short lyric, let alone a sustained work, the material immediately "given" to consciousness, the automatic element is very small, that, in his own experience, what he is most aware of are technical problems, the management of consonants and vowels, the counterpointing of scenes, or how to get the husband off the stage before the lover's arrival, and that psychology concentrating on the symbols, ignores words; in his treatment of symbols and facts he fails to explain why of two words dealing with the same unconscious material, one is æsthetically good and the other bad; indeed that few psycho-analysts in their published work show any signs of knowing that æsthetic standards exist.

Psycho-analysis, he would agree, has increased the artist's interest in dreams, mnemonic fragments, child-art and graphiti, etc., but that the interest is a *conscious* one. Even the most surrealistic writing of Mr. James Joyce's latest prose shows every sign of being non-automatic or extremely carefully worked over.

The Conscious Element

Creation, like psycho-analysis, is a process of re-living in a new situation. There are three chief elements:

(1) The artist himself, a certain person at a certain time with his own limited conflicts, phantasies and interests.

(2) The data from the outer world which his senses bring him, and which, under the influence of his instincts, he selects, stores, enlarges upon, and by which he sets value and significance.

(3) The artistic medium, the new situation, which because it is not a personal, but a racial property (and psychological research into the universality of certain symbols confirms this), makes communication possible, and art more than an auto-biographical record. Just as modern physics teaches that every physical object is the centre of a field of force which radiating outwards occupies all space and time, so psychology states that every word through fainter and fainter associations is ultimately a sign of the universe. The associations are always greater than those of an individual. A medium complicates and distorts the creative impulse behind it. It is, in fact largely the medium, and thorough familiarity with the medium, with its unexpected results, that enable the artist to develop from elementary uncontrolled phantasy, to deliberate phantasy directed towards understanding.

11

What would be a Freudian literature

Freudianism cannot be considered apart from other features of the contemporary environment, apart from modern physics with its conception of transferable energy, modern technics, and modern politics. The chart here given makes no attempt to be complete, or accurate; it ignores the perpetual overlap of one historical period with another, and highly important transition periods, like the Renaissance. It is only meant to be suggestive, dividing the Christian era into three periods, the first ending with the fifteenth century, the second with the nineteenth, and the third just beginning; including what would seem the typical characteristics of such periods.

Misconceptions

Freud belongs to the third of these phases, which, in the sphere of psychology may be said to have begun with Nietzsche (though the whole of Freud's teaching may be found in *The Marriage of Heaven and Hell*). Such psychology is historically derived from the Romantic reaction, in particular from Rousseau, and this connection has obscured in the minds of the general public, and others, its essential nature. To the man in the street, "Freudian" literature would embody the following beliefs:

(1) Sexual pleasure is the only real satisfaction. All other activities are an inadequate and remote substitute.

(2) All reasoning is rationalisation.
(3) All men are equal before instincts. It is my parent's fault in the way they brought me up if I am not a Napoleon or a Shakespeare.
(4) The good life is to do as you like.
(5) The cure for all ills is (*a*) indiscriminate sexual intercourse; (*b*) autobiography.

The Implications of Freud

I do not intend to take writers one by one and examine the influence of Freud upon them. I wish merely to show what the essence of Freud's teaching is, that the reader may judge for himself. I shall enumerate the chief points as briefly as possible:
(1) The driving force in all forms of life is instinctive; a libido which of itself is undifferentiated and unmoral, the "seed of every virtue and of every act which deserves punishment."
(2) Its first forms of creative activity are in the ordinary sense of the word physical. It binds cells together and separates them. The first bond observable between individuals is a sexual bond.
(3) With the growth in importance of the central nervous system with central rather than peripheral control, the number of modes of satisfaction to which the libido can adapt itself become universally increased.
(4) Man differs from the rest of the organic world in that his development is unfinished.

	1st Period.	2nd Period.	3rd Period.
First Cause:	God immanent and transcendent.	Official: God transcendent. The universal mechanic. Opposition: God immanent. Pantheism. Romantic.	Energy appearing in many measurable forms, fundamental nature unknown.
World View:	The visible world as symbol of the eternal.	Official: The material world as a mechanism. Opposition: The spiritual world as a private concern.	The interdependence of observed and observer.
The End of Life:	The City of God.	Official: Power over material. Opposition: Personal salvation.	The good life on earth.
Means of Realisation:	Faith and work. The rule of the Church.	Official: Works without moral value. Opposition: Faith.	Self-understanding.
Personal Driving Forces:	Love of God. Submission of private will to will of God.	Official: Conscious will. Rationalised. Mechanised. Opposition: Emotion irrational.	The unconscious directed by reason.
The Sign of Success:	The mystical union.	Wealth and power.	Joy.

	1st Period.	2nd Period.	3rd Period.
The worst sinner:	The heretic.	The idle poor (Opposition view — the respectable bourgeois).	The deliberate irrationalist.
Scientific method:	Reasoning without experiment.	Experiment and reason: the experimenter considered impartial. Pure truth. Specialisation.	Experiment directed by conscious human needs.
Sources of power:	Animal, Wind, Water.	Water. Steam.	Electricity.
Technical materials:	Wood, Stone.	Iron. Steel.	Light alloys.
Way of living:	Agricultural and trading. Small towns. Balance of town and country.	Valley towns. Industrialism. Balance of town and country upset.	Dispersed units connected by electrical wires. Restored balance of town and country.
Economic system:	Regional units. Production for use. Usury discouraged.	Laissez-faire Capitalism. Scramble for markets.	Planned socialism.
Political system:	Feudal hierarchy.	National democracy. Power in hands of capitalists.	International Democracy. Government by an Order.

15

(5) The introduction of self-consciousness was a complete break in development, and all that we recognise as evil or sin is its consequence. Freud differs both from Rousseau who denied the Fall, attributing evil to purely local conditions ("Rousseau thought all men good by nature. He found them evil and made no friend"), and also from the theological doctrine which makes the Fall the result of a deliberate choice, man being therefore morally responsible.

(6) The result of this Fall was a divided consciousness in place of the single animal consciousness, consisting of at least three parts: a conscious mind governed by ideas and ideals, the impersonal unconscious from which all its power of the living creature is derived but to which it was largely denied access; and a personal unconscious, all that morality or society demanded should be forgotten and unexpressed.[1]

(7) The nineteenth century doctrine of evolutionary progress, of man working out the beast and letting the ape and tiger die, is largely false. Man's phylogenetic ancestors were meek and sociable, and cruelty, violence, war, all the so-called primitive instincts, do not appear until civilisation has reached a high level. A golden age comparatively speaking (and anthropological research tends to confirm this), is an historical fact.

[1] The difference between the two unconscious minds is expressed symbolically in dreams, e.g., motor-cars and manufactured things express the personal unconscious, horses, etc., the impersonal.

(8) What we call evil was once good, but has been outgrown, and refused development by the conscious mind with its moral ideas. This is the point in Freud which D. H. Lawrence seized and to which he devoted his life:

"Man is immoral because he has got a mind
And can't get used to the fact."

The danger of Lawrence's writing is the ease with which his teaching about the unconscious, by which he means the impersonal unconscious, may be read as meaning, "let your personal unconscious have its fling," i.e., the *acte gratuite* of André Gide. In personal relations this itself may have a liberating effect for the individual. If the fool would persist in his folly he would become wise. But folly is folly all the same and a piece of advice like "Anger is just. Justice is never just," which in private life is a plea for emotional honesty, is rotten political advice, where it means "beat up those who disagree with you." Also Lawrence's concentration on the fact that if you want to know what a man is, you must look at his sexual life, is apt to lead many to believe that pursuit of a sexual goal is the only necessary activity.

(9) Not only what we recognise as sin or crime, but all illness, is purposive. It is an attempt at cure.

(10) All change, either progressive or regressive is caused by frustration or tension. Had sexual satis-

faction been completely adequate human develop-
ment could never have occurred. Illness and
intellectual activity are both reactions to the same
thing, but not of equal value.

(11) The nature of our moral ideas depends on the
nature of our relations with our parents.

(12) At the root of all disease and sin is a sense of guilt.

(13) Cure consists in taking away the guilt feeling, in
the forgiveness of sins, by confession, the re-living
of the experience, and absolution, the understanding
its significance.

(14) The task of psychology, or art for that matter, is
not to tell people how to behave, but by drawing
their attention to what the impersonal unconscious
is trying to tell them, and by increasing their
knowledge of good and evil, to render them better
able to choose, to become increasingly morally
responsible for their destiny.

(15) For this reason psychology is opposed to all
generalisations; force people to hold a generalisation
and there will come a time when a situation will
arise to which it does not apply. Either they will
force the generalisation, the situation, the repres-
sion, when it will haunt them, or they will embrace
its opposite. The value of advice depends entirely
upon the context. You cannot tell people what
to do, you can only tell them parables; and that is
what art really is, particular stories of particular
people and experiences, from which each accord-

ing to his immediate and peculiar needs may draw his own conclusions.

(16) Both Marx and Freud start from the failures of civilisation, one from the poor, one from the ill. Both see human behaviour determined, not consciously, but by instinctive needs, hunger and love. Both desire a world where rational choice and self-determination are possible. The difference between them is the inevitable difference between the man who studies crowds in the street, and the man who sees the patient, or at most the family, in the consulting-room. Marx sees the direction of the relations between outer and inner world from without inwards, Freud vice versa. Both are therefore suspicious of each other. The socialist accuses the psychologist of caving in to the status quo, trying to adapt the neurotic to the system, thus depriving him of a potential revolutionary: the psychologist retorts that the socialist is trying to lift himself by his own boot tags, that he fails to understand himself, or the fact that the lust for money is only one form of the lust for power; and so that after he has won his power by revolution he will recreate the same conditions. Both are right. As long as civilisation remains as it is, the number of patients the psychologist can cure are very few, and as soon as socialism attains power, it must learn to direct its own interior energy and will need the psychologist.

Conclusion

Freud has had certain obvious technical influences on literature, particularly in its treatment of space and time, and the use of words in associational rather than logical sequence. He has directed the attention of the writer to material such as dreams and nervous tics hitherto disregarded; to relations as hitherto unconsidered as the relations between people playing tennis; he has revised hero-worship.

He has been misappropriated by irrationalists eager to escape their conscience. But with these we have not, in this essay, been concerned. We have tried to show what light Freud has thrown on the genesis of the artist and his place and function in society, and what demands he would make upon the serious writer. There must always be two kinds of art, escape-art, for man needs escape as he needs food and deep sleep, and parable-art, that art which shall teach man to unlearn hatred and learn love, which can enable Freud to say with greater conviction:

"We may insist as often as we please that the human intellect is powerless when compared with the impulses of man, and we may be right in what we say. All the same there is something peculiar about this weakness. The voice of the intellect is soft and low, but it is persistent and continues until it has secured a hearing. After what may be countless repetitions, it does get a hearing. This is one of the few facts which may help to make us rather more hopeful about the future of mankind."

BOOKS TO READ

Freud. *Collected Works.* International Library of Psychoanalysis.

Jung. *Psychology of the Unconscious. Two Essays in Analytical Psychology.*

Klages. *The Science of Character.*

Prinzhorn. *Psychotherapy.*

Rivers. *Conflict and Dream.*

Nicoll. *Dream Psychology.*

Burrow. *The Social Basis of Consciousness.*

Heard. *Social Substance of Religion.*

Thomas Mann. *Essays.*

Blake. *Collected Works.*

D. H. Lawrence. *Psycho-analysis and the Unconscious. Fantasia of the Unconscious. Studies in Classical American Literature.*

Homer Lane. *Talks to Parents and Teachers.*

Lord Lytton. *New Treasure.*

Mathias Alexander. *The Use of the Self.*

Groeddeck. *Exploring the Unconscious. The World of Man.*

Herbert Read. *Form in Modern Poetry. Art Now.*

I. A. Richards. *Principles of Literary Criticism,* etc.

Bodkin. *Archetypal Patterns in Poetry.*

Robert Graves. *Poetic Unreason.*

Bergson. *The Two Sources of Morality and Religion.*

Benedict. *Patterns of Culture.*

POETRY TO-DAY

Louis MacNeice

POETRY TO-DAY

By Louis MacNeice

POETS do not know (exactly) what they are doing, for if they did, there would be no need to do it. So much of truth is there in the Plato-Shelley doctrine of Poetic Inspiration. Poetry is not a science and it is more than a craft. This is why, when the poet tries to explain his work, he is much less helpful than the mechanic explaining an engine. But it is a human characteristic that the poet must try to explain and the reader to comprehend why, how and what the poet writes. What both of them want, or at least what they get, is a collection of working hypotheses, often mutually contradictory. Both writer and reader will lose heart unless they can put their finger on something apparently definite, in motive, method or end achieved. Thus even the psychologist having giddied you into a glimpse of chaos will promptly cover it up with an hypothesis.

People will not read poetry unless they think they know what they are going to get from it, and people will not write poetry unless they think they know what they are driving at. Hence the importance of poetic theory and criticism. But what is needed is not necessarily the best criticism. The best criticism, like the best

philosophy, tends to be negative. It is inferior philo-
sophy, like pragmatism, that influences action, and it is
a narrow and limited criticism that encourages the
production of art. What the artist and the reader need
is an Aristotle or a Dr. Johnson.

Poetry at the moment is becoming narrower and less
esoteric. The narrower it becomes, the wider the public
it represents and the nearer it comes to being popular.
It will not become so narrow as to be truly popular
(representing the masses) but it seems at the moment in
England to be reaching a stage where it will represent
and be acceptable to a considerable minority. Very
few poets can dispense with a public and be content,
like Blake, to have their works printed in eternity; it is
therefore only common sense to acquiesce in the present
trend of English poetry. Before trying to assess this
present trend as exemplified in the new school of young
English poets, I shall consider the development of
modern verse by their immediate predecessors. But
first of all I will dogmatise.

In every field of æsthetics people have been searching
for what is *essential*. These investigations are mostly cant
and clamour. You may not eat the shell of a nut but
you can't grow nuts without shells. Artistic organisms
are too inextricably complex to be amenable to deliber-
ate vivisection. You cannot divorce the substance of a
poem from its accidents. No amount of theorising will
give you the essential in a bottle. What then are we to
do? Must we renounce theory altogether? To banish
theory is as much of a half-truth and a whole lie as to

make theory omnipotent. The functions of theory are propædeutic, prophylactic and corrective; just as in learning to play tennis. When it comes to the point, the work is done with the hands. I hope it will not seem precious to speak of the hands of the soul. Poetic Inspiration seems to me as well symbolised by the psychic hands of the individual poet himself as by any annunciation *ab extra*.

The theorist has, for example, always divided Form and Content. The hands of the poet know better. This crude distinction has had its uses but it has made the writing of poetry appear superficially easy but actually impossible: all you have got to do is get the Right Content and put it into the Right Form. This would take to eternity. Take rhythm for example, which, in speaking of poetry, we put on the side of Form. But any particular rhythm x is always the same —blank x, until the so-called Content comes and *enforms* it. One of the good deeds of modern thought is to have remembered the abstract nature of abstractions (see e.g. Gentile, *Mind as Pure Act*). We no longer spend our time trying to jigsaw together a preconceived Form and Content. And so good-bye to the *mot juste*; on a correspondence theory of art all the *mots justes* would have been used up long ago. Language on one side and thought on the other are dead weights on that kind of theory. The history of recent poetry is a history of various reactions against dead weights.

The common factor in these reactions appeared to be a revolt against tradition. This was not so. All the

experimenting poets turned their backs on mummified and theorised tradition, but the more intelligent realised that living tradition is essential to all art, is one of the poles. A poem, to be recognisable, must be traditional; but to be worth recognising, it must be something new. Some poems are merely new at a first reading and we do not like them afterwards; others we like merely for their familiarity (e.g. those we have heard as children). It is snobbish to condemn these two classes of poems, but the higher poem should be partly familiar from the first, and new at the latter end. Whatever the "true function" of poetry is, there is something idolatrous or fetishistic in our pleasure in it. One can make an idol, like a fashion, out of anything; it is part of our Self-Respect to fit up a good idol. And here again we must beware of fixing a great gulf of abstraction between the Self and the Object (or the Product).

The poem, like the idol, is a kind of Alter Ego. But the Alter Ego is another polarised concept. As Ego it is self-expression; as Alter it is escape from Self. Hence the dangers in explaining a poem through its author. Hence also the falsity of the hackneyed distinction between Poetry of Escape and poetry which represents or interprets "Life." And the generalisations so often offered by poets themselves we must accept only as dramatic; they are not scientific rules but are merely a moment in the context of the poet's life and work, which can be contradicted by other moments in his life and work, just as one character in a play can give

the lie to another character. *"Je rature le vif"* is not the same kind of statement as 2+2=4 (or, to be safer, as 0=0). Posterity affects to put dead poets and movements in their place; to tell us their real significance and cancel out their irrelevances. This habitual procedure of posterity is, like other affectations, useful in that it is tidy and saves thinking (I do not mean one-way thinking). Most people can only afford the time to see contradictions in their contemporaries. The self-contradictory is what is alive, therefore for most people the most living art is contemporary art. Yet people are ungrateful; they prefer the dead to the living and try to kill even their contemporaries by looking a hundred years forward. I continually hear people saying "Yes, but I wonder what people will say of him a hundred years hence," or "I dare say, all the same, posterity will think more of Mr. X." They herein miss the point. If we do our duty by the present moment, posterity can look after itself. To try to anticipate the future is to make the present past; whereas it should already be on our conscience that we have made the past past. We fail to appreciate a great poet like Horace because we don't let him puzzle us; to indicate the concreteness of Horace, as of Mr. Yeats, we should need a dialectic of opposites. If poetic criticism is to develop, it must give up one-way thinking. As it is, the man who reads a poem and likes it, is doing something far too subtle for criticism.

I will not try to explain further why it is necessary for some people to write, and for more people to read

modern poetry. Assuming that this is so, it is important that the individuals of both these classes should co-operate; to be mutually intelligible these poets and readers must have a more or less similar orientation of tradition. They must avoid the two extremes of psittacism and aphasia. There are cultured people in England to-day who write poems which are mere and sheer Shelley; these are psittacists; they are betraying themselves (and, incidentally, betraying Shelley). There are also the enthusiasts (mostly Americans in Paris) who set out to scrap tradition from A to Z; this should logically lead to aphasia; that they do not become quite aphasiac is due to their powers of self-deception. How are we to do justice, not to the segregated Past or Present, but to their concrete antinomy?

The problem is especially difficult for us because, unlike our more parochial predecessors, we have so many Pasts and Presents to choose from. We have too much choice and not enough brute limitations. The eclectic is usually impotent; the alternative to eclecticism is clique-literature. The best poets of to-day belong to, and write for, cliques. The cliques, lately, have not been purely literary; they identify themselves with economic, political or philosophical movements. This identification is more fruitful when it is voluntary; I am told that Communism in Russia and Fascism in Italy have not, as yet, elicited much good poetry to order. The poet must be primarily a poet and this is still possible in England. But the common assumption that English poets have always been free lances is a gross

misrepresentation. Those who admire the "freedom" of the free lance should take a course of Spinoza; the best English poets have been those most successfully determined by their context. The context must be a suitable one. The English context is now more congenial to poets than it has been for a long time.

English poetry of the nineteenth century was doomed by its own pretentiousness ("poets are the unacknowledged legislators of mankind"). Victorian scepticism made us draw in our horns: "Poetry is a Criticism of Life." But Samuel Butler and his kind were the Critics of Life; the English poets of the 'nineties, misapplying some recent hints from the French, left Life and Mankind out of it and turned to cultivating their gardens. A suburban individualism prevailed, the penalty for the bumptious anarchism of the Romantic Revival. The poets of the 'nineties and the Georgians who succeeded them were crippled by a reaction from the prophets; they did not dare to be moral, didactic, propagandist or even intellectual; fear of being thought hypocritical precluded them from interest either in God or their neighbour. This bogey of hypocrisy had hamstrung our intellects.

Contemporary with this fairly homogeneous suburban movement (which began with æstheticism and ended with a castrated nature-poetry and occasional pieces: see the *Georgian Anthologies* "passim") there were certain sturdier freak-growths, e.g., Mr. Kipling's jingoism and Mr. Housman's pastorals. Neither Kipling nor Housman has had successors, though they

both anticipated certain freedoms of diction and Housman anticipated the all-pervading irony of post-War poetry. More important was the Irish movement, where poetry was healthily mixed up with politics. Yeats' early poems, which many would take as typical escape-poetry, were very much more adulterated with life than e.g. the beery puerilities of Messrs. Chesterton and Belloc. We now laugh at the Celtic Twilight and at the self-importance of these dilettante nationalists, but their naiveté and affectation had manured the ground for poetry. Where it is possible to be a hypocrite, it is also possible to be a hero, a saint, or an artist. It was hardly possible for a poet to be a hypocrite in England in the pre-War period. Hence the thrill (and subsequent, as it seems to us, hypocrisy) of writers like Rupert Brooke, when the War broke out.

We must not too readily assign the War as a cause of developments in the arts. By the time the War broke out, Mr. Pound and his Imagists had already asserted themselves, Mr. Eliot had read his Laforgue, Mr. Yeats was working steadily to make his verse less "poetic," Free Verse was an old story and Marinetti had invented Futurism. But in England at any rate this left-wing literature did not become notorious till after the War. And in 1922 appeared the classic English test-pieces of modern prose and verse—*Ulysses* by James Joyce and *The Waste Land* by T. S. Eliot. To most of the intelligent minority both these works appeared incoherent and obscure; *Ulysses* was also considered overwhelmingly obscene. The same minor-

ity would now agree that neither work is so difficult if
approached from the right angle, and that as for
obscenity there is far more in any popular magazine.
We have new standards of coherence and of poetic
meaning. Joyce as well as Eliot has had great influence
on our poetry—for two reasons. As a technician he
uses words in that subtle way which is usually the
privilege of poets. As a very sensitive observer his
acceptances and rejections (vulgarly called his realism)
have sanctioned the acceptance or rejection of certain
subject matters in poetry.

Joyce and Eliot were accepted as protagonists of the
New Order. Both these writers have an aristocratic
objectivity or impersonality due to a wide acquaintance
with European culture. The hot-gospelling element
for post-War England was supplied by D. H. Lawrence.
The young contrived to be influenced by these three
very different writers simultaneously. The three had
this in common, that they transgressed the limits of the
pre-War Suburban Individualists. Eliot reintroduced
into poetry first the intellect and later Christianity;
Lawrence had the welcome bad taste to be a prophet;
Joyce, instead of cultivating his garden, attempted with
superb effrontery and industry to assimilate the modern
world.

For a decade after the War these three were dominant.
But Lawrence was too vague and Eliot and Joyce were
too wide. Before discussing the present very important
poetic reaction, I will mention some of the experiments
tried in English poetry during this post-War period.

In France[1] the surréalistes appeared soon after the War, though knowledge of their work is beginning only now to penetrate into England; Paul Valéry, on the other hand, broke a fifteen years' silence in 1917 with *La Jeune Parque*. English poets have, however, been mainly (and too much so) influenced by other English poets; the imitators of Eliot would have done well to read Eliot's originals, just as the irrationalists would have done well to read their Freud. On the whole the period is too literary. It is only now that poets are learning to forget their literature. Here Mr. Pound is one of the worst offenders. For very many years he has been repeating, rather hysterically, that he is an expert and a specialist; but he has specialised his poems into museum pieces. His recently published *A Draft of Thirty Cantos* is, I suppose, a good piece of its kind; like *Ulysses* it is certainly far the longest of its kind. I maintain, however, that the kind is not one to be encouraged. What Mr. Grigson has called "the cultural reference rock-jumping style," even if feasible in a poem of the length of *The Waste Land* where every reference can be manœuvred to pull its weight, is bound to lose its virility in a work as vast as the Cantos. Apart from this, Mr. Pound's effects are very monotonous; he uses the same cadences again and again for glamour, and the same contrasts again and again for brutality (or reality). The faults in his work should remind us of

[1] I make no attempt in this article to assess contemporary poetic movements in foreign European countries, or even in America. It goes without saying that all the arts are more cosmopolitan than they were, but my scope is purposely narrow.

certain practical, if pedantic, truths. Quantity must always affect quality. A metre of green, as Gauguin said, is more green than a centimetre, but a bucket of Benedictine is hardly Benedictine. Mr. Pound does not know when to stop; he is a born strummer. The second Aristotelian truth against which he offends is this. The poet's method must be specifically poetic (something between the philosopher's and the somnambulist's). Or we may put it that poetry is a genre somewhere between play and science. The poet must ape neither the scientist nor the child with his ball; Mr. Pound apes them both. The child, and the ordinary man when he is being childish, exploit an activity which is other than the poetic. They go out of their way to use a home-made jargon, nicknames, private allusions, tags of special knowledge. It can, of course, be maintained that all this is poetic or artistic efflorescence, that when a middle-class Englishman quotes French he is satisfying an artistic impulse. It can similarly be maintained that dreams, alcohol, sex or looking at the landscape give us a pleasure (or a release or a consummation or any-thing else) identical with that given us by poetry, and that we take to reading poetry for the same reason as we take to these other things. Thus Mr. E. E. Cum-mings says that his poems are competing with roses and locomotives. All this may be so, but if poets are to continue to exist (as they will so long as there are people not contented with roses and locomotives) it is essential that the poet should do more than give you a drink or tell you to look at the view; he must use words and at

that he must still give you more than the child gives you when he distorts or jingles for his pleasure or the grown man when he makes a pun or a quotation. We may agree with the psychologist who tells us that all these activities are fundamentally akin. Mature and civilised man is concerned with the surface. We must maintain differences. Or else we must be honest monist-nihilists and not meddle with the arts. It is honest to say of a picture "It doesn't matter which colour goes there, it's all canvas underneath," but it is not honest, if one holds this point of view, to become a painter. There has been a great deal recently of this (often unwitting or half-witted) dishonesty; see the past numbers of *Transition* "passim," or Mr. Pound's recent *Active Anthology* or even the earlier, almost forgotten *Imagists*. It is the kind of dishonesty which was magnificently attacked by Mr. Wyndham Lewis in *The Enemy No. 1*. I am summarising the "Enemy's" attack when I say succinctly that Mr. Pound lacks grip; professing to offer us poetry he is always falling back on easier substitutes. These substitutes, thanks to the psychologists and the flux-philosophers, are to-day at a high premium; this is made an excuse for both excessive laziness and excessive industry. Further instructive examples of this intellectual epidemic are found in the poetry of Mr. Robert Graves, Miss Laura Riding, the Sitwells and Mr. E. E. Cummings.

Mr. Graves and Miss Riding are very conscious moderns and purists. Mr. Graves began with an admiration for ballad and nursery rhyme and produced pretty

little poems of that type, using a rather Georgian technique. After the War as a remedy for shell-shock he took to reading Freudian psychology and analysing the latent symbolic elements in his own work. He decided that the manifest-content of most poetry is irrelevant; his careful pruning of content, combined with technical austerities, has left his more recent verse bare and arid and approximating more and more to the metaphysical tenuities of Miss Riding, who is obsessed by the paradoxes of Nothingness. They are both painfully lacking in worldly content.

The Sitwells, on the other hand, offered plenty of the traditional kind of content—"plot," "story," "characters" and even "morals," thinly disguised by a kind of syncopation. They caused exaggerated surprise among their contemporaries merely because they sowed with the whole sack certain tricks which had previously been used more sparingly. Their mythology was borrowed mostly from the eighteenth century, the nursery, and the circus side of post-Impressionist painting. They have inverted the usual flux-attitude; the dominant characteristic of their work is a devaluation of the living moment and an apotheosis of memory (cp. Proust). They are topical only in order to be satirical. Their manner of dealing with the past is pre-Raphaelite; it is not therefore surprising that they rarely attain higher values than those of the fairy-story (just as the only good that came from the Pre-Raphaelite painters was fairy book illustrations). Miss Sitwell can write very handsome lines but she is not good at

architectonic. Hence her better poems are her shorter ones (e.g. *Bucolic Comedies*). *The Sleeping Beauty* is, however, a very fine jazz fairy story; she has filled in all the corners with twirls and iterations and the whole is pervaded with a kindly sentimentality (she has a country-house sympathy with such types as housemaids and spinsters). In her more recent poems she has repeated herself with a bigger ration of moralising and a more obvious derivativeness from her favourite Old Masters. Mr. Sacheverell Sitwell also is derivative in his decoration, most obviously in his octosyllables which are reminiscent of *Appleton House*. His longer poems, with a looser line, were more interesting experiments but unfortunately, like his sister and like Mr. Pound, he gives too much merely accumulative and not significant detail. When the atmosphere is not destroyed by cultural padding he can produce an admirable poem like *Convent Thoughts in Cadiz*.

Mr. Cummings is the humorist among these poets. An American like Pound and Eliot, he cannot get over the contrast between the vulgarity of the modern world and the beauty of European culture (cp. *A Draft of Thirty Cantos, Burbank with a Baedeker: Bleistein with a Cigar*, or even the novels of Mr. Sinclair Lewis). Mr. Cummings is a simple-minded poet. He has two manners, his (earlier) grand or sentimental manner with use of the vocative "thou," and his impressionist or humorous manner which Mr. Graves has described as a "taxi-and-gin shorthand." This latter is seen at its best in his volume *Is 5*. The verse here is speeded up

and staccato; he has made many typographical experiments—commas in the middle of words, gaps (of all sizes) horizontal between words and vertical between lines, no capital letters where expected and capital letters where not, etc. This has irritated many people but I cannot remember meeting in *Is 5* any typographical oddity which I could not see a reason for. Here Cummings compares very favourably with most of the American contributors to *Transition* or *The Active Anthology*. In the matter of chopping lines Cummings chops off his lines with a sense of rhythmical or dramatic fitness, whereas in a writer like Dr. William Carlos Williams the arrangement into lines is entirely indifferent. Cummings is the best of his group[1] but he is unsatisfactory, just as the Impressionist painters were unsatisfactory. In art you must have an *a priori*. The preface to *Is 5* states "If a poet is anybody, he is somebody to whom things made matter very little—somebody who is obsessed by Making. . . ." The poet's business is "ineluctable preoccupation with the Verb." But then the poet, if he is logical, will give up writing for action; we are reminded of Marinetti's walking statues.

All these poets, Pound, Graves, Riding, Cummings, and the Sitwells, have been admirably adventurous and ingenious, but, as far as living tradition is concerned, they are so many blind alleys. One can make use of their discoveries but it will not be to the same ends.

[1] Cummings, in *Is 5* at any rate, is, thanks to his ingenious codification, a better poet than e.g. Mr. Richard Aldington who tries to be clear and objective and is merely dull and sloppy.

To find a bridge between the dominant poetry of the early nineteen-twenties and the dominant poetry of the early nineteen-thirties we have to look back again to T. S. Eliot. Eliot as a craftsman has been greatly influenced by Pound—one more instance of the greater being conditioned (*but not caused by*) the less. The difference between Eliot and Pound can be seen from their likes and dislikes. They both (if for different reasons) admire Dante but Eliot admires, while Pound detests, Dryden. More people talk about Dryden than read him but there is undoubtedly a Drydenism in the air. Mr. Wyndham Lewis' recent *One-Way Song* is professedly Drydenesque. One of the younger poets, Mr. Charles Madge, recently went so far (in an article in *New Verse*, No. 6) as to say that all poetry is *didactic*. For this general movement towards clarity and rigour Mr. Eliot is largely responsible; more through his criticism than his practice.

Eliot's precisely tentative essays have reminded a world deafened by catchwords in how delicate a ratio or harmony a poem consists. But he has necessarily committed himself to a catchword or two in return, the most notorious of which is "impersonality." To understand a man's catchword you must collate it with his tastes; among those authors whom Eliot most admires are the Jacobean dramatists and Donne, Dryden and Baudelaire. Herein (excepting Dryden?) most of us agree with or follow him. But we must notice that though Eliot, having an imitative mind and ear, has details in his work similar to all four of the above, yet

40

in the total effect of his poems he is not only different from but alien to these writers. The reason for this is partly his basic romanticism. If you compare the defeatism of *Prufrock*, or *The Waste Land* with the apparent defeatism of the *Fleurs du Mal*, you can see why, if Baudelaire is classic, Eliot is romantic. For me

"I should have been a pair of ragged claws
 Scuttling across the floors of silent seas"

shows the same romantic nostalgia as

"Thou wast not born for death, immortal Bird!"

No amount of wit[1] can counterbalance the mood, and in Eliot's verse the mood is dominant. But if Eliot has failed to be classical himself, his influence has been towards classicism. At a time when English poetry was sagging desperately he has restored its nervous tension.

In an essay on the Metaphysical Poets (1921) Eliot issued a kind of manifesto—"A thought to Donne was an experience; it modified his sensibility. When a poet's mind is perfectly equipped for his work, it is constantly amalgamating disparate experience; the ordinary man's experience is chaotic, irregular, fragmentary. The latter falls in love, or reads Spinoza, and these two experiences have nothing to do with each other, or with the noise of the typewriter or the smell of cooking; in the mind of the poet these experiences are always

[1] I have not space to discuss "Wit" which Eliot restored to English poetry. It is now again realised (i) that the poet has a right to be witty but (ii) that wit is sometimes dangerous, as encouraging unconscious cheating.

forming new wholes. . . . We can only say that it appears likely that poets in our civilisation, as it exists at present, must be *difficult*. Our civilisation comprehends great variety and complexity, and this variety and complexity, playing upon a refined sensibility, must produce various and complex results. The poet must become more and more comprehensive, more allusive, more indirect, in order to force, to dislocate if necessary, language into his meaning." Most of the younger post-War poets accepted this very plausible statement of the probable nature of present day poetry. Writing to this pattern they produced with great ease the two salient characteristics of difficulty and intellectuality. But the difference between Eliot and his imitators was this; a thought to Eliot is, in most cases, really an experience of the first value but to most clever young men thoughts rank far below sensations. And so their poems were frigid intellectual exercises (though very good practice for undergraduates). Mr. Empson's poems seem to me to be still of this type.

Apart from difficulty and intellectuality the most notable thing in Mr. Eliot's prospectus is the importance of the empirical element (the noise of the typewriter, the smell of cooking). This has, of course, always been present in poetry, but the manipulation of it has more often been left to the poet's hands (his psychic hands) and not to his deliberating brain. The deliberating brain tends to hamper, rather than to assist, those experiences which are forming new wholes. Mere contemporaneity will be taken as a final sanction; this

will lead to fake-poetry. You cannot force the empirical element; an obvious danger also in surrealism.

We may contrast with the passage quoted from Mr. Eliot the Preface to *New Signatures* (1932) written by Mr. Michael Roberts. *New Signatures* was an anthology of poems by Messrs. W. H. Auden, Cecil Day-Lewis, John Lehmann, Stephen Spender and others; for many people it was the first intimation that there was a new movement in English poetry. Mr. Roberts says in his preface, "The solution of some too insistent problems may make it possible to write 'popular' poetry again: . . . because the poet will find that he can best express his newly-found attitude in terms of a symbolism which happens to be of exceptionally wide validity. . . . The poems in this book represent a clear reaction against esoteric poetry in which it is necessary for the reader to catch each recondite allusion." Mr. Roberts then brings in the criterion of *elegance* and defends the abandoning by his poets of free verse which, he says, "offers none of the possibilities of counterpointed rhythm which has been one of the technical delights of English verse." Finally in regard to the communism of most of these poets he says "It is . . . not surprising that some of these poets should combine a revolutionary attitude with a respect for eighteenth-century ideals. . . . This impersonality comes not from extreme detachment but from solidarity with others. It is nearer to the Greek conception of good citizenship than to the stoical austerity of recent verse." Poetry is to be "a popular, elegant and contemporary art."

This was an exciting declaration, though it was not fully borne out by the poems themselves. Mr. Tessimond on the one hand remained a left-wing exhibitionist and Mr. Julian Bell, on the other, a too easy reactionary. As for the revolutionary, or communist, attitude, it was often so facile as to appear a mere nostrum. We are now in danger of a poetry which will be judged by its party colours. Bourgeois poetry is assumed to have been found wanting; the only alternative is communist poetry. This seems to be an oversimplification. I doubt whether communist and bourgeois are exclusive alternatives in the arts and, if they are, I suspect these would-be communist poets of playing to the bourgeoisie. And I have no patience with those who think that poetry for the rest of the history of mankind will be merely a handmaid of communism. Christianity, in the time of the Fathers, made the same threats; all poetry but hymns was bogus, no one wâs to write anything but hymns. It is significant that it was Tolstoy, the most vehement of recent Christians, who handed over this destroying torch to communism (see his fallacious polemic *What is Art?*). This intoxication with a creed is, however, a good antidote to defeatist individualism; poets could not be expected to go on writing *Prufrocks* and *Mauberleys*. The three most interesting poets in *New Signatures* are W. H. Auden, Stephen Spender and Cecil Day-Lewis; all three in their poems are implied communists and often propagandists. Like all propagandists (cp. Shelley) they sometimes make themselves ridiculous. Auden is often

saved by his technical concentration and Spender by his technical economy but Day-Lewis, who writes longer and looser works and has not much sense of humour, has committed lamentable ineptitudes while preaching for the cause. Compare his two long poem sequences, *From Feathers to Iron* and *The Magnetic Mountain*. In the former the theme is personal and is maintained throughout with dignity. *The Magnetic Mountain*, which is propagandist, begins with a very fine figure (that of the Kestrel) but falls away into slipshod satire, derivative Auden, and priggishness. Both Auden and Day-Lewis (in common with so many less articulate admirers of the Soviet) suffer from an inverted jingoism reminiscent of Kipling or Newbolt:

"A blinding light . . . and the last man in."

Day-Lewis is (so far) an inferior poet to Auden and Spender, perhaps because his vision is purer and more consistent. Auden has many thoroughly bourgeois tastes and Spender is a naïf who uses communism as a frame for his personal thrills. (It is significant that he admires the now unfashionable Romantic Revival). Spender is the easiest of these poets to understand (but not to appreciate) at a first reading; Auden, who to start with was very difficult, is grinding his verse into simplicity. As simplicity, which is (from one angle only) a matter of technique, is so called for by the majority of readers, I will consider in more detail the technique of these poets. Then I will come back to their content, their beliefs and emotions.

Mr. Michael Roberts has given a reason why poets are ceasing to write free verse. But many intelligent people cannot see why they began to write it. The plea is sometimes made that free verse is an attempt to express the quickened and irregular tempo of modern life. This explanation is vague and bad (like most explanations which hinge on the word "express"). If the critic viciously separates form from content, it is difficult to see that any definite form x is especially suited to expressing any definite subject matter y; consider the vagaries of the sonnet and the various (and unelegiac) uses of the Greek and Latin elegiac. I would lodge the same objection against the doctrine of phonetic significance. There are certain roughly identifiable onomatopœic noises but in the practice of nearly all poets sound has been kept in gear with meaning and it is impossible to say that the sound is significant when abstracted from that meaning. The reason for changes in technique is not to be found so simply in an "expression" doctrine of progress. I would rather be very humble and say that changes in poetic technique are on a level with the changes each season of woman's fashions in dress. In the latter it is admitted that there is a certain deference to utility (appropriateness to the occasion) but the great majority of innovations are due to the love of novelty. And the love of novelty and variety is psychologically the mainspring of the universe.[1] Feminine fashions in dress are notoriously fickle merely

[1] But I do not say this frivolously. A *new* poem remains a higher thing than a *new* hat.

46

because women wear clothes all the time and the fashions soon become stale. If we read poetry sixteen hours a day it would become stale sooner than it does. In poetry, of course, we keep in with the old fashions while we practise the new ones; and the old ones owe their freshness to the freshness of the new ones (e.g., it is difficult to imagine that when the Romans had written like Virgil for four hundred years, they were not sick of Virgil.) Poets, therefore, began to write free verse merely because, at the time, there seemed to be nothing else to write. All the traditional forms appeared to be played out. I will take as the most obvious example the traditional line used in blank verse and in the rhyming couplet. The traditionalist sometimes maintains that this line served our purposes for four hundred years and that therefore there is no reason to discard it. A little attention will prove that the line during those four hundred years was not the same line. Marlowe, Shakespeare, Webster, Milton, Pope, Keats and Tennyson all used it differently. The differences were sometimes rhythmical, sometimes textural, but by the end of the Victorian period it seemed impossible to push it any further without snapping its up to then elastic identity. Also with the Victorians (e.g., Tennyson and Morris) it had become an effeminate or autumnal thing. Swinburne by a *tour de force* managed to give it some virility. He did this by sacrificing its capacity for conversation (or sober narrative) to its incantational qualities; e.g.:

"Men cast their heads back, seeing against the sun
Blaze the armed man carven on his shield, and hear
The laughter of little bells along the brace
Ring, as birds singing or flutes blown, and watch,
High up, the cloven shadows of either plume
Divide the bright light of the brass, and make
His helmet as a windy and wintering moon
Seen through blown cloud and plume-like drift,
 when ships
Drive, and men strive with all the sea, and oars
Break, and the beaks dip under, drinking death——"

This (first published 1865) is magnificent but it is a
cul-de-sac, as Swinburne found out himself. At the
same time Browning was pushing the blank verse line
to the other (the conversational) extreme; there were
perhaps a few more possibilities here and he has had
more influence, e.g., on Pound and Yeats and through
them on others. But the time came when most poets
had to renounce nominal adherence to this tradition.

One of the results was that long poems went out of
fashion. The poets of the 'nineties and the Georgians
kept to small patterns with only slight technical innova-
tions. No parallel[1] appeared to the verse of the French
Symbolistes, perhaps because Shakespeare had already
drained those wells in England. Then, before the War,
the Imagists and others began writing free verse. This
was verse in lines of uncertain length, without definite
metre or rhyme. Rhythm is, of course, almost im-

[1] Critics who explain everything by contemporaneity are as bad as those
who explain everything by influences. In either case there is a glut of evi-
dence, but is it evidence?

possible to exclude but the rhythms were purposely those of prose or of everyday talk. This apparently random outbreak released poets from the suffocation of the Victorian salon. Next (inevitably) we find them looking back to earlier points in the English tradition. Thus in Eliot, who at first sight seems formless and prosy, we strike patches almost too deliberately lifted from his private classics. Thus:

> "These with a thousand small deliberations
> Protract the profit, of their chilled delirium,
> Excite the membrane, when the sense has cooled,
> With pungent sauces, multiply variety
> In a wilderness of mirrors."

This is very neatly on the model of Mr. Eliot's favourite passage from Tourneur. Eliot in his earlier poems was addicted to a monumental kind of wit; later his style has been more diffuse, sometimes reminiscent of Pound in *Cathay*:

> "Then at dawn we came down to a temperate valley,
> Wet, below the snow line, smelling of vegetation;
> With a running stream and a water-mill beating the
> darkness,
> And three trees on the low sky,
> And an old white horse galloped away in the
> meadow."

In his latest verse, the choruses in *The Rock* (1934), the Bible has (appropriately) been an important stylistic factor. Eliot is as receptive to stylistic influences as Joyce. Thanks to a stern self-discipline he has avoided

writing mere pastiches but a less wary poet who tries to adopt the Eliot way of writing will find it is not one way but many and be lost in derivativeness. What first strikes readers of Eliot is his gift for point and his surprise effects; but point and surprise can both be faked. In *The Rock* Eliot himself seems to me to get some of his smart effects, especially of antithesis, too easily; they are too pat; they do not ring true. This is an inevitable trap for his imitators.

Eliot's verse was only free in that he allowed himself to ring the changes quickly; one moment conversation; the next moment Senecan sententiousness (for the latter the traditional blank verse line is always cropping up again; but thanks to quick change juxtapositions it had temporarily regained its freshness). But other poets were bound to want a more stable medium. There were two ways of obtaining this; to loosen the verse more (as in *Cathay: The Journey of the Magi*, etc., Walt Whitman and Blake's Prophetic Books) or to tighten it up to the tension of blank verse or heroic couplets by devices which would make it appear new. Abstractly these are alternatives; actually the New Poets have compromised between them. An example of loosening without tightening is Mr. Sacheverell Sitwell who uses a resolved verse somewhat like Blake's and sustains it through long poems without it falling to pieces but at the same time without achieving any powerful effect. At its best it is simple and adequate:

This mill that was true harvester now lifts his flail in vain for them,

And the stream slaves for ever and can have no rest.
The cockerel and his fanfare to their last march of sun
Stood on that stone bridge, the highest station for his
 watch,
And was moved in a hen-coop before the sun rose high.

Here again we cannot talk of technique without bring-
ing in content; Mr. Sitwell enumerates too much; he
has no economy. Economy is the key-word to the
best modern poetry and it is that which resolves the
loosening and tightening processes into one. I give
three examples of simple statement; notice the reappear-
ing beat of the old verse, which yet, thanks to careful
restraint, does not override their essential novelty;
notice also what the three have in common.

(1) From Clere Parsons:

Memory obfuscates and fancy obscures
also these sentences which slacken and pause;
causeless intrude the Quarter Boys of Rye
and early golfers walking on Camber dunes.

(2) From W. H. Auden:

You talk to your admirers every day
By silted harbours, derelict works,
In strangled orchards, and the silent comb
Where dogs have worried or a bird was shot.

(3) From Stephen Spender:

Then those streets the rich built and their easy love
Fade like old cloths, and it is death stalkes through life
Grinning white through all faces
Clean and equal like the shine from snow.

In these examples the absence of "cleverness" is notable, and the loosening is more evident than the tightening. Before enumerating the tricks which belong to the tightening I will remark on the affinities of this new verse with modern prose.

Prose nowadays had lost its graces; similes and metaphors are comparatively rare; it shuns the purple patch and the personal digression. Writers who keep up an appearance of *Belles Lettres*, whether playful or serious appear unreal. In reaction from æstheticism we write our everyday prose to very simple recipes; we feel that in Walter Pater style and ideas were not fused together; his prose is indigestible. We avoid conscious pattern. But pattern will always assert itself; our omissions and the abruptness of our syntax acquire positive value; e.g., the following: "I found a bookworm, no longer young, living from home, a mainlander, city-bred and domestic. Married but not exclusively, a dog-lover, often hungry and thirsty, dark-haired. . . . No farmer, he had learned the points of a good olive tree. He is all adrift when it comes to fighting, and had not seen deaths in battle. He had sailed upon and watched the sea with a palpitant concern, seafaring being not his trade. As a minor sportsman he had seen wild boars at bay and heard tall yarns of lions. . . ." (From T. E. Shaw's introduction to his translation of the *Odyssey*). One need only imagine how the essayist of the old school would have spread this out and smothered it with butter. The elegant austerity of this prose (relying largely on asyndeton) is well matched in the verse of

W. H. Auden. But verse, unlike prose, cannot attain adequacy merely by avoiding padding; the poet's object is not merely to tell you certain facts. Verse therefore will need more tricks than prose.

The most common tricks in Auden and his fellows (who however different from him, have gone to him for a model) are the following (which I mention in a random order):

(a) Counterpointed Rhythm (with occasional imitation (1) of G. M. Hopkins' so-called "sprung" rhythm; (2) of Skelton's rhythms as revived by Robert Graves in his *Marmosite's Miscellany*). Need I say here what I have already implied, that rhythm in poetry is a different thing from rhythm in music? In poetry you cannot eliminate the pull and thrust of *meaning*; e.g. "Put up your bright swords or the dew will rust them." If the poet ignores this fact, his versification will be coarse (as much of Swinburne).

(b) Assonance in the place of rhyme as used by Wilfred Owen, e.g.,

"But cursed are dullards whom no cannon stuns
That they should be as stones."

(c) Merely vowel assonance: (blood, sun).

(d) False rhymes as used by Yeats, Owen and many others : (blood, cloud ; drop, up).

(e) Rhymes of the kind much used by Robert Graves: (may, caúseway; stick, prophétic).

(*f*) Feminine false rhymes as used in Pound's *Mauberley*.
(Τροίή, lee-way).

(*g*) Internal rhymes. (Day-Lewis' speciality).

(*h*) Alliteration (often dominant, on the Anglo-Saxon model).

(*i*) Pauses (mental and metrical), cp. "Free Verse."

(*j*) Broken or accelerated syntax (cp. Joyce).

(*k*) Telegraphic omission of minor parts of speech such as articles and pronouns. (Auden's speciality.)

(*l*) Omitted punctuation (for the sake of continuity).

(*m*) Omitted capitals at the beginning of lines (ditto.)

(*n*) The above are *technical* innovations in the narrow sense, but these poets also innovate in the technique of content, e.g., instead of metaphor or simile imposed *ab extra* they use what is rather the concrete instance of an immanent theme. This can be seen best in Auden.

The above tricks, which I have mentioned at random, had previously been exploited for their own sakes by experimenters; the New Poets, as a rule, take them in their stride, confidently. It can be maintained that they still overdo some of the tricks, e.g., false rhyme; that false rhyme has a certain psychological effect (a kind of heroic bathos, as found in Yeats) and that these poets use it indiscriminately and therefore viciously. Here I would refer to what I said about expression and fashion. It might have been said of the eighteenth-century heroic couplet that it was only adapted to certain effects or only capable of expressing a very limited sphere, that therefore the eighteenth-century poets used it indiscriminately

and viciously (as was maintained by the nineteenth-century Romantics). But here, at the risk of appearing a fatalist, I would reply that the eighteenth-century poets could not help using the heroic couplet and that, if one must talk of "expression," the heroic couplet was the best expression of their world because it was a powerful fashion and powerful fashions are *constitutive*.

Passing from their technique, which we have isolated for our purposes, let us isolate also the content of these New Poets. We could not do this if they were exponents either of Pure Music or of any kind of automatism. For in Pure Music the content should be nothing, and in automatism it might be anything. But these poets are reactionary; they not only have themes but they have a partiality for a special kind of theme. Just as they are acquiring a new poetic diction or poetic syntax which is used without questioning (a good thing; poets have not eternity to make up their minds in) so they are acquiring a new poetic subject matter which, like classical mythology, will be amenable to a variety of poets and comprehensible by a variety of readers. The New Poets have a theme and treat it, as a rule, directly. This is another reaction; allusion and suggestion are still used but they are subsidiary; the New Poets tend to mistrust a mystical obscurantism (e.g., the Abbé Brémond or Mr. A. E. Housman's recent lecture on "The Name and Nature of Poetry"). This is where their propagandist element has helped them; you cannot propagand on a Symboliste basis. Those who say that prose describes while poetry sug-

gests, are making too easy a distinction. You must walk before you can dance; you can't be a master of suggestion unless you are a master of description. Description is always present (implicitly) in suggestion, as walking is in dancing. To describe anything well is difficult and the New Poets realise, as some of their predecessors did not, the necessity of hard work.

Three notable elements in the poetry of Auden, Spender, Day-Lewis, etc., are the topical, the gnomic, and the heroic. These elements qualify and reinforce one another. To be merely topical, by mentioning carburettors or complexes, is not truly modern. To be merely gnomic, without a concrete foreground, is boring and ineffective. To be merely heroic is escapism, shallow decoration. The value of a poem consists in a ratio. The ratio is, naturally, difficult to maintain. Day-Lewis e.g. is sometimes too facile in introducing his culverts, gasometers, cylinders and other modern properties; similarly Auden in enumerating (often for purposes of satire) his heterogeneous strings of things or people who are "news."[1] In these three poets there is a strong personal element (contrast the professions of Eliot); thus *The Orators* by Auden, an admittedly personal work, is made very obscure by a plethora of private jokes and domestic allusions. The personal element is a bridge between the topical and the heroic; these poets make myths of themselves and of each other (a practice which often leads to absurdity, e.g., Day-

[1] Auden is a journalist poet (I do not mean journalistic). If the *Odyssey* is the work of a longshore Greek, and *The Winding Stair* is the work of a crank philosopher, Auden's poems are the work of a journalist.

Lewis's mythopœic hero worship of Auden in *The Magnetic Mountain*). This personal obsession can be collated with their joint communist outlook via the concept of comradeship (see again Mr. Roberts' preface to *New Signatures*). Comradeship is the communist substitute for bourgeois romance; in its extreme form (cp. also fascism and youth-cults in general) it leads to an idealisation of homosexuality. Here we are reminded of Mr. Roberts' remark about the "Greek" quality of these poets. They are in several aspects more "Greek" than any English poets for some time, e.g., in this concern of theirs with comradeship, in their parade *à la* Greek chorus of heroic or fatalistic truisms (see Auden and Day-Lewis *passim*), in their careful pruning (excepting perhaps Spender) of exclamatory sentimentality. They show, however, an un-Greek vindictiveness, which they inherit from D. H. Lawrence. Having so far spoken of the common qualities of these poets as a group, I will try to indicate the importance of Auden and Spender as individuals.

By far the most important work yet produced by any of this group is Auden's *Charade, Paid on Both Sides* which appeared first in *The Criterion* in 1928. It can be very profitably contrasted with *The Waste Land*. It is tragic where *The Waste Land* is defeatist, and realist where *The Waste Land* is literary. *The Waste Land* cancels out and ends in Nirvana; the *Charade* (cp. once more the Greeks) leaves you with reality, an agon (see the final chorus). The obscurity of the *Charade* is not the obscurity of *The Waste Land* but mainly an obscurity

57

of method (condensed syntax, etc.). Auden has been very much influenced by the Icelandic Sagas; the plot of *Paid on Both Sides* is the simple saga plot of the vendetta; a chorus does the moralising. The result is an illusion of history. Poetry to-day is seen (contrast Aristotle with twentieth-century philosophers) to have affinities with history. History is not, for most people, a science; they read it because they take its persons and events as symbols. But symbols of what? The whole point, perhaps, is that we do not know what they symbolise. Philosophies of history over-simplify and cheapen, just as psycho-analysis tends to over-simplify and cheapen our dreams. In his *Charade* Auden is not (not obviously at any rate) grinding an axe; it consequently has a higher kind of value than his satirical poems. (True to type; for tragedy is specifically higher than satire.) We are still suffering from Shavianism, the heresy that the highest work of art is the pamphlet; it will be a great pity if Auden declines into this. The desire to show off your opinions, like all forms of egoism, is useful as yeast; it must not be your main ingredient. Auden, the journalist, runs the danger of merely showing off, of pamphleteering. I suspect that some of the surrealists are in the same position; if they could remain passive they might be artists but they are too deliberately wire-pulling their reflexes; they have made of their unconscious a kind of political platform. If you want to give your unconscious a chance you must keep your eye on something else. Your unconscious and your opinions are both important, but neither

58

is the main concern of your poetry; poetry lies between, though not cut off from either. Poetry consists in a ratio.

Auden's great asset is curiosity. Unlike Eliot, he is not (as a poet) tired. It is significant that in *The Rock* where Eliot attempts to give his poetry a social reference, the passages which ring truest are still those which are non-social, individualist, even suicidal. (There is nothing so individualist as suicide). Auden is not so sophisticated; he is not old with reading the Fathers. He reads the newspapers and samples ordnance maps. He has gusto, not literary gusto like Ezra Pound, but the gusto which comes from an unaffected (almost ingenuous) interest in people, politics, careers, science, psychology, landscape and mere sensations. He has a sense of humour. To say he is an Æschylus as some people have done, is merely stupid and might encourage him to be pompous. His job is to go on observing things from his very unusual angle and recording them (need I say that the combined process of observing and recording=creation?) in his very individual manner. His style is still changing, towards a wider intelligibility; and he has a strong tendency towards satire and burlesque. He may therefore be expected to produce either further "serious" work as in the *Charade* and the earlier poems, or comic work ranging from mere satire to Aristophanic fantasy. His recently published little play, *The Dance of Death*, was not interesting as verse, but it is a good sign that his eye was on the stage; the new poetic drama, if it is to exist, must have enter-

tainment value. Auden's versatility and fertility are invaluable at a time when too many writers are hampered by the fear of not being modish.

Stephen Spender is very different from Auden, who has, however, greatly influenced both his outlook and manner of writing. He has been advertised as the "lyricist" of the new movement and is the most likely of these poets to become "popular." He will also be the man for posterity, if our poetry is ever dug up in fragments; here is someone who really *felt*, posterity will say; and will conclude that he died young. His poems have a fragmentary appearance as it is. I sometimes think that this is vicious but prefer to conclude that it is their virtue. His poems have not got that crystal self-contained perfection which is so glibly attributed to the ideal lyric. Nor do they impress one with the approved shock at a first reading. Their machinery is creakingly evident; the last line of a poem tends to be an especially telling one, while the personal or propagandist (and in either case not very unusual) subject matter is enlivened with "poetical" images (roses, stars and suns) or with save-work epithets like "beautiful" and "lovely." As for the cultural background, Spender has swallowed D. H. Lawrence whole and mixed him up with Shelley, Nakt-Kultur and Communist Evangelism. Yet, if you read Spender's one volume of *Poems* (published 1933) through several times, you will probably decide that he is an interesting and valuable poet. An American critic, claiming that Spender is over-rated, calls for "a re-inspection of his

performance, a re-inspection of his thoroughly conven-
tional, 'poetical' idiom, his relaxed rhythms, and his
thin, almost feminine, subject matter." This is a point
of view which it is only too easy to take up. He has
not Auden's fecundity or felicity; he is patently very
limited. But this being so, he has made capital out of
his limitations. The poet's "hands" are in this case not
deft and virtuoso but they have a patient tact (like that
of Cézanne) which presses his confused world of
emotional clichés into a harmony which is, fittingly,
incomplete. His "relaxed rhythms" are entirely suited
to his subject matter; slickness is alien to him. I find
myself that when I want to make sure not to be fulsome,
I tend to write in this way. Thus two lines of mine
which I consider good—

"These moments let him retain like limbs,
His time not crippled by flaws of faith or memory"

are, if I am not mistaken, typical of Spender's manner.
It is inevitable, as with most "emotional" poets, that
some of his poems should be failures, should appear
merely bald and therefore blatant statements of personal
feeling (economy has the same pitfalls as bravado).
Spender is an individual poet; individuality (cp. again
Cézanne) is always in the making; Spender works hard
at his job; that is why his poetry at first sight is incom-
plete but at second sight necessarily so. It is uncon-
vincing to analyse him. All the features of a face may
be "bad" but the face itself "beautiful."

There are a dozen or so other young poets in England

who, whatever their "creed," at any rate believe in, and write about, something other than their own moods. I have not spoken of them because, having only seen their work so far in periodicals, I am more struck by what they have in common than by their individualities. There seems also to be a flourishing school in America, which, in reaction from experimental impressionism, is consciously limiting itself to a certain well-girdered and substantial way of writing. Again, I have not read them enough or re-read them enough, to criticise them. For me the history of post-War poetry in England is the history of Eliot and the reaction from Eliot. By Eliot I mean the Eliot of *Poems* 1909–1925. Needless to say Eliot himself has been reacting from his earlier poetic self in *Ash Wednesday*, his various Ariel poems, and, most recently, in the choruses in *The Rock*. But though these later poems may as *kinds of poem* have more possibilities for the future, I feel at the moment that *Gerontion: The Waste Land: The Hollow Men* and even *Prufrock* are better *of their kind*. Eliot is a theologian manqué; he is very susceptible to myth; his myths make him as much as he makes them. *The Waste Land* is a very delicate dovetailing of his favourite myths, profane and sacred. He has written much more simply and clearly from the public's standpoint but not perhaps from his own. On this question of obscurity, I would say finally that, though it is wrong to go out of one's way to be obscure, it is just as wrong to go out of one's way to be intelligible. The poet must fulfil (a far better word than "express") himself.

Eliot fulfilled himself in *The Waste Land*. He is essentially that kind of poet. *The Waste Land*, like *The Ancient Mariner*, cannot become a practical classic, i.e., a classic which the next poets shall use as a model. I have written this article primarily to indicate how the new English poetry is developing. This is why I have spoken of Eliot's poetry mainly as *a point from which* instead of assessing it on its own undeniable merits. This is also why I have not spoken of our other great living poet, Mr. Yeats.

Mr. Yeats is the best example of how a poet ought to develop if he goes on writing till he is old. I am not one of those who have nothing to say for his earlier poems and everything to say for his later poems. He is a very fine case of identity in difference and anyone, who is not pleading some irrelevant cause, can see this; e.g., to mention details, he still speaks of "Tully" and he still uses the fantastic refrain *à la* D. G. Rossetti or Morris. But he has, in his own way, kept up with the times. Technically he offers many parallels to the youngest English poets. Spender is like him in that they both have worked hard to attain the significant statement, avoiding the obvious rhythm and the easy blurb. Auden and Day-Lewis both use epithets in Yeats' latest manner. But when all is said, Yeats is esoteric. He is further away from the ordinary English reader or writer than Eliot is; not only because of his cabalistic symbols, etc., but even more because of the dominance in him of the local factor. His rhythms and the texture of his lines are inextricably implicated with

his peculiar past and even with the Irish landscape. They are, therefore, not to be too closely copied. If we must copy we should either copy people of our own age and society (wholesome plagiarism) or else people so far removed from us by time or language that our copying will not impose upon anyone. Thus I avoided reading Eliot for three years or so, that I might not write fake Eliot. But when I wrote the Spenderesque lines quoted above, I did not regard them as fake Spender because I knew that they were proper to me; whereas Eliotesque lines would not have been proper to me but merely composed *ab extra*.

I will end with a few predictions for the near future. "Pure poetry," as we have seen, is on the decline; this does not mean that poetry is to masquerade as anything else. For poetry *qua* poetry is an end and not a means; its relations to "life" are impossible to define; even when it is professedly "didactic," "propagandist" or "satirical" the external purport is, ultimately, only a conventional property, a kind of perspective which many poets like to think of as essential. In the near future we shall have a great deal more communist poetry (and a certain amount of reactionary nationalist —witness Mr. Hugh Macdiarmid). But in as far as these poets have the sense of touch, their poetry (whether they think so or not) will not be ancillary to their politics, but their politics ancillary to their poetry. The same applies to psychology. Poets may believe that a poem is merely a psychological document, and such a belief may encourage their output but, in as far

as they have the sense of touch, their psychology will be subordinated. I see a future, therefore, for both psychological and political poetry, though in both classes there will inevitably be a good deal of faking and a good deal of honest futility.

What I have said about "History" should indicate the importance of narrative poetry. I have noticed that most theories of what poetry is, leave no room for Homer, though nearly everyone assumes that Homer is poetry. This inconsistency is due to the dominance in modern times of the lyric; disgracefully fostered by both dilettantes and mystagogues. The short poem has naturally a unique concentration; even so I notice that, in spite of the popular assumption that any one "lyric" should be entirely self-supporting, yet our appreciation of it is greatly helped by a reading of other lyrics by the same author; more than this, we think of it (generally half-consciously) as a part of a whole, constituted by its author's other poetry and often (if we are not to cant) by certain aspects of the author himself.

Spender's latest poem, *Vienna*, is a poem of nearly thirty pages on a contemporary theme. Unsuccessful, I think (still too *voulu*) but the right kind of experiment. I expect - poets in the near future to write longer works (epics, epyllia, verse, essays and autobiographies) which will, for the intelligent reader, supersede the stale and plethoric novel. The more sensitive novelists (e.g., Mrs. Virginia Woolf) are approaching poetic form. The novel-reading public will always gulp its port, and writers who want their historicised symbols

to be taken seriously would be better advised (provided they have "a feeling for words") to deploy them in verse.

As for poetic Drama, there are at the moment many signs of a renaissance. Here, as in narrative, the verse-technique will at first have to be rather loose, until a compromise is reached between significant condensation and more or less instantaneous intelligibility. In its *dramatic* aspect it will probably go through an eclectic stage (borrowing from the music hall, morality plays, etc.) until, in Aristotle's phrase, it attains its own nature.

In narrative, drama, propaganda, satire, etc., we shall have to compromise with the public. In the shorter poem not so much so. It would be a great pity to go back to the Georgians and sacrifice the intellectual gains of the "difficult" poets. But I imagine we shall allow our readers some compensation. When we are esoteric (mystical or metaphysical) we shall prop them up with a palpable outward form (like Yeats or Valéry) till they have time to collect our tenuous implications. When, on the other hand, we are chaotic in outward form we shall give them something to grip in the nature of "content." The best poems are written on two or more planes at once, just as they are written from a multitude of motives. Poetry is essentially ambiguous, but ambiguity is not necessarily obscure. There is material for poetry everywhere; the poet's business is not to find it but to limit it. Part of his job is forgetting. We want to have the discoveries of other poets in our blood but not necessarily in our minds. We want just enough *a priori*

to make us ruthless so that when we meet the inrush of
a posteriori (commonly called "life") we can sweep
away the vastly greater part of it and let the rest body
out our potential pattern; by the time this is done, it
will be not only a new but the first pattern of its kind
and not particularly ours; the paradox of the individual
and the impersonal. To write poetry needs industry
and honesty and a good deal of luck.

BOOKS TO READ

Besides the poems of T. S. Eliot, Ezra Pound, W. B. Yeats
(particularly those in *The Tower* and *The Winding Stair*), Robert
Graves, Laura Riding, Edith and Sacheverell Sitwell, D. H.
Lawrence, Roy Campbell (a free lance who makes something
of high falutin), W. H. Auden, Stephen Spender and Cecil
Day-Lewis, it is important among dead poets to read Gerard
Manley Hopkins and Wilfred Owen. Hugh Macdiarmid's
A Drunk Man looks at the Thistle is a vigorous fantasia in synthetic
Scots. Wyndham Lewis' *One-Way Song*, a long didactic poem
in vigorous rhyming couplets, should be read as the only one
of its kind.

The chief anthologies are *New Signatures* and *New Country*,
both edited by Michael Roberts—the latter contains work by
Charles Madge, R. E. Warner, and Richard Goodman—and
Active Anthology, edited by Ezra Pound, and instructively bad.
It includes poems by William Carlos Williams, Marianne
Moore, etc.

Of books on modern English poetry I recommend *A Hope
For Poetry* by Cecil Day-Lewis, and *The Destructive Element* by
Stephen Spender. Work by most of the younger poets is pub-
lished in *New Verse* (every two months, 4a Keats Grove,
London, N.W.3).

PAINTING AND SCULPTURE
TO-DAY

Geoffrey Grigson

PAINTING AND SCULPTURE TO-DAY

By Geoffrey Grigson

I. Art, Is It?

ONE thing we in England should now be able to accept without pain or surprise—the series Cézanne —Cubism—"Abstraction." Cézanne died in 1906; he was born two years after the accession of Queen Victoria. Picasso was born in 1881, Cubism in 1908. These names with what they signify should be as firmly stuck in our pavement as lamp-posts, as Lord Tennyson, as August 4th, 1914. We should be able to guide ourselves by them, and catch hold of them when the traffic of nonsense or reaction becomes too thick and dangerous. But a majority of us, so it seems, can do no such thing. We cannot accept art even with the faith, which precedes understanding. Social common sense has contracted until it no longer accepts the idea of art in the present manifestation of its continual process. In this country the arts of painting and sculpture have been degraded by a succession of "artists" as near as possible to the vulgarity of absolute or concealed realism (Frith to Nevinson and Duncan Grant), to the vulgarity of identity with imitation. Such democratic art, ready to use the language of the least valid and valuable community-attitudes, may no longer be unrivalled or every-

where received. Pictures of the kind may still be painted, still be sold to the art galleries of Yorkshire cities, of Melbourne and Sydney. They are still conventionally praised; but every kind of informed and serious criticism which is not journalism or cliquepuffery attends to a different language. The democratic public, convinced now of the right of every man to his own opinion on every subject (which means that every man attends to and repeats those "opinions" which he hears most often and *wishes to hear*) regards the language as an esoteric puzzle, the dark thing concealed by some Etruscan script; or else as the language of an idiot. Reactionary propaganda through the mouths of academic "art" has quickened the separation between the arts and the life of the people. It has fed perplexity; and "in all perplexity," said Coleridge, "there is a portion of fear, which predisposes the mind to anger."

What is generically called "abstract" art, then, the art style of the last twenty years in every country of Europe, the now receding stage in the unique vital process of the arts, is reviled and wondered at enough, even by persons of good mind, to make the now usual defence and exposition which opens every book or article on the arts, still necessary. This defence here will not be long, or I hope, without value.

II. *Abstraction—Creation*

What is "abstraction"? Abstraction is the extreme withdrawal from the "real" forms of nature, from representation, to and beyond the real forms of art.

All art exists in a tension between geometry and what affects the beholder as being organic or vital.[1] The tension shifts, becoming slack or tight one way or the other. Art is at one moment bounded by the wiry line of Blake, at another almost centrifugal in the flaming etherealism of Turner's extreme phase. At one time the tension tightens just far enough to produce the perfection of Sardinian bronze figures and four thousand years later it has slackened to the violent vulgar expansiveness of Rodin. The tensity shifts according to the nature of the thought and feeling of particular ages and the nature of individuals; and in our time it has shifted and tightened until the geometric has pinched the organic, till art has been mechanised almost to the flat emptiness (in such "ideal" painting as that of Mondrian) of pure ornament. An art of feeling, released from geometrical tensity becomes quickly diffuse, until it weakens and turns volatile as fog. A same weakness and volatility is apt in such times to have affected every kind of best response and attitude in the community. Cézanne revolted against the weakness and volatility of Impressionism, realising that art needed "a Poussin made over according to nature." He geometrised within the organic forms of nature, reaching a tensity as in the good landscape at the Tate or the less good *Montagne Sainte-Victoire* now in the National Gallery.[2]

[1] By this I do not mean that the artist imposes a control of his form from the outside, by process of subtraction. On the contrary the tension is obtained within, working out, as it were from a seed-centre to that exact limit at which the tension is created.

[2] Comparison of this picture with Poussin's landscape: *Phocion* in the next room will be unfair to Cézanne. The *Montagne Sainte-Victoire* is a picture of feeling, rather than creation, and is pretty beside the monstrous calm and grandeur of the Poussin landscape.

Examine paintings by Monet in the Tate, and Cézanne's achievement and value become at once obvious. In his pictures a geometric organic tension is powerfully re-established, through which Cézanne explains to us his "view of life," his vision bodied out and involved in his response, spiritual and sensual, to the experiences received by his eye; and his art makes it obvious that Cézanne felt deeply into the temporal aspect and into the timeless nature of existence.

How Cézanne fecundated the Cubist movement, how his pictures, together with the spiritual, formal, rather than vital content of negro sculpture obsessed such men as Braque, Picasso, Juan Gris, Léger, is the story of all big and small histories of modern art. Not to go into the technical desires of Cubism, into its revulsion from the academic sequelæ of Impressionism, into the outward facts of its creation, something needs to be said on its "philosophy"—a philosophy which has come after rather than before the art it explains. Cubism and the Abstraction which follows Cubism form the art of a distracted world. In our century the renaissance process of creating the *mass of individuals* has been very much quickened and enlarged. Religion has faded away in a new era of degraded "humanism" until there exist in the European and American scene no unifying interest or way of life and no transcendent belief, which the artist can accept and through which he can express himself without insulting and betraying his own superior nature. The forms of life which this individu-alised mass employs, become unbearably distasteful; and

74

the artist, not led by his own wilfulness, but betrayed by the public, abstracts himself to some degree from distraction. He is in revolt anyway from an exaggerated realism, and at this point he is still half-abstract, organic and valuable. He is like Picasso at his best. But he aims eventually in his art, if he does not hold himself back, or if he is weak, at a refined, static, almost total idealism. From coming to paint pictures which excellently reject most of the visual world of common sense and discard fragments of the old realistic machinery (e.g., perspective), he goes on to make a virtue of painting like Braque without Braque's fanciful and pleasant harmony, like Picasso when he is most empty; and he becomes one of those lesser abstractionists who severely replace life with mechanism. There is little depth in these pictures except the depth of transparent plane upon plane, and even that disappears as geometry tightens in on them until only ideal, flat and patterned surfaces remain. This hard kind of machine painting, which I shall have to examine later on, and the more organic painting are both known as "abstract," but they are attacked without distinction. The organic, the fanciful and the extreme are confused as a Public Enemy and vilified as art of the individual, private, revolutionary art, which denies its own past. All kinds of art, it is often said sophistically by those who reply, are abstract, but "abstract" art as it is known to-day has its own peculiar qualities and it must be divided into these two kinds: into the half-abstract and organic art, the art of life or spirit through life, and the properly

abstract art or art of an ideal death. It is the former which demands (though it should not need) justifying; and as far as it is "individual" or novel, can it not in truth be claimed, that all art, even anonymous, religious art, has been to a degree the art of individuals, and also that abstract geometric art is as old as art itself, and a more valuable half-abstract art of a severe and simple variety only a little younger?

III. Cave—Picassos

The plastic arts have a history of about 18,000 years.[1] Before the famous cave-paintings of Magdalenian man, which are found in the south of France and north-west of Spain, came the sculpture, the engravings and the decorative art of the Aurignacian culture. There is no point here in arguing about their motives, about the way in which they originated. One can choose out of anthropological controversy only the most probable hypothesis to explain the emergence of the various types. For this argument what is important is to emphasise that early in the history of Upper Palæolithic culture, there appear not only the art of making figures in two or three dimensions, but the abstract and half-abstract arts I have mentioned. The first artist in figures, the first to make some figure which preceded the Venuses of Willendorf and Lespugue, may have recognised in a tool, while shaping it, or in a stone or other fragment which he picked up, an accidental

[1] This date is given as an approximation by Childe and Burkitt in an article accompanying their "Chronological Table of Prehistory"—*Antiquity*, June 1932.

likeness to creatures that filled his mind, creatures such as a woman or one of those animals which gave him his means of life; or, as we shall see, he may simply have read into objects the shape of which affected him the important memory images of animal or woman. The chance likeness, or the imagined likeness could then be deliberately or accidently increased, or made "real," and the figure in this way would have been an act of creation by himself. It would have given him satisfaction (pleasure is a dangerous word) by its visible analogy or identification with the living object, for he held life in his hand, as well as by the complex of attributes which one may be allowed to call its form.

But there also exists the Aurignacian "geometric," "decorative" or "abstract" linear art, if the word art can be used for its extreme crudity. On cave-walls wavy and more or less parallel lines exist, known to anthropologists as "macaroni," and made possibly by drawing the fingers across the damp clay of the walls; and on such objects as reindeer teeth pierced for wearing in necklaces and tools or reindeer bone are found more or less parallel notches, disposed on the edge or surface. "The incisions are at first transverse to the main axis of the decorated surface. Then from the Middle Aurignacian, they are found also disposed obliquely. At about the same epoch appear alignments of punctuations which recall the series of points or disks painted on the walls of Lower Aurignacian caves."[1] There are

[1] G. H. Luquet, *Art and Religion of Fossil Man*, p. 47. Yale University Press, 1930.

as many arguments about the origin of such "decoration" as about the origin of the figured sculpture, engravings and paintings. The "macaroni" may first have been idly made by a wandering hand; it may be imitation, it has been said, of the claw-scratchings of cave-bears. Accidental scratchings on a weapon or a tool may have given it a firmer hold and have been repeated first for that reason; but without considering the complex possibilities of a link between such decorations on objects and decorations on the body, or the contriving of necklace patterns with shells, teeth, etc., one can suggest that any utilitarian motive altered to a motive which can be called æsthetic, that such crude arrangement of marks may have satisfied Aurignacian man to some degree in the way which the "science" of æsthetic tries to explain.

I believe, in fact, that the first "works of art," linear or in the round, may have been abstract, that art as representation in some degree, as we are familiar with it, may have arisen from reading into such lines or into weapons and stones of affective shape the nature of familiar forms. "The earliest æsthetic stimuli," wrote Wilhelm Wundt, "are symmetry and rhythm,"[1] and he found the beginnings of pictorial art in simple geometric designs. He cites observations made among the Bakairi of Central Brazil who scratch such designs on wood and read into them "the memory images of the objects of daily perception," such as a snake or a swarm of bees; since the Bakairi can draw ordinary objects in

[1] *Elements of Folk Psychology*, pp. 102-5. Allen & Unwin, 1916.

78

the ordinary way when they wish to, he concluded that the designs came first for their own sake and could not be geometric schematisations reduced from snakes, etc.

Accident, if you like, and creative desire or the two together could lead to giving such geometric patterns a "real" as well as an imagined identity and from the first abstract art would evolve the "figured" art of the sculptors, of the engravers and of the painters of Altamira. This figured art is less "art itself." It is bodied art. Its products appealed to Upper Palæolithic man by their creative nature and by that process of vital identification between a living being and its representation in any material, which has been observed as common among primitive peoples and peoples of a much more elaborate culture. The original "decorative" or "geometric" or "abstract" art, not derived from organic shapes, could also change very easily into decoration. But its affective quality makes the centre of all the plastic arts, of the Altamira paintings, of which I have more to say, the art of the Egyptian sculptor, of Poussin or Constable or Picasso. The organisation of form which thoroughly moves us, moves us first through this affective centre of rhythm and symmetry, not by an appeal to reason but by a correction of our internal disharmony. The greatest artists, who are men of great intellect and insight, combine this affective quality with those scraps they have managed to see of spiritual truth; and it is partly to attract others to their work that they have bodied out the spiritual and affective centre in a visual language which they know will be understood.

Abstract art first, then figured art, then a new move to abstraction by tightening in on the forms of the figured art—that seems to have been the earliest course of things. The first abstract art may be compared with the extreme geometric abstractions of our own day, the great cave-paintings with the masterpieces from Giotto to the last century bodied out in visual language, the half-abstract art, which followed the cave-paintings with Cubism, and with the new painting of such artists as Miró and Hélion which seems to be going back to figured forms through a new semi-abstraction. The first half-abstractions from organic forms eventually became abundant in the Upper Palæolithic Age, and the process of such abstraction anyone can study for himself in Breuil and Burkitt's *Rock-Paintings of Southern Andalusia*, a picture-book illustrating a much later Neolithic and Copper Age art-group; or they may study it, and see its value in an art-form which may usefully be compared with the paintings in particular of Joan Miró (see p. 93)—the art of the Azilian painted pebbles. The Azilian culture, regarded as a culture of decay, comes after the Magdalenian culture, and it produced instead of such magnificent work, only numbers of these pebbles painted with vital designs in red ochre. "The motive for painting these river pebbles," Mr. Miles Burkitt declares, "and their use is unknown,"[1] but I do not think that any acute

[1] *Our Early Ancestors*, p. 12. Cambridge University Press, 1926. These painted pebbles have also been likened to the churinga, the sacred objects of wood and stone, of the Arunta and other Australian tribes, which represent their ancestors and are their spirit objects. Most churinga seem to be as inferior in design to the coloured pebbles as Australian drawing is to that of the Palæolithic cave-artists.

painter of our day would doubt that an essential motive in making them (whatever their "use") was an art-motive. They are paintings in which an organic-geometric tension is very well obtained. Many of their forms are almost certainly "degraded," as orthodox anthropologists would say, from organic forms which came nearer to nature. Some forms are further from any originals, and these have been described as "bio-morphic," which is no bad term for the paintings of Miró, Hélion, Erni and others, to distinguish them from the modern geometric abstractions and from rigid surrealism.

What, last of all, of the individuality of the Palæ-olithic artist and his beliefs? It has been mentioned that primitive minds do not distinguish between the object represented and the representation. Both are equally real, equally alive. Arguing from this fact and from the analogy of various practices among surviving peoples of a Stone Age culture (such as the Bushmen of South Africa), many leading anthropologists give most Palæ-olithic, and in particular the famous Franco-Cantabrian, cave-painting, a magical "inspiration" or a magical purpose. Primitive man, then as now, believed that he gained power over a living thing by creating it in its own likeness and possessing the likeness. This seems a good argument; and Abbé Breuil believes that art has gained very much from magical belief, since only in this way was it socially approved and so made import-ant;[1] yet I can see no reason, and certainly no evidence,

[1] "Les Origines de l'Art Décoratif," in *Journal de Psychologie*, 1926.

against art being in its origins "disinterested," and in its essence still disinterested, though made a function of social esteem, first by magic and then through the centuries by religion; and if primitive art was, in the sense of which we hear so much from such practititioner-critics and expositors as Mr. Eric Gill, an anonymous art, I do not see why one should doubt the notion that it came to be practised by artists or "artist-sorcerers," persons individual, yet without our own sense of individuality, persons of special artistic aptitude, who revealed their imagination, within the sharp limits of a tradition, of community attitudes and of varying styles, in a "more than usual state of emotion with more than usual order." "I believe," Picasso has said, "that at the source of all painting one will always find a vision subjectively organised, or an illumination inspired as was Rimbaud's." Is there no such vision bodied out in the crouching bison from the great fresco at Altamira? Painted in the red ochre which Magdalenian man used on the dead and their graves, with its volumes so vitally indicated with darker and lighter colours—is not the whole a design of attractive insistent rhythm, a painting not only as the artist saw a bison, but as the artist knew it, and through which he records that life-feeling which tremendously possessed him, an experience which was emotionally and also intellectually affective? This miraculous art of the polychromes, far more excellent than that of any other "Stone Age" people of modern times, including the Bushmen, in reality is also near to being a half-abstract art, not drawn from the model nor

drawn realistically, in realistic or imitative colours. It is an art of good geometric organic tensity, which reveals much of the artists who made it, and of the meaning of art. To examine it and to examine also the less naturalistic art of Upper Palæolithic times, is to be better off in solving our own problems of Cézanne-Picasso-Abstraction.

IV. Puritans and Impure

The division I have made between abstraction and half-abstraction I believe to be a test of the value of one artist against another; and it divides the art of our time very precisely. There are artists who affirm, such as Gris, Picasso, Léger, and artists who deny, such as the Neo-plasticians, until they take a section of space, which they wipe with brush and warm water, disinfect, and then divide with neat geometry, making a pattern of area and colour which as far as possible is purified of its emotive power. I regard these puritans, the un-natural children of Picasso and Braque by Kandinsky and Matisse, not as absurd or pathetic, not wholly as artists shivering at a modernity more powerful than they are themselves and erecting a series of little, flat, hard geometric heavens over which they etherealise themselves as refugees, but in some degree as martyrs, whose martyrdom is valuable. "We have no desire to bottle ourselves up in scientific geometry," said Picasso, "yet there are volunteer observers who give themselves up to making all sorts of researches in this direction. So much the worse for them. So perish the weak." They

will perish, except as paragraphs in art-history: but they will have served; and since services earn their D.C.M.'s and Albert Medals, it was ungrateful to print, as Ozenfant and Jeanneret have done in *La Peinture Moderne* a Mondrian beside a Meisonnier, as the two follies of two extremes. Mondrian, who is a Dutch painter, has rolled pictures out like Holland and cut them up with insubstantial canals. "By the horizontal-vertical division of the rectangle," he has declared, "the Neo-plastician obtains tranquillity, the balance of the dualism, the universe and the individual"; and his pictures attract one less than the most usual Cuyp or the dreariest seascape by Van der Velde. He is a Cubist shaved thin, a severe and tedious moralist. He is a social product by contradiction; and there are many others like him from Van Doesburg and Vantongerloo down to the Constructivist Cesar Domela (working in wood, metal and glass)[1] who continue his rigid simplifications as though a new way of art had been discovered. Their art, as I have said, is a sociological product. Also it makes coldly an idealist long nose at the kind of painting represented by the old academic Realists, the Impressionists, the Post-Impressionists, the Fauves, or "wild men" for

[1] "Elles sont montables et démontables comme des machines"—Anatole Jakovski On Domela's construction; and there is much flirtation with the clear mathematical, superhuman machine in all forms of this art puritanism. See, *passim*, the Cahier Abstraction-Creation Art Non Figuratif, or pronouncements of the "Purists" Ozenfant and Jeanneret (le Corbusier). "On peut créer le tableau comme une machine. Il est certain que l'ideal auquel tendent le Cubisme et le Purisme est de créer des agencements ne devant rien a la nature." *La Peinture Moderne*, p. 167, "La peinture est une machine pour la transmissier des sentiments."—But the best machines break down, and these machines, anyway, have not even a machine-life; they have never been started up.

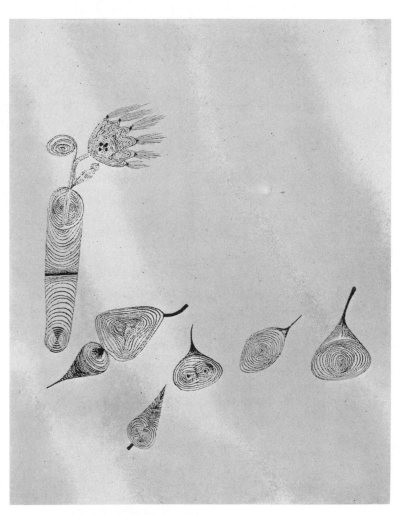

Paul Klee. FLOWER AND FRUIT. Drawing, 1927.

whom it has been enough to discover a new way (often by rediscovering old ways) of organising into pictures the familiarities of knowledge and observation. This reaction is very useful. It is useful, on any side to be a martyr and to light candles even if the opposition faggots burn you up; and if these Puritans of modern art would not have been burnt, they would at least have dried up from their deliberate self-starvation, if a new school had not matriculated itself, a school all wearing red caps and gowns, but not ready to be contemplative and quietist.

To surrealism a good introduction is the *Petite Anthologie Poétique de Surréalisme* which has lately been published. M. Georges Hugnet, the compère, explains that surrealism cannot be called another literary school like romanticism, or symbolism. You cannot separate surrealist painting from surrealist poetry, one surrealist activity from another. The surrealists exist to explore, to establish, those elements of art, and those forms of association which pride of intellect and pride of spirit have never acknowledged, although all artists have used them. In a review of this anthology in a recent number of *New Verse* Mr. Charles Madge has rightly said that the surrealism has developed "as a method of dealing with the irrational without sacrificing a rational point of view." André Breton's definition of surrealism as "Pure psychic automatism, by which it is intended to express, verbally, in writing or by other means, the real process of thought," has often been quoted against the surrealists. But those who deride these scientific

explorers of the nature of art conceal from themselves that they do not regard the artist as a Maskelyne who says "I will make something," and at once creates pigeons and a bottle of burgundy out of the emptiness of a top-hat. The artist whether he writes or paints "automatically" or not can only take out or allow to come out a mixed portion (which he recreates) of what has been put in. In as far as surrealism depends upon the "dream-æsthetic," let it be remembered that dreams must be fed, and that pieces of surrealism such as Coleridge's *Kubla Khan* or Yeats's *Cap and Bells* (which he wrote down as he dreamt it) have been bodied out with pieces from the very big store of experience acquired by two such acquisitive and creative men. Coleridge, in analysing the imagination, explains one of the principal things which damage much surrealistic expression in modern painting. He said that the imagination "dissolves, diffuses, dissipates, in order to recreate." It breaks down the items of percipience, before it combines them again into new wholes.

Such surrealist painters as Ernst, Dali and Chirico, and many more with much less talent (Mr. Tristram-Hillier or Mr. Edward Burra in England, for example) too frequently take pieces, and separate them, and build them into their pictures without that preliminary possession and preliminary damage. In this way their pictures are realistic and "literary," since they do not tell their stories by the methods of paint. Isolate a section, and it may be impossible to discern that it is by this or that artist. In fact it may not be by them at

all, only chosen by them. This is one reason for which the puritans attack the surrealists; another is the impartiality with which they examine and make use of all forms of irrational experience, expressing it like Dali or Ernst through symbolism which much upsets the moralistic, idealist conscience of the puritans. It is true that the way of Dali is the way of paranoia. All depends upon the intellectual strength of the artist; and in exploring nervously but without nerves those modes of mental activity and association which have been important in the art of such different types of sanity and intellectualism as Blake and Poussin, the surrealists are once more martyrs, "martyrs to science." They might be called the "impure puritans."

Their work must obviously mean much to us, and more than that of their Abstraction-Creation, Neoplastician and Constructivist opponents, who when they might have been dead have been given a new life, or new sense of mission, even a new importance, by the rise and militant organisation of surrealism. Picasso has recognised and used this value in what has been called his "surrealist" period. But as most artists are concerned in these activities, a dualism, actually, has been divided by a no-man's land. Two opposite principles which should be present in the one artist and held together, oppose each other in rival art armies; and what must come is a new synthesis of the two ways, the idealist way and the way of surrealism, a resynthesising of intellect with emotion, of form with matter, of geometric with organic. Puritans of modern painting

have declared that art is emancipated. Its Wilberforces have been the camera, freeing art from the need of providing imitations, and the sensational novel, freeing art of the need to satisfy us by telling stories. This is a risky rationalisation of their own desires. It may decently be said of Puritan art that it can only become dry. It cannot dissolve into an unpleasant excess. But is there any reason why it should not use any impurity, any "body," body of representation, body of story-telling, anything which will make it more rich and more vital? By surrealism and puritanism art has been rediscovering its complex nature.

V. Four Abroad

Consider, then, the value and example of four artists, Constantin Brancusi, Paul Klee, Joan Miró and Hélion; for the work of these four possesses, in different ways, the virtue of synthesis, and the virtue of the necessary half-abstraction. Brancusi is now an old man. He is a mystic—creative, that is to say, and not negatively puritan like Mondrian (who is by many years his junior). In influence and perhaps positively Brancusi is the most important sculptor of the last half-century. His severe and simple figures, many of them variations of an ovoid shape, are not geometric or mechanical. They have been made by a severe and exquisite refinement of natural forms, reached by spiritual athleticism, and expressing a calm vision, which is not so much one of an escape from the evils and confusion of an age which is diseased, dishonest and without dignity—a vision encouraged

by disgust—as one of happiness, a vision almost of a
man who has reached after intense struggle a final
stillness and certainty. Brancusi has assured himself of
his "feeling"; and it is only an outward judgment on
his sculpture to say that like most artists of our time,
he has been compelled to recrystallise the energy spent
with repulsive commonness by such popular artists as
Rodin. In a sense Brancusi may be regarded as a
martyr, but his martyrdom is of a much deeper kind
than the martyrdom of the neo-plasticians. As the
Egyptian sculptors expressed their religious idealism in
serene figures staring into an intellectual infinity, which
they cut out of basalt and granite, the hardest stones, so
Brancusi has cut his vision into simple shapes of onyx,
marble, and bronze. The forms of Egyptian sculpture
modify the solid block. They permit no disturbance
and no distraction. The hardness of Brancusi's materials,
the severity and compactness of his forms, body out in
the same way a severe and piercing insight. Such works
as *L'Oiseau dans l'espace*, *La Negresse Blonde*, the onyx
torso of a young girl (1918), the ovoid *Le Nouveau-né*
or the elliptical *Fish* are sculpture of that remarkable
rare simplicity which only a devoted and unworldly
artist can produce. If Brancusi is a martyr, he is one
because his vision has forced him to what may seem a
very limited expressive range. Yet his vision through
ellipses and egg shapes is no more restricted than
Maillol's vision through heavy females. It is Maillol
who has been taken over in England and made dull by
Mr. Frank Dobson. It is Brancusi whose polished

unicellular forms have been the basis for such different figures, more complex, more "impure," as those of Mr. Henry Moore. Brancusi, unworldly in his vision is yet worldly in its expression; he makes idealism apprehensible in tense organic forms. He uses, that is, the irrational, affective, central quality of art, its sensitivity, for a spiritual end, without damaging the equilibrium between the two. Brancusi is positive, rich in his poverty, refreshing. The idealist school of Mondrian is negative, poor because born in poverty; and dry.

Against Brancusi, the idealist through the lively medium of stone, can be set Klee, the new centralised romantic. Klee's fantasies have seldom been seen in England, and when seen have not always been understood. Brancusi is simple, Klee is variegated and complex. Like Picasso, he has found innumerable ways of dressing his more serious vision. The Blaue Reiter, the Munich group with which Klee worked before the War, published a manifesto illustrating the influences on their work; among these were Coptic textiles, figures from Easter Island, peasant glass paintings, Byzantine mosaics, Gothic sculpture, early woodcuts, German primitives, paintings by El Greco, Cézanne, Henri Rousseau and Picasso. Many other things have enriched Klee, many painters such as Goya, Blake, Ensor, Beardsley, Matisse, many kinds of savage art, such as the bark drawings of the Australian black fellow and the dance masks of the Alaska Eskimos. Klee has observed the world which he lives in and every object, art object or natural object, which could feed

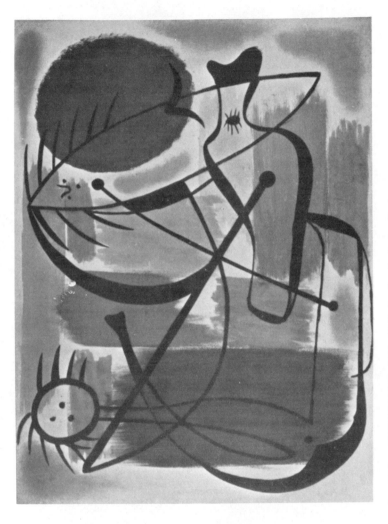

Joan Miró. COMPOSITION, 1934. (*Collection Douglas Cooper, Esq.*)

his imagination; and his art, thoroughly "impure"
by the neo-plastician ideal, uses every means by which
the beholder can be irrationally and rationally moved.
He paints what he knows as well as what he sees, the
realities which he dreams, liberated from the dull
physical laws of life on the pavement. "Un homme
endormi, la circulation de son sang, la respiration
mesurée des poumons, la délicate fonction des reins,
la tête avec un monde de rêves et leur relation avec les
puissances du destin. Un ensemble de fonctions unies
dans le repos." This description by Klee of one of his
own pictures[1] reveals all his purpose, and he is enabled
to do that complete thing he wishes to do by a mastery
over the methods of paint and surface and line which
has not often been excelled. If Klee paints as a child,
it is because he has preserved the child's innocent free-
dom of associations. Yet he is a man, witty and intelli-
gent, able to mix irony with innocence; and he is a keen
psychologist. The stories which he tells when one of
his active lines "sets out for a walk for its own sake and
without an aim" could be told only in line and by
colour, and the stories picture a world created by Klee
himself to express his own vision, a world with its own
fauna of birds and animals and fish, its own flora of
dark green and blue plants which bloom in the night
more mysteriously than the flowers inside a green cone
of Bristol glass. Fat arrows fly this way and that.
Spirits, like the debils-debils of the black fellow, hurry
across his canvases. Letters R and C come to life,

[1] Quoted in *Paul Klee* by Will Grohmann. Éditions Cahiers d' Art, 1929.

fantastic villages on mountainsides, bizarre cities and cathedrals and gardens are created with a loveliness of colour enforcing an expressive line of the most amazing sensitivity. There is no traditional logic in Klee's pictures. They satisfy us with their symbolism, which we apprehend but do not always comprehend, in a way, essentially an "art-way," which we should find it hard to analyse. Klee's pictures, as it were, extend and complicate such famous lines of poetry as "Child Roland to the dark tower came" or "La fille de Minos et de Pasiphaë"—lines Mr. Herbert Read has said with only a quarter of the truth, the appeal of which "is probably one of pure verbal music, mingled with a vague wonder, at the significance of such musical names." Such lines are microcosms of art and such pictures as those of Klee are examples of the Bergsonian return to pure nature. Klee's art rationally employs the irrational.

Klee is a surrealist though not an official surrealist; he is Klee, an artist, and no laboratory worker; and though he is a man of the most sharp intellectual percipience, he is one of those painters who, in relation to the great masters, stand as Herricks beside a Shakespeare. But one would have to mix Herrick with Vaughan to make an illustrative image of Klee, and it would remain then only a rough inept approximation.

Joan Miró and Klee resemble each other in some ways. Both invent pictures by means of irrational association. Both are witty and intelligent, both are "poet painters," but Miró, the younger man, uses a

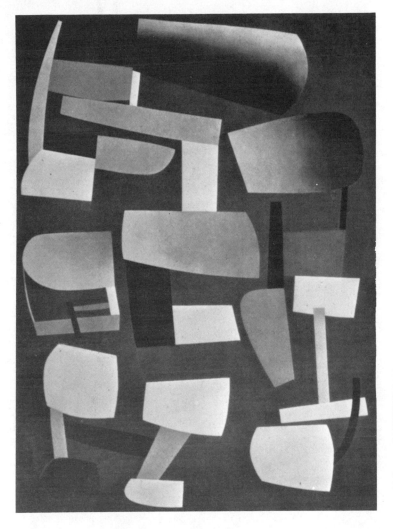

Jean Hélion. PAINTING, 1934.

simpler method. He does not depend so much upon an exploratory line. He invents plastic shapes in a half-abstracted manner which seems to me most suggestive, and valuable. The designs on the coloured Azilian pebbles, as I mentioned before, have been divided by one anthropologist into two classes, designs produced by the more or less obvious abstraction of natural forms (such as the human figure) and "biomorphic" shapes. Miró decidedly is a biomorphic artist. The term may cover him as well as others, though he also works by creating in a half-abstract way shapes with which we are familiar. He puts these shapes to play in wide spaces of pure affective colour, and his art, surrealist again, is yet complete again and not experimental. "Miró, poet like Klee, animalises all sorts of animals who fight, embrace and unite under a veil, drawn at the propitious moment, a shining veil. Sometimes he catches colours and anonymous lines and agitates them altogether, like bells, like birds in cages, and clouds in tempests. He is the exception of surrealism, as Picasso is the exception of Cubism. He always manages to end with colours and rhythms, and never closes himself within a dogma." He is so described by Jean Hélion; and the just insight of this description will be acknowledged by all those who have enjoyed Miró's Ballet *Jeux d'Enfants* which has had in England a success among thousands who did not suspect that what was before them to enjoy had been invented by a "modern artist" and even by a "mad" surrealist.

Miró was born in 1893. Hélion in 1904. He is an

artist who will become much better known, I believe, and influential; and he must be mentioned here since he converges from the idealist, machine side of modern art towards that synthesis which one must desire. Hélion is a Frenchman very concerned with the virtues of clarity and order. He has been a semi-neo-plastician. With Carlsund, Doesburg, Tutandjian and Wantz, he founded a group in 1930 known as "Art Concret." "Toujours concrèt, jamais impalpable," they quoted from Mallarmé, and they exalted the intellect. Their painting was to attain to "la clarté absolue." It was to be "peinture concrète et non abstraite parce que rien n'est plus concret, plus réel qu'une ligne, qu'une couleur, qu'une surface," and it was affirmed that "l'évolution de la peinture n'est que la recherche intellectuelle du vrai par la culture de l'optique." In an article on Art and Mathematics, Hélion wrote: "Quand il (l'homme) résumait l'univers en Dieu, l'art a trouvé son apogée dans la figuration de l'histoire religieuse . . . aujourd' hui, la civilisation substitue aux mystères divins ceux de l'univers, et les étudie positivement par les mathématiques." The inference meditation has probably modified and will modify still more. Until recently he belonged to the rather inchoate swollen group of "Abstraction-Création," but in his practice he has moved away from the divided rectangle to a kind of ideographic painting which appears to me more and more organic. If his forms are not "biomorphic," they are created in organic wholes of considerable vitality. In reproduction they lose much: for Hélion

employs an exquisite limpid harmony of colour, "une clarté absolue," as an element of design, and an element of form. He is convinced that painting must "grow out" again. He is an enemy of surrealism only as a rigid orthodoxy which obscenely pleases itself by preferring certain groups of association to other groups and as a movement which denies the method, in searching for the material, of art. His "concrete" painting works with imagination and therefore vitally and to some extent spiritually; and it is certain to develop as Hélion explores new ways of expression. Before long, it is good to know, Hélion will probably be exhibiting in this country with the Seven and Five.

VI. Four in England

It is dangerous living on an island, even if the island is on the edge of Europe, and only twenty miles at the nearest point from France. It is the cause of provincialism, or individuality, if that charge is offensive; and since English art has always been provincial in its best levels and individual, isolated in its mountains (in the sense that its mountains are seldom part of a range which can be surveyed and has a name: they rise usually from a marsh or at best, from a plateau), I have a reason for not mixing the artists of Europe and the artists of England. Even the best of the artists of England are separate; and when the best with the worse have been praised for their "Englishness," they have often been praised for amateur qualities, for provincial quirks, for eccentricities which come from being tangent to the

circle of Europe. They are not praised for being artists, or even for those good qualities which grow out in them from a social tradition; and their works, if they themselves are half-living, moribund, or just dead, are hung in the Tate Gallery, where provincialism of execution is exalted by those who seem to have all knowledge and all qualifications except courage and acute taste controlled by exceptional intelligence. Since England has been the richest country in the world, and the most powerful country, her art provincialism has been strengthened and still remains strong. America has sent dollars to Europe for culture; and for good or bad reasons, there are many collections in America of paintings by Picasso, Léger, Braque, Gris, Matisse, Miró, Klee, and of sculpture by Brancusi, etc. American collectors have gone about collecting without compromise in a "determination to achieve culture" as Mr. Untermeyer has said of Robert Frost's entry into Harvard. England, with a culture of her own, and a new moneyed class, separated herself from European culture in the last century, and incubated sitting after sitting of "artists" in her coops near Burlington House; the chicks preserved the old feathers, but grew into new cockerels underneath, crowing a new tune which agreed with the new money-men who were neither of the people nor of the aristocrats; and this new tune, apparently traditional, had nothing to do with the life of the old tradition which stopped for a time with such different painters as Blake, Turner, Constable and Cotman. From influencing Europe for some seconds

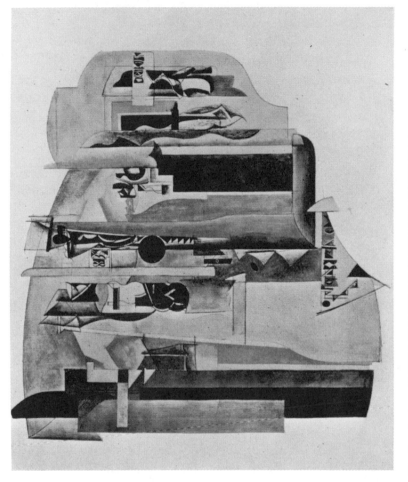

Wyndham Lewis. ARCHIMEDES RECONNOITRING THE ENEMY FLEET, 1924.

England in painting settled down on to the vulgar sofa of self-satisfaction. Even when the webbing broke under such dropsical flesh, she snored there still. The Pre-Raphaelites were as provincial and as vulgar as anything which they disliked, and the first artist to give a creative kick to the sleeping lady seems to me to have been Mr. Wyndham Lewis. In chief, I shall mention only four English artists as being clear above the level of the murky waters of the Tate Embankment—Lewis, Mr. Ben Nicholson, the late Christopher Wood, three painters; and one sculptor, Mr. Henry Moore.

Wyndham Lewis stands over our time in England as its most remarkable artist, a fact of which many of his contemporaries have been afraid, even Mr. Eliot, who has named him a bit priggishly the best "journalist" of our time. As a painter (and here Lewis can only be encountered as part of himself, or as one of his many selves, which include Lewis the critic, Lewis the novelist, Lewis the poet, Lewis the enemy pamphleteer) Wyndham Lewis alone in England ran nearly from the white line with such men as Picasso, even if distractions, such as the need that he felt to hack away in pamphlets at the ignorant and prejudiced and rotten timber around the track, have made him fall to some extent from the running. In the movements or groups which he has formed, such as the Vorticists before the War and the "X group" after it, Lewis has been by far the most eminent man intellectually, and as an artist (Gaudier-Brzeska perhaps excepted). He is an enemy of Bergsonian flux, and enemy to Hegel for the masses, and a

heavy-weight of the intellect; as far as anyone he has seen into the confusion of the present world. He has not been deceived into taking sides or going to church. He has taken his own side and gone to his own church. He has not been deceived by communism into making that generous, emotional gift of oneself to the foundation of a "happier" and "healthier" race of human insects; he has not been *deceived* by fascism. As an artist, he has not religiously surrendered himself to Picasso, to the Naïf, the Primitive, the artists of the Dark Life or the artists of Puritanism.

"The important thing is that the individual should be a painter. Once he is that, it appears to me that the latitude he may consider his is almost without limit. Such powerful specialised senses as he must have are not likely to be over-ridden by anything." "But the work of art does the re-ordering (of the sensations) in the interests of the intellect as well as of the emotions." Those two statements are Wyndham Lewis' illuminated diploma for his own practice. They authorise him only to be an artist, not this *kind* of artist or that. "In art there are no laws, as there are in science. There is the general law to sharpen your taste and your intelligence in every way you can."

Lewis's practice and style began by exploration of a number of elements common to other artists. He has meditated, thoroughly, one would say, upon the work of Cézanne; and when negro sculpture and other kinds of "savage" art were found for a new recension of painting and sculpture, in Paris and in Germany, Lewis

also found that kind of art by modification of which he could set his own peculiar style in growth. Mr. Lewis may correct me, but it seems that this style, outwardly, develops from the carved and painted woodwork of Oceanic art, in particular of the art of what is called New Ireland (Neumecklenburg). One case in the ethnographical gallery of the British Museum is full of this curious, fierce, linear woodcarving, each piece intricately made up with superimposed planes, with sharp colours which emphasise volume as well as being elements of a colour design, into complex rhythmical wholes. Plane, volume, line and colour are here only to be borrowed. If the savagery also of a New Ireland dance mask has attracted Lewis, it is not because Lewis is a savage (he is a man of rare civilisation), but because Lewis, like other English artists of intelligence, does not think too highly of the smallness of mankind or its social behaviour, and knows that there is much in it which is beastly and overbearing and which needs the cut of satire. Moreover this New Ireland style is tense, organic, and complicated enough to be borrowed and made the vehicle of complex intellectual and emotional experiences. Lewis's visual method I can best explain through one of his verbal usages. He calls Mr. Chesterton somewhere a "fierce, foaming Toby Jug." He creates, that is a satirical image for the idea "G.K.C." which can at once be visualised, and packed into this image are the derogatory notions of a jug-man, of mere pottery, of an Olde English jugge, of a pot trying to be fierce, of a pot brimming with froth in general, and

froth in particular of Mr. Chesterton's emotionalism over pubs and ale and distributism and the Catholic Middle Ages. In a by-the-way, not very exalted image, intended to create an esteemed yet in many ways stupid author and at once to destroy him, is contained the method which in his best pictures Lewis uses magnificently. His paintings are visual statements of indivisible idea and emotion. Possessed by some myth or story which he discovers, Lewis forms an emotion mixed with his idea; visual objects coincide with the emotion-idea, which penetrates them, and the picture is created.

Lewis works in an imaginative way as a whole man, for intellect is part of human life; but he would never make the error of putting the spiritual content in painting before the affective content (though in the noblest painting the two cannot be separated). Much can be adduced against much of Lewis's work. His imagination sometimes appears to go cold, and his forms then shrivel, and become pinched. The tensity of his drawing suddenly vanishes, and the line from being moving becomes merely a line. When this happens, Lewis's pictures lack the balance and fullness of such a painter as Léger, whom Lewis resembles in a few points. With colour he attempts no pretty harmonies; but his more severe, peculiar and imaginative vigour is impersonal with no care or corner for softness of the flesh; and this rather than its cruelty, or its lapses, has prevented its proper understanding. It may be said, though I should not say so, that Wyndham Lewis is worth more as

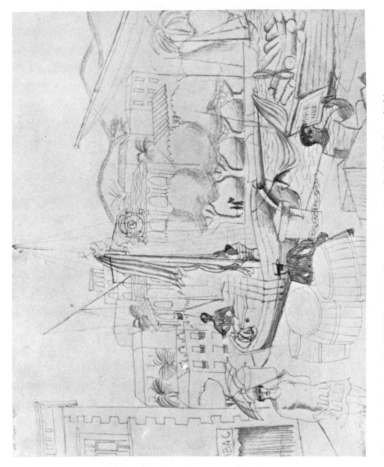

Christopher Wood. DRAWING, 1927. (*By courtesy of Alex. Reid & Lefèvre, Ltd.*)

an example of method than as a performer. But certainly, he is the first important, and so far, except Henry Moore, the only important English artist of this century.

Lewis belongs to the Leonardo type of artist, he cannot release himself through one kind of art only or satisfy himself only with one kind of intellectual activity. He is the volcano with many vigorous craters and vents, in continual eruption, throwing out a hot fusion of different work together with burning distructive polemic. Henry Moore belongs to the Cézanne type. His energy emerges, not volcanically, but in the slow and solid block. All of it is in the block. None is used elsewhere, none in words, in expression of thought, or in opposition. But Moore is not an idealistic sage like Brancusi. He is not a puritan. Contemplation of nature gives another English sculptor (or the other English sculptor), Barbara Hepworth, "the power to project into a plastic medium some universal or abstract vision of beauty:" and her figures are simpler and more stern, or prim. Moore attempts to be less impersonal. "Abstract qualities of design are essential to the value of a work, but to me of equal importance is the psychological, human element." His spiritual vitality he creates in a stone-life; and in much of what he makes (this is most obvious in his finished drawings) the power of "mystery," the dream-nature, the irrational enticement, are willingly encouraged. Moore carves extremely well. The method of his work is good and consistent. It is right for him that he should explore the human figure in its relation to material and to

natural objects. What is less good is that Moore should have taken over the pin-headed giantesses, as Lewis has called them, of Picasso. Moore is not an eclectic. The giantesses have become his own property, created under his own method; but even when they are translated into stone, which partly justifies their bulk, they still have something of that "vegetative imbecility" which is charged by Lewis against the Picasso original. By the paradox of size, they belittle the human; they puff out the stone, they encourage the organic to become almost the tumescent, and I believe that, in making them, Moore allows the psychological element to give him too many orders. One expects one of these pin-headed or bird-beak-headed monsters (which resemble figures on early Greek jars of the eighth century) to pursue one almost like the paranoic growths of Dali spawning in the flat horror of an endless perspective. When Moore synthesises his vision and his human, psychological element by enlivening and promoting the form of flints and bones and shells, his sculpture is more acceptable, for he will never allow objects to impose on him their own deadness. Some extra wilful control, even puritan control would benefit Moore, but, as it is, he is an inventive sculptor, not timid, not needing to compromise since he is a big enough artist not to be confused and dismayed by the scepticism and aimlessness around him. Like Miró, but more thickly and strongly, without a witty, gay, almost entertaining graciousness, he is exploring and opening up a world so unfamiliar that one is almost deceived into calling it a new world, of

new "real" ideality; certainly it is a world into which many others will trek.

Though Christopher Wood has been fashionable since his death five years ago, his painting in any public way has not been deeply enough considered. Perhaps the reason is that he does not seem "modern." His language, but not his manner would have changed; and till he killed himself, he worked as a "Fauve." He painted landscape situations, uncommonly dramatic pictures in which selective, emotive line was emphasised by emotive colour, more obedient to Wood's imagination than to the colour facts of what had been before his eyes. Trees, persons, cows, houses, boats, harbours, sea, cloud, the ace of spades or the three of hearts, a palm-tree or a wine-barrel—every object he needed, he placed dramatically within the rectangle of canvas; but he always placed it there as an artist, not as a recorder. Tones, whether dark or light, delicate or strong, he created with the fullness of their nature. He was witty, dramatic, affective and he could be so at one time. He used the naturalistic method, changing it subtly, for ends by no means those of the naturalist; and this delicate irony connects him with many other painters from Klee to Miró. Not all his landscapes are vitalised by that imaginative passion which makes Wood superior to such an able painter as J. D. Innes. Sometimes he depended too much upon wit and ironic drama; sometimes he was too pretty; but when he did possess what he saw and recreated it in terms of pure Wood, he did it with so much energy and light that

our experience grows larger at once, deeper and more happy. There are not many English painters now of whom so much can be said. It cannot be said exactly of Mr. Ben Nicholson. Mr. Nicholson was a friend of Christopher Wood, and his painting has perhaps developed much as Wood's might have done. Puritanism in England is led by Mr. Nicholson. The Seven and Five Society, with which Wood also exhibited, has become a group for abstract art, and through Mr. Nicholson's puritan zeal Arp, Tauber Arp, Domela and Mondrian are to exhibit here with the English members. Miró, Hélion and Erni have also been invited, so that the biomorphic abstractionists as well as the geometric abstractionists are allowed. Nicholson is between the two sides. He is an uncompromising searcher for an absolute, for a "real" harmonious world in which one can "live"; but though he has disciplined himself in recent pictures, making them impersonal, putting away the sensational pleasures of pure colour, and constructing rectangle shapes in relation to circle shapes, coloured only in whites, and greys and browns, he has never really gone beyond himself. If he wishes for an elemental gaiety or harmony, to create apprehensibly a piece of the absolute and infinite, he wishes for something which cannot be created. "Art is a lie which allows us to approach truth, at least such truth as may be conceived"—an observation by Picasso which I am tempted to write on postcards and send every day to every puritan idealist who believes in the modern emancipation of art. Some of the latest pictures of all which Mr.

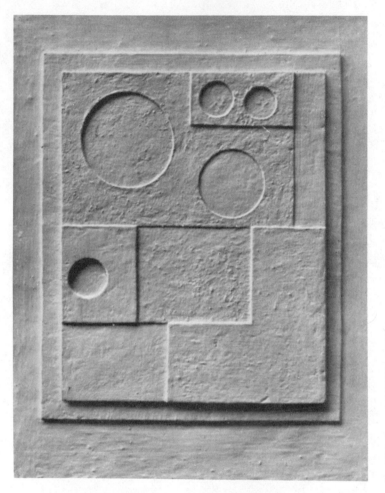

Ben Nicholson.　CARVED RELIEF, 1934.

Nicholson has painted are stronger in form, and in colour less easily charming, than those which came before his latest discipline; and against all desires for impersonality, they are more Mr. Nicholson himself. Such artists seem afraid of the liberty of the artist to use everything which he likes; and some of them perhaps are wisely afraid. A touch of sentimentality, of easy though not vulgar emotion, does no damage if one can guide it ironically or with wit. Those whose nature does not allow such guidance do best to be no more personal than they can help or their pictures need. I admire Mr. Nicholson's painting very much. Its attraction is more than charm, and there is no painting by an Englishman who knows better what he is doing with brushes, colour and surface; but what may be right for Mr. Nicholson is not right for others, and the puritanism or abstraction which he encourages may be popular with many English artists because imaginatively they are too weak to face complication, or to do anything else than nestle in the comfort of a cold absolute.

There are other English artists whom it would be necessary to write about in a larger examination. Mr. Epstein needs some severe criticism to get at the little which is good in his work, and such criticism would have to be made tactfully so that his pioneering value would not be slighted. Barbara Hepworth's sculpture diverges now from that of Henry Moore in a puritan manner which will probably concentrate it and do it no harm. The painting of Wadsworth, Roberts, Frances Hodgkins, John Aldridge, Paul Nash, Winifred

Nicholson and the naïf, Alfred Wallis, has some connection with art at present, but there is no more point in examining here what seems less energetic than in publicising those who are just beginning to discover a method of painting or sculpture.

VII. Art Language

However painting and sculpture go on abroad (though such artists as Miró, Hélion, Erni, and perhaps Giacometti and Calder) or in England, in general idiom I doubt if the masses of people will find them easy to apprehend, or accept. Are we not in error when we insist that art was once very much "easier"? Centrally, I believe, the best art has always been obscure. If the artist's aim is truth, truth is the most obscure of mysteries, reached—rather approached—only by discipline and meditation over many years. The artist's version of truth or apprehension of truth is never likely to be obvious. And the matter is more elaborate than that. Three things may be found in a painting or piece of sculpture, the affective, the spiritual and the attractive. They must always be there, though the amount of each in their interpenetration may differ from age to age, as one may see from comparing an Altamira bison with a Piero della Francesca, a classical composition by Poussin with a landscape by Cézanne, a marble figure with crossed arms from the Cyclades with an arrangement of wires in space by Calder. The attractive is in part the language of enticement; it is a way of saying one's something so that others will be persuaded to

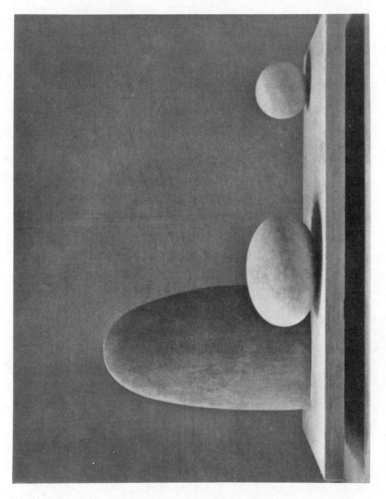

Barbara Hepworth. CARVING, 1935.

examine the statement. Representation is the language. By representation, in all its degrees from the realism of Courbet to the biomorphism of Miró, the affective and the spiritual, which make the artist's "vision" and are peculiar to him, are set down in terms common to other men. The mediæval guild craftsman who built Gothic cathedrals or carved tall saints to instruct the people was as much an individual artist, if he did not recognise his individuality so keenly, as Picasso or Wyndham Lewis. What the mediæval sculptor created may have been "visible speech," and the language, the attractive part, together with much of what it said, the speech, may have been understood by the community. But the common man in the 13th century did not understand all that was displayed in stone in the porches of Chartres. The affective, and the spiritual, then as now, spoke only to those of trained sensitivity. If art in our time has become too obscure, it is not the fault of the artist. The painter of Italian primitives, the man who decorated Byzantine walls with black and green tesseræ among gold, the mediæval sculptor—each of them could speak in the language of Christianity and the language of common forms. The artist now has found common forms degraded and prostituted by the yes-men of art. He can share in no common transcendent belief, and the social system and the substitutes proposed for it provide no possible language. The artist is now betrayed by his audience, not the audience by the artist, and what Ortega y Gasset has called the revolt of the masses ("The characteristic of the hour is that the common-

place mind, knowing itself to be commonplace, has the assurance to proclaim the rights of the commonplace and to impose them wherever it will"[1]) drives him to produce art in which the affective and spiritual dispense with the attractive element, art which is more "art itself." Art in its modern form will become more familiar and will be acceptable to more people than at present; but it will still attract a minority only, made up of those with the most finely sharpened senses. Art will not lose its social function by pleasing neither the mob and the rich vulgarian nor the politicians of every colour, for art does its best social service by being art. Modern painting and sculpture will help to preserve the spiritual and emotional health of those few without power and place who retain in times of mob-rule and mob-fascism those qualities which allow civilisation and prevent life from being a sensational mockery. The kind of art which in my belief they will most enjoy, is not art of a frigid, geometric, mechanical idealism, but that viable art, that viable sculpture and painting with an organic tensity, with a contained energy of its own which has been produced abroad by the succession from Brancusi to Miró, in England by the few such as Lewis and Moore.

[1] *The Revolt of the Masses*, p. 18 (American Edition, 1932).

BOOKS TO READ

The best writing about art, as about much else, in England has been done by Wyndham Lewis. His *Review of Contemporary Art* (in *Blast* No. 2. 1915) and his *Essay on the Objective of Plastic Art In Our Time* (in *The Tyro* No. 2. 1921) should be read by all who can get hold of them. It is a pity they have never been republished. Most knowledge of modern art has stained through to England through a not very admirable though most respectable colander, and the first number of *The Tyro* should be referred to for the best statement on "the inconvenience of possessing an eminently Victorian group of advocates and go-betweens in our relations with Paris." In *The Caliph's Design* (1919), which is out of print, but not impossible to obtain, Mr. Lewis has criticised Picasso and the modern movement with remarkable insight, though he would probably alter now the opinions put down about one or two artists. Much more of the first value will be found in his other books such as *Time and Western Man* and *The Diabolical Principle*. Mr. Herbert Read's *Meaning of Art*, *Art Now*, *Henry Moore* (1934), *Art and Industry* and *Unit I* in which members of this group, including Moore, Nicholson, Hepworth and Wadsworth, make personal statements, are all useful, and Mr. Raymond Coxon's *Art* in the Pitman series is a well-informed detailed and intelligent book by an able artist and teacher which is not as well known as it should be. The Gallery of Living Art, 100 Washington Square East, New York has published an inexpensive catalogue with more than thirty reproductions of paintings by Picasso, Léger, Miró, Mondrian, etc. and an important article by Jean Hélion. The Puritan half of modern painting is well illustrated in the *Cahier Abstraction-Création*, of which three numbers have appeared, the surrealist side in the Paris periodical *Minotaure*, with the famous *Cahier d'Art* in between. A special number of *Cahier d'Art* on the work of Miró was published in 1934.

FICTION TO-DAY

Arthur Calder-Marshall

FICTION TO-DAY

By Arthur Calder-Marshall

I

THE nature of each art predetermines its material. Music must deal with sounds, painting with shape and colour, sculpture with what is also tangible. These arts, then, look for and select different qualities from reality.

The arts of writing in the same way, approach the existent world from different angles. Their spheres though wider than those of other arts, are still limited. Poetry deals with the general principles of the world in which the poet lives: it reveals the skeleton of existence. Fiction, however, treats with the multiplicity of phenomena. It presents the moving body of life, its flesh, blood and bone. Poetry reveals: fiction presents, catching "the very note and trick, the strange irregular rhythm of life."

The purpose of all art is fundamentally to delight: but it is not to entertain. Confusion often arises between the many novels produced for entertainment and those few which are works of art.

I use the word "novelist" to mean an artist in fiction, and "fictioneer" to mean a writer whose aim is enter-

tainment. The number of fictioneers was increased by the economic depression.

The public school and universities produce young men whose level of education unfits them for business, commerce or manual labour. These men were formerly absorbed into the civil services and the professions: but demand has now fallen below supply. The young men turned first to teaching until that unenviable profession was overcrowded for the first time in memory: and then in desperation to commercial travelling and fictioneering, in both of which they have sustained a high level of incompetence.

They are not to be blamed. The necessity of their living is apparent to them: and they are given every encouragement by publishers whose search for genius is more urgent than discriminating. I know one young man of immaculate appearance, no achievement and small promise who was paid a substantial advance by a publisher to write a novel of his life at the age of twenty-three. This is not exceptional, but typical.

In consequence, a vast bulk of novels are published which have no literary merit: are mechanical, badly planned and worse written. Even the increase in the semi-literate reading public is not sufficient to absorb this diet of undigested autobiography. There are already signs of fictioneering being overcrowded. The young men will soon be driven to ragpicking, beachcombing and open mendicancy.

A novelist's training is perhaps the most difficult of all

artistic trainings: because it is not patent that he needs training. Music, painting, sculpture and poetry, though even these have of late been invaded by amateurishness, conspicuously need technical knowledge. But any fool can write; and most fools do. The short story has superseded the essay in many schools. Fiction is taught by post: and in America, degrees are awarded for novels.

This encouragement of fiction is bad. It thwarts originality and prospers the second-rate. Schoolmasters, themselves ridden with pompous language of evasion, impose the set phrase, rubbed epithet and threadbare metaphor upon their pupils, until they produce prose without distinction, life or individuality. In *Tales of Shem and Shaun*, Joyce extended the pun from a play on a word or two, to the length of a short story. The fictioneers have gone better, they have prolonged the cliché, once a set phrase, to the full length of a novel.

The novelist must redeem common speech from loose phrase and thought. His language must be clear, precise and economical. Unnecessary words burden style as fat an athelete. The man is best equipped for communication, whose each word enforces his meaning. Again, to the novelist style is what tools are to an engraver, or a sword to a fencer: the condition without which his work is impossible to perform. The technique of writing differs from other techniques in that at no stage can it be taught. It can only be learnt.

Technical skill, however, is only the preface to writing. Knowledge how to write is valueless to the man

who has nothing to say; as R. L. Stevenson proved by his *Essays*, the most perfect vacua in literature.

The world in which he lives, his own age, is the proper medium of the novelist. They may be charming, these novels of fantasy; or instructive, these historical romances, but they have significance only in so far as they throw light on the age in which the author lives. I say *author* and not *reader*. *Gulliver's Travels*, the novels of Fielding and Smollett, *Anna Karenina*, *Crime and Punishment*, *Fathers and Children* have significance still, even though the age is past which they describe. *Madame Bovary* is authentic in a way in which *Salambo* and *La Tentation de St. Antoine* are not. Political, social or other changes may cause the reputation of these masterpieces to fluctuate, but there is a level below which their integrity of conception does not let them fall.

The civilisation of modern England is urban and industrial; and this is the direction in which all civilisations are travelling. Soon for example in this country agriculture will be recognised and treated as a branch of industry, instead of its antithesis. The Erewhonian idyll will give place to other means of mastering the machine than by rejecting it. Modern writers are faced with this situation, and its effects on people of to-day. Many of these effects are unpleasant, dissatisfying and unsettling. But if the novelist is to write well he must accept and understand before he can begin to reject. Most contemporary novelists dare not or cannot do

this. They escape down one hole or another. They write novels of the past which are sometimes interesting, but usually dull and false. (The latest development is to sex up history, a modern form of historical pornography, the amours of the present being pitifully unexciting.) Or they write about the future, a less obvious but more effective escape than return to the past. Wells plumps for a nudist Erewhonian paradise in *The Dream*; Huxley for a mechanical ectogenetic nightmare in *Brave New World*. Arlen rehashes Huxley for more popular consumption.

Fantasy and its poor relation, whimsy, are more popular forms of escape. Though they are sometimes entertaining and sensitively written, they avoid the essential function of the novel. Detective fiction is fantasy in modern dress. A detective story with a full reality basis becomes *The Brothers Karamazov* or *Crime and Punishment*.

The commonest form of escape, however, is into the world just past or passing, the countryside as yet untouched by commerce or industry.

The world in which these people live belongs to the past, a thing unfortunate in many ways. For it is true that generosity, simple goodness and wickedness, freedom from money lust, and the leisure which is not an alternative to work, but its companion, are qualities found more in country than in town. But lunacy, bastardy, incest, suicide and child mortality are also more frequent in the country than in the town, facts forgotten too often by the idealists of nature, who

expand their emotions at the expense of intellect. These writers fail to show that country people are members of modern society, who will soon encounter the same problems that town-dwellers are already encountering. Their eyes are fixed too keenly on the idyllic past to see the troubling present. I do not say that no good novel can be written of the countryside; I say merely, that no good novel has been written in modern times.

Apart, therefore, from the novelist's need to perfect a prose, each word of which is essential, he must face the world in which he lives and understand the nature and form of its problems.

The nature of human problems has always been the same. Whether it has presented itself in political, religious, philosophical or economic terms, the problem has always been to achieve happiness, to effect a working partnership between internal and external life. The psychological constitution of man to-day is little different from that of *Homo neanderthalis*. What is different is his conduct. Social sense has grown, while the essential *id*, the unconscious personality, has remained the same.

Perhaps war is due not so much to the insidious propaganda of armament firms (for propaganda can only spread among those propagandisable) as to the fact that society has grown too rigid for the individual. Since in time of peace the individual has no outlet for his aggression, he must have the sanction of war, to fulfil the barbaric needs of his nature.

But the form of man's problems changes as society and conscious life change. New qualities develop and old ones take new forms: are repressed in one form and break forth in another. Two examples will make this clear.

Until the beginning of the last century, belief in religion was intellectually tenable; but since then the successive findings of science have made belief in God impossible for a large number of people. The emotional significance of this is even more important than the intellectual. A belief in God the Father is unconsciously founded in the children's belief in their own father's goodness. There is, therefore, a tendency that a disbelief in God will produce a disbelief in the goodness of the parent, and in all those figures who stand as parents. If the parent is distrusted, it is likely that there will be a union of the children to take over the task of self-preservation. The political significance of this can be seen in both fascist and communist movements, youth movements founded on comradeship and brotherhood.

In U.S.S.R. children are encouraged to teach their parents to read and write and to satirise them for drunkenness, inefficiency and other social shortcomings. Note, atheism in Russia, and in France during the Revolution: Hitler's attempt to enrol Christ in the Brownshirts.

Disbelief in God will increase, despite the Buchmanite revivals in which the brotherhood of the confidants is stressed rather than God's fatherhood. It has caused an

unrest which will continue until society can readjust itself to the change. But there is no doubt that there will ultimately be a successful adjustment. The present danger is that the adjustment will not be made before a period of communist or fascist dictatorship—Lenin, Marx or another taking the part of God incarnate.

This change in belief is now significant because it is changing ways of life and thought in European countries. Individuals are being stimulated in a fresh way by new movements: different elements of their personalities emerge as a result.

Second example. During the last war, individuals experienced conditions of life entirely different from those of peace. They found themselves and others more savage, brave or cowardly than they had imagined. When peace came, most readjusted themselves to the old conditions. Others found it impossible. It is noticeable that many criminals who appear in courts to-day, had fine war records; that is, those whom the war most suited, find least satisfaction in peace.

The human character behaves under the influence of social conditions in the same way that a spread of iron filings acts when a magnet is passed over them. Now these, now others stand on end, the formation they take up depending on the position of the magnet. So, though human nature is the same at different times, its form changes from one age to the next.

The War was followed by a period of comparative quiet. All sense of national emergency went and social feeling sank to lowest ebb. The General Strike and

Russian Scares (in the case of the Zinoviev Letter and the Arcos Raid, stampeding election manœuvres) were the only events which renewed in part the feeling of national unity in the face of emergency, that was so strong during the War.[1]

This uneventfulness partly caused the sense of death and waste, experienced so acutely by Eliot, Lawrence and Joyce.

"Who live under the shadow of a war,
 what can I do that matters?"

Peace came as an anti-climax, the War ending like Eliot's world, "not with a bang, but a whimper." The problems of reconstruction, which might in fact have provided a release of national feeling, if properly organised, were shelved. And men, denied the old neurotic outlet, were faced again with their own neuroses: faced with, terrified and perplexed.

There are signs now that these neuroses will be diverted once more from individual to state. Tension grows in Europe, in the whole world rather. There is war in the East and trouble in India. Russia is arming against Japan. Revolution in Austria and Germany. In America, riots, drought and leaping unemployment. Riots in Amsterdam. Weekly burnings in Barcelona; the union of communist, socialist and anarchist parties to overthrow the present Spanish Government. War in South America. In France, suspicion and anxiety.

[1] In England, national feeling appears to be inseparable from national hysteria. The U.S.S.R. is the only modern power which seems to have succeeded in separating them.

Mounting antagonism between Poland and Danzig. Gdynia, the vast base that would hold all the shipping of the Baltic and have some docks empty, built with French money to bottle the northern exit of the Kiel Canal. Lithuania still at war with Poland. Everywhere uncertainty, bankruptcy, gang wars, strikes, shootings, censorship of opinions, unemployed marches, assassinations, revolution, war and rumour of wars.

I detect in men's voices, in their excitement, even in their shocked horror and anticipation, a joy and relief, dating from the depression. Economically it has been a depression. Emotionally it is an elation. Something is happening at last. No need now for conflict to be personal. The war within the self can be postponed in face of objective war and the fear of it. Even the pacifists are *fighting*. The other day, one shook his fist in my face, because I wouldn't accept a pamphlet called *No More War*.

In Vigo a young Spaniard, who hates his father so much that he won't go home till his father's in bed, or get up till his father's gone out, said to me: "When there are riots here and I see a crowd in the street, I join them even if I don't know what they're doing. When the police come up, I like to throw stones at them and then run away. I like to wait till they come up before I run. I want to give them a chance of riding me down. It's silly of me, but I have to do it." He was uneducated and could not or chose not to explain his conduct elaborately. But I believe men who can give much

more rational explanations of their conduct, are actually as simply motivated as that.

Unless we have a permanent state of chaos, this relief from personal unhappiness can only be temporary; and only relief, not cure. I see no cure, unless that individuals should face their neuroses, instead of trying to work them out on an international scale.

Question. Why should this unhappiness arise? Why be greater after, than before, the War? Partly, as I have said because of peacetime stagnation following the emotional spate of the War-years. Partly because of the increase in religious disbelief, hastened by war experiences.

Religion during the last hundred years has become intellectually impossible to hold, for more and more people. The spread of the scientific outlook has made this so. But for those who have faith, religion effects an emotional adjustment to reality, by playing out internal conflict—in a variety of different ways, the fight between Good and Evil, God and the Devil; God the omniscient, omnipotent Father who will help those who need him; Forgiveness, purification, etc. The emotional basis of religion is founded deeply in man's needs for reassurance.

Religious belief gone, a code of rationalist conduct, such as Wells and Shaw advanced, was adopted as a way of life. The standard proposed was higher—or more socially desirable—than the Christian code as adapted to British political, imperial and economic requirements. And for that reason it was more difficult

to fulfil. But furthermore this moral code, based on the reason, took no account of the antisocial nature of the emotions and provided no mechanism for satisfying these emotional needs symbolically. It is for this reason that rationalists run with such eagerness to each new political disaster, eyes gleaming, to tell in shocked whispers, how here a Jew was beaten with hosepipe or there a woman ravished *en plein air*. How ten men were killed in a strike, ten hundred in a flood, ten thousand in earthquake, revolution or war. That underground periodical, *The Week*, exists to retail to these people, the news beneath the news; the pukka inside information at 3d. a week.

This is the world of which the novelist must write. Loony mysticism in Dodder, conger-fishing in Cornwall, life in cathedral towns and Cumberland are all very well; but none good enough. When I apply the criticism of contemporaneity to novelists of to-day, I find that of the many writing there are very few who fulfil even this primary purpose of the novel. It is like a steeplechase with a vast field, in which all but a few horses baulk at the first jump. The desire to amuse, soothe or terrify has supplanted the ability to feel, sympathise and judge.

II

I take my subject, Fiction To-day, as dealing with those younger novelists who have not yet reached prime but whose work will prove significant in the next few

years; and for that reason, I intend only to deal with Joyce, Lawrence and Wyndham Lewis in so far as I consider they are or can be formative influences on the generation of younger novelists.

Joyce did for the city of Dublin what Proust did for pre-War Parisian society, forming a conspect of the life and consciousness of a whole group. While *The Portrait of the Artist as a Young Man* and *Ulysses* have not the analytical subtlety of *La Recherche Du Temps Perdu*, they are much closer to the modern world in spirit. There is dissolution in Proust's work: but there is no relaxation of social rules. He describes a spiritual decadence, controlled by formal correctness. In Joyce, however, everything is fluid, and it is this fluidity which is so important as a liberating yet formative influence.

Joyce has freed literature from many constrictions. He never comments on his characters or moralises. His duty is merely to present. If moral judgments are to be made, he leaves the reader to make them. He has accepted and presented the phenomena of human existence, thought, wish and act, more fully than any of his contemporaries or predecessors. In presenting thought directly, without the ponderous introductions usual in other authors, he has enlarged the scope of the novel beyond imagined possibility, at the same time increasing the immediacy of contact between reader and character. Finally, his attitude to language as a fluid method of communication, rather than a crystallised collection of words codified in dictionaries, has freed his successors in their attitude to verbal invention.

While Joyce accepts and records, Lawrence analyses and tries passionately to remedy. The same problem underlies their work, though it is more apparent in Lawrence's characters, than in Stephen Dedalus: it is the problem of reconciling thought and action, of resolving that state where the mind inhibits the emotion. It resembles Eliot's problem presented in *The Waste Land*, *Prufrock* and *The Hollow Men*.

Lawrence found in modern society a split between consciousness and unconsciousness, which existed even more in idealistic freethinkers than in conscience-ridden Christians. Their ideas denied the principle of living. Thinking and talking usurped the place of living and loving. The reason, in fact, so far from functioning disinterestedly, merely presented reasons why inhibitions should not be broken down.

Primitive and peasant people, because among them no great divisions exist between mental and emotional life, showed most conspicuously the potency which Lawrence saw was lacking among modern civilised people. Lawrence is often accused of being an escapist, because of his preference for primitive people. But this is not an accusation that can be made against him. He writes always of the contrast, between the primitive and the civilised, dark and light. His work is always a criticism of modern life, to such an extent that sometimes one feels that he loses objectivity in criticism.

Lawrence was not an enemy of the mind, as many of his interpreters maintain. He opposed the usurpation by the mind of functions that were truly emotional or

physical. He hated sex in the head, the mind as phallus. But he did not hate the mind, when it performed its own functions. Birkin in *Women in Love* and the game-keeper in *Lady Chatterley's Lover* are both active-minded men: but men whose life is founded on full sexuality.

Lawrence's style and use of language is unique. He deals with sensation and those feelings which lie latent in consciousness. His words do not analyse these feelings intellectually: instead, they convey the sensations which he describes. His style resembles rhetoric in that his words are chosen for emotional not intellectual force; it differs from rhetoric in that his purpose is to induce not belief but feeling. Intellectual meaning is not absent, but subordinate: his writing being essentially musical and not pictorial.

Stylistically Lawrence is infectious. His rhythm gets inside you and is difficult to forget. Its influence is pernicious, however. The division between his writing and empty ranting is narrow. At his worst, he himself was guilty of deplorable bombast. His stylistic imitators are seldom innocent of it.

Lawrence's contribution to his successors is incomparably greater than that of Proust or Joyce, because he knew and felt people with a much deeper intensity. He has presented, as no one else has, the extraordinary play and counterplay of conscious and unconscious forces in the human psyche. The force and unity of his work is due to his constant working towards the solution of his own problems: in this as with the work of so many other writers, his strength is inseparable from his

limitations. It is not in that, that his influence is productive, but in his values, the depth, passion and insight of his mind.

D. H. Lawrence worked from his intuition and from self knowledge. Previous to and coincident with his artistic career, Freud and his increasing band of psycho-analysts were making similar discoveries about the human psyche, in the course of clinical analyses of "normal" and "abnormal" patients. (Interestingly, they have discovered that the analysis of the so-called normal patient differs very little from that of the abnormal, except that it tends to last a longer time, since the "adjusted" patient does not feel the same urge to be rid of his neuroses. This provides the final answer to critics who call Dostoievski, Tchekov and Lawrence "morbid.") The findings of psycho-analysts, though they are too often hidden in a jargon which is scientifically pompous and academically falsifying, have extended the knowledge of the human psyche much further than Lawrence went in the study of his single problem. The curious mechanisms, for example, of self punishment and the will to disease, reveal an unsuspected world, the territory of which has not yet been fully charted by analysts themselves.

Wyndham Lewis cuts across the course of modern fiction. He is the Enemy by profession and conviction. Even where he admires contemporary writing, his attitude is antithetic to it. James, Proust, Joyce and D. H. Lawrence were interested in the human psyche, with

interior rather than exterior life, viewing external reality in relation to and frequently through the minds of their characters. But Lewis is concerned with surfaces, not with sensations, with things seen rather than emotions experienced. (Note that the antithesis is not so much between thought and action, but between inside and outside.) Lewis associates the interior attitude of Joyce and Lawrence with Bergsonian and Time philosophies. But *Time and Western Man*, acute attack though it is, does not really establish this connection nor does it successfully refute the philosophies criticised, Lewis's attack being fundamentally a moral one. Nor again in *Pale Face* does Lewis succeed in maintaining his identification of Lawrence's philosophy with Rousseauism. The parallel is a purely superficial one. But the discussion of Lewis's critical attacks is not germane to Lewis's own performance in fiction.

The basis of Lewis's opposition to Joyce and Lawrence and his own achievement in fiction is double. Firstly and superficially, Lewis is a visuel, a painter. What he considers important as a writer is what is important to him as a draughtsman. His metaphors—"He ran his eyes round the party like a stick down railings"—are sight metaphors. They leap before the eye as pictures. Lawrencian and Joycean metaphors are seldom visual in this way: instead, they involve often what Irving Babbitt chooses to call "Confusion of the Senses," but I would prefer to describe as their *fusion*. The metaphor is not a resemblance visually or even mentally apprehended, but an unconscious association.

This form of writing is common in Shakespeare and Donne but though Lewis pretends to dislike it as a form, he really dislikes the use to which it is put, the dredging of the psyche, "interiorness" of writing.[1]

Faced with the problem which the complication of consciousness poses to the writer, Lewis gives it a kick and says I refute it thus. Not so simply or directly as Dr. Johnson disposed of Bishop Berkeley, but by fixing on surfaces, physical appearance and the acts of those neurotic people whose freedom consists in courage to express their neuroses. In *Tarr* and *The Apes of God* his humour is superficially that of the robust man, amazed at and amused by the vagaries of the weak and unhealthy. But beneath his gusting laughter there is an unwillingness to admit the existence of the life explored by Lawrence and Joyce, as a man with cancer may scoff at illness, while a man with 'flu will go to bed.

Lewis is often described as objective. But his objectivity is very different from that of a writer like Defoe. In Defoe the reader is most conscious of the thing seen. In Lewis he is more conscious of the man seeing. Defoe is an impersonal writer, Lewis always personal.

In *Satire and Fiction* Lewis pleads for the sovereignty of satire (*The Apes of God*) over fiction (*War and Peace, Ulysses: Sons and Lovers*): and to support his thesis he quotes the passage from *Point Counter Point*. Look at that. Sentimental muck. That's fiction. The fact that this is true does not prove Lewis's contention.

[1] The style of Thomas Nashe for example, does not upset him as Joyce's does, because despite the similarity of expression Nashe's style is devoted to exteriors.

I do not wish to minimise Lewis's satirical powers, nor impugn the creative achievement of *The Childermass*. Lewis's novels are among the most remarkable of our time. I wish merely to point out two things. Firstly that Lewis limits his scope to groups of writers, artists, and ninnies to satirise whom is to choose the easiest material for his thesis. I should like to see what he would make of doctors, typists, solicitors and bricklayers. Secondly that the claim for the sovereignty of satire is the reverse of true and could only be made in an age where positive emotions are inhibited and the negative emotions are thus substituted as valid in their place.

Lewis's work is limited in material by his thesis but by reason of its being satire is limited also in its mood. The strength of hatred is inexpugnable, the Enemy wears all his armour. But for that reason, there is no necessity to deny the power of love. In a mouthwash astringency is an excellent quality, but not in a wine.

Compared to that of Swift the satire of Lewis shows interesting points of difference. Swift's style is bare, clean and accurate, it reaps like a sharp scythe, each sentence takes a reckoned toll, and tries to take no more. Lewis is more like an enraged elephant, delighting in its strength, and stamping on an antheap till each separate ant is dead. The object of Swift's attack is mankind; the vices satirised are vices common to the human race. Lewis attacks individuals and personal neuroses. Swift's effect is satirical, because he touches home to the reader:

whereas Lewis would not pierce to anyone, except perhaps the person whom he is describing. The reader of *The Apes of God* is a spectator watching the butchery with amusement.

The author of *Gulliver's Travels* embraced man in his whole relation to society, but Lewis in his novels does not see these relations as he does in his criticism. (It is noticeable that in his criticism he is more concerned to establish the political significance of the individual than to relate the individual to society.) But the fundamental difference between *Gulliver's Travels* and *The Apes of God* is seen in the contrast between the central characters, Gulliver and Dan. Gulliver is a man with whom in Lilliput and Brobdingnag the reader feels sympathy and in the land of the Houhynyms amusement at the limitations of his physical and mental powers. Gulliver is the ordinary man, the measure of the abnormal characters, in the same way as the Surveyor is in *The Castle*. Dan, on the other hand is a cretin whose thought processes provoke no sympathy and whose own character blends rather than contrasts with the world he is viewing.

Taken beside the work of such contemporary novelists as Charles Morgan, Hugh Walpole, or J. B. Priestley, Wyndham Lewis's novels are tonic. Their vitality, vigour of phrase and thought, courage and strength are qualities which will survive the objects against which they were directed. But on examination, Wyndham Lewis proves to be the opposite of what his technical daring would lead one to suspect, to be in fact a reaction-

ary repudiating not only the products of his time, but
the time itself.

The material of novels is the whole life of man. And
there is no part of man's life on which psycho-analysis,
which Lewis as a novelist rejects, cannot throw light.
For this reason, I believe, that with a knowledge of
analysis, which means actually merely a knowledge of
their own unconscious motives and those of other
people, that novelists will write with a much greater
depth of understanding.

But analysis is also a phenomenon superior in import-
ance to Marxism, Fascism or Buchmanism; superior
because it will change the whole mental life of man.
But before it does so, it will result in extreme confusion,
because knowledge of analysis cannot be gained surely
by the reading of books. An example of the confusion
in life caused by misunderstanding of psycho-analysis
is that of *War, Sadism and Pacifism* by Dr. Edward
Glover. The book is a study of motives underlying
militarism and pacifism and it suggests that the motives
underlying militant pacifism are similar to those of
militarism, except that they are turned in on themselves,
in the same way that masochism is sadism turned in on
itself. The book was no plea for war; but merely an
explanation of why pacifist propaganda is ineffective,
and what further considerations must be met before it
can be effective. Yet the book was taken and inter-
preted by certain people, first as an attack on peace,
next as a plea for war.

Psycho-analysis clarifies writing by its treatment of symbolism. Symbolical stories have always been taken as non-realistic. But analyses have shown that acts, thoughts and gestures have symbolical meanings other than their purely objective significance. A conversation between two people for example has, apart from the surface communication of the spoken words, a deeper interchange of emotion. An example of symbolism accepted by society, is the raising of the hat at meeting. It is a gesture of recognition and to that extent, the gesture is common to many European nations. But the different ways in which a hat can be raised are almost infinite; the gesture can be personal or impersonal; a homage to all women or a particular woman; the granting of or the plea for acquaintance; a sexual advance or a withdrawal from sexual contact into politeness; an insult, a duty or a humiliation. While raising the hat is an action of which society recognises the symbolism, there are vastly more gestures, the symbolism of which has not been standardised by society into a convention; casual or habitual gestures, such as the clicking of knuckle joints, which Tolstoi stressed so effectively in Karenin. Deeds and words have behind them a symbolism even deeper than the symbolism of raising hats. Realistic fiction therefore is symbolical in its most significant sense—"symbolical" fiction loses reality and gains nothing in the depth of its symbols.

III

Coleridge said that one should not write of those whose work one considers to be inferior. In this age when it delights critics more to disapprove than admire, I believe this advice should be recalled more often. But there are certain authors whose work, though it is not in the first class, deserves mention. Aldous Huxley, whom I believe primarily to be an essayist and travel writer, has written a series of novels of which the best are *Antic Hay*, *Those Barren Leaves* and *Point Counter Point*. It is significant that the same ideas are usually advanced a few months later by Mr. Huxley in a volume of essays. It is a clue to his work that it is possible to abstract the ideas from his novels in essay form. It shows that the novels are not planned integrally as stories; but they are an incarnation of ideas. Mr. Huxley is a sincere writer but his approach to problems of conduct and consciousness is philosophical and mechanical rather than psychological. This gives his work at the same time a brilliance and wit and a fundamental superficiality.

Mrs. Woolf is a subjectivist. Her interest in reality is confined to the effect which it produces on her sensibility. Such an outlook demands an entirely fresh conception of the novel. But though Mrs. Woolf's work shows qualities of singular originality she has never abandoned the pretence of objectivity. *The Waves* is the best example of this fluctuation between the implications of subject and object. Ostensibly

objective, it describes the thoughts of, I think, six characters of different sexes. These thoughts if anæmic, are subtle, witty and beautifully expressed. But they are the thoughts not of six, but one person, Mrs. Woolf herself. *The Waves* could be written either as the thoughts of one person, or, and this I think would be more interesting as a contrast, between the minds of six different people. As it stands, it is a failure. It is an inevitable pity that after *The Waves*, Mrs. Woolf should identify herself in *Flush* with the mind of a literary lap-dog.

T. F. Powys, whose Dodder country is as mythical as Mary Webb's Shropshire, is an excellent writer, but his theme of lecherous gossiping old men and village maidens under "t'old oak tree," is extremely monotonous. While his brother's novels such as *A Glastonbury Romance* are florid, overwritten and marred by a mysticism which has not even the justification of existing in the muddled heads of mystics.

James Hanley, the Realist, is fundamentally a romantic, whose dark colours are as sentimental as the brightness of Wilhelmina Stitch, and is as obsessed with perversion as that poetess is with optimism. Yet at times, notably in the short story called *Narrative*, he achieves the strength of accuracy—he is like a powerful man trying to drive a nail into a piece of wood: five times out of six his hammer misses, but the sixth time he drives it right home.

No one can expect more than one novelist or two in a generation. Artists cannot be mass produced, so

there is no reason why our age should possess more than those previous. Of the younger novelists I find four only whose qualities are likely to produce novels of permanent interest. Of these the finest artist is Seán O'Faoláin, an Irish Catholic, and author of *Midsummer Madness* and *A Nest of Simple Folk*. He writes of his country and feels that country and its unrest more deeply than any English writer feels England. The division which has been made in England between the writer and his public is not so common in Ireland. As a result there is a humility in O'Faoláin's work, a sympathy with and understanding of people in general, similar to that found in Joyce. But whereas the latter's work springs from a hatred of the Catholic religion, the former's finds its certainty there. O'Faoláin is a realist, whose religion permits him to accept a number of conflicting facts which the freedom of free thought is liable to suppress.

The second, Grahame Green is also a Catholic, but his work, like his material, is very different from O'Faoláin. After a number of faltering novels he seems to have found certainty of purpose in *It's a Battlefield*. In that book he treats of London with its peculiarly stratified yet interconnected life. His knowledge of people of different classes, his treatment of them without contempt, his curt style and sense of form are remarkable. There is almost no fault to find with the book, except that even though he has cast his net wider and his catch is more diverse, his characters are hectic, as if they were kept alive not by the ordinary air but

periodic draughts of pure oxygen, administered by the author. I know of no other way to describe the feeling of tensity induced in the reader, a tensity which is not dispelled by finishing the book. It is not cathartic—perhaps because the theme is frustration, the reader is frustrated. He is left at the end with a feeling of emptiness rather than of fulfilment. There is still something basically lacking in Green's work, something I will try to define at the conclusion of this essay. But the direction in which Green is travelling is the right direction, if the English novel is to regain grasp of contemporary life.

Christopher Isherwood is younger than Green or O'Faoláin by a few years, and his two novels do not show full maturity. The latter, however, *The Memorial*, is technically one of the most perfect books published since the War. His material, however, is very limited and until it expands he will produce nothing of major importance.

The fourth, Margiad Evans, is a writer whose work will never be of contemporary importance, in the same way that the work of the Brontës was never of contemporary importance. But she has a power and intensity of feeling that makes the bulk of modern novels look pale. She is uncontrolled in a way that neither Green nor Isherwood are ever uncontrolled and she often mars her work for that reason. Yet I feel that basically she is very near to being a great writer. Her best book is *The Wooden Doctor*, though it is her narrowest and most personal. *Turf or Stone*, which followed, is broader in

conception but crude and shockingly engineered. She lacks, at present, a strict sense of form.

The outlook for the short story is more favourable than for the novel. The personnel of short story writers is not recruited so consistently from public schools and universities; and in consequence, short stories are not so depressingly "in the movement." On the other hand it is difficult to assess the short story in the same way as the novel, because the content of a short story is necessarily fragmentary. The attitude of a short story writer therefore emerges more slowly than that of a novelist.

H. E. Bates, however, has already proved the extent of his powers. He is a master within the limited field of the lyrical incident, the sudden moment of exaltation, of scarcely apprehended contact or failure to make contact. His writing is uneven and when he tries more ambitious structures, he is liable to fail: but certain of his stories are as perfect in their kind, as seventeenth-century love lyrics in theirs. His is an art that demands absolute certainty of phrasing.

James Stern on the other hand has much greater scope and depth; so that his style does not need to be so perfect. Of the young English short story writers, he, I think, will prove to be the greatest. But with the short story as with the lyric it is possible for minor writers to achieve perfection once merely, or twice, a fact which makes it difficult to assess short stories in bulk.

Among the others Frank O'Connor, Rearden Connor, Douglas Boyd, and Mervyne Lagden are certainly of this class, even if they prove to be no higher.

IV

Contemporary American fiction is cruder but stronger than English. It has the vulgarity and contact with the life of the people which English fiction needs if it is to be revitalised. The material of American life is new to literature, previous American writers having looked to England for technique and in many cases for material. Consequently American writing shows an energy and courage in technical experiment which, may, by example refertilise English literature also. The course of culture in the past has been from east to west, it may return now from west to east.

> "Nations of Europe, we leave you now to drag
> Your worn-out bellies on the sun-warmed rock
> And huddle by the ashes of old fires
> That warmed you once, swaying your shrunken
> bodies
> And keening your thin, sad wail. The flame of life
> Leaps now in us, and we will make our own
> Songs of living fire from it with hands,
> That burn in writing them."

The novels and short stories of Ernest Hemingway, though his subjects are limited to muscle-bound strong men of inarticulate passion and unquenchable thirst, have strength and economy of statement: an athletic reliance on the integral story without the aid of pseudo-poetic and pretentious description. (Compare Hemingway with Walpole, or Galsworthy.)

The subject matter of tragedy is the same as that of melodrama, their difference being one of realisation. English writers, sheering from melodrama or sentimentality choose subjects so trivial that avoiding errors, they lose importance also. The American, William Faulkner is not afraid of sentimentality or melodrama. *Sanctuary* in which he fails as an artist is little more than a thriller. But in *Soldiers Pay*, *Sartoris*, and *Light in August* he has achieved tragedy. In detail he is a bad writer and in *The Sound and the Fury* and *Sanctuary* an obscure writer also. But he has a "bigness" which makes the reader forget or ignore the continual stylistic ineptitudes, in the same way that in reading Dostoievksi, one ignores the poorness of the translation.

His latest tendency is towards the supernatural, as if he wished to test his own power of writing by making the grotesque natural and the impossible credible. It is to be hoped that he will turn back from this financially remunerative cul-de-sac.

John Dos Passos, though he has less insight and power of writing than Faulkner, is a more important influence in American literature. Faulkner confines himself to the Southern States and their decadence; while Dos Passos is aware of the whole unity of the U.S.A. and its relation to the rest of the world. He is a more contemporary writer than Faulkner and is feeling his way from the "sectionalism" that has been the limitation of previous American writing. The importance of Dos Passos is summed up by Granville Hicks (whose communist bias must, however, be discounted): "Dos Passos is

willing to face America because he has faith that out of the squalid chaos a decent civilisation may come. When one believes that the horrible can be defeated, when one has good reasons for that belief, feels it deeply as a challenge, acts upon it as a philosophy of life, then one need no longer think of flight."

In his two most important novels *The 42nd Parallel* and 1919, he takes a number of representative Amercans in the years before, during and after the War; an I.W.W., a typist, an interior decorator, a garage hand, a publicity agent, a sailor, a parson's daughter, a Harvard liberal, etc. Some of these characters are involved with the others. Some continue a solitary course. What binds them together is that they are swept along by the same historic forces, are living in the same age. Dos Passos gets his background of world and mass events by two devices. His "news reels" give the raw history of the time; while "The Camera's Eye" contains fragments of Dos Passos's autobiography and gives the sense of the author himself as part of the same scheme which he is describing. Meanwhile the separate lives of his characters present us with individuals, living under the shadow of history by the light of their own emotions.

Of other American writers Erskine Caldwell, George Milburne, William March, and Kay Boyle as well as the contributors to the American short story magazine *Story*, show a vigour, freedom, humour, and technical freshness unknown in England.

V

The only German writers who are liable to influence English literature are Döbelin and Franz Kafka.

Döbelin is the author of *Alexanderplatz*, a novel of Berlin life, which has the same power of correlating the individual and society that I find in Dos Passos and *It's a Battlefield*. Döbelin is a doctor, and the background of his book is more medical than economic but the balancing of physical against psychological life is not dissimilar from that of communal against individual life. Technically, *Alexanderplatz* is an application of the Joycean method for unJoycean purposes.

Of Franz Kafka's books only two have been translated into English, *The Castle*, a long unfinished novel and *The Great Wall of China*, a volume of short stories and aphorisms. Their translator, Mr. Edwin Muir, has done his work excellently.

Kafka is a difficult writer to understand. When *The Castle* was published, it was acclaimed a work of genius by critics of very different views. But though they agreed on its merit, they did not agree on its meaning. Hugh Walpole for example described it, as far as I can remember, as a modern *Pilgrim's Progress*, and the view that it is a religious book is popular even though it contains no mention of God, or anything to do with religion.

While Kafka was alive, he published only a few short stories: and when he died, he left the injunction that all his unpublished work should be destroyed. His friend

and executor, Dr. Max Brod, assumed that like Virgil he was filled at death with a sense of the inadequacy of what he had written in comparison with what he had wished to write. Dr. Brod therefore prepared Kafka's manuscripts for the press and published them.

To me it seems more probable that Kafka did not want his work published, because it revealed the deepest secrets of his life and that this was also the reason why he published so little during his lifetime. Experience however has showed that he need not have been afraid.

He was haunted by a sense of frustration as well as of persecution. In life, he was so scrupulous to keep appointments properly dressed, that he began his preparations several hours before it was necessary. But these preparations became so elaborate that he was always late in the end, a fact which caused him acute distress. In the story, *A Common Confusion*, he describes a similar but more terrifying situation. In the process the characters are impersonalised. It is no longer himself trying with the whole of his will to keep an appointment and always failing, but it is A who wishes to meet B and does not succeed. This is taken by many people as a brilliant piece of witty, logical suspense. I believe in fact that it was the only way in which his deep personal distress could express itself.

A similar process occurs in all Kafka's work. Its basis is sometimes pathological, but is always so intense and personal that he cannot bear to present it directly. His intellect did not distort but dematerialised it: and

as a result we get a short story like *The Burrow*, a masterpiece of persecution mania, but in terms of moles, instead of human beings.

The Castle is similar. It has a logic which is internally coherent but in relation to the known world is madness. The main character, the Surveyor, has the same mind as we have, the human logic. But the inhabitants of the Castle and the village below the Castle have another logic, which is unpredictable yet when it appears is plain as daylight. The Surveyor's one purpose is to have his appointment gratified by the Castle authorities; but the more he tries, the further he gets from success. All that he does in good faith leads to ruin: and it is only chance that saves him. The end of the book, finished only in notes, is that the Surveyor after having won the approval of the suspicious villagers dies; and a fortnight after his death, news comes that his appointment has been ratified by the Castle authorities.

I believe that Kafka's sense of frustration originated in his childish attempts and failure to establish contact with his parents. His two logics are the logics of child and adult, each mutually incomprehensible, and the fact that the Surveyor's independent actions lead him to disaster is due to the fact that independent action is most resented by parents and leads to the worst rebuffs. What appears to the child as pure chance is all that saves it from imagined destruction.

The work of Kafka is unique and queer, the work of an abnormal man, who had genius. I feel sure that only his writing in this dematerialising way kept him sane,

'but this is not the factor which makes him so important. He would be a greater writer if he could have borne to give his characters flesh and blood. As it is Kafka's greatness lies in the deep source of his writing, which penetrates to the fantasy life underlying everybody's conduct. The truth of Kafka is universal; the divergency of interpretations is due to the rationalisation of that truth by different intelligences.

VI

In the foregoing essay, the reader will have observed two different tendencies, each of which I have applauded, the Dostoievski—Joyce—Lawrence—Kafka tendency and the Tolstoi—Dos Passos tendency; the first a tendency towards the deepening of the novel and the second towards the broadening of it. The novel can develop profitably in either or both of these directions.

The reader must also have felt that a great deal of what I have written is theoretical; and that is true. It is theoretical because there is something lacking in modern English fiction, something which I am at pains to make clear to myself. It is not technique: writers are better equipped in technique to-day than they have ever been. There are a dozen finer stylists living than Balzac or Dostoievski. Nor is it culture: for culture is oppressively high among novelists. Yet still novelists are floundering as economists are floundering, because of the complexity and sheer size of the problems of modern life. What is needed is perhaps a person

who can see at the same time their fundamental simplicity.

The stench of the library hangs over too many books. Literature is begetting itself on itself, a sort of parthenogenesis or self-fertilisation such as is found in tapeworms. Contact has been lost with the centre of English life. Think of the English country side, Cornwall, Dorset, the Peak, Wales and the border counties or the Lakes. They're not tame nor are they always beautiful. They're savage, cruel and ugly often, as men know who work there. Beside that, think of the trash written by those who go to these parts on excursion tickets and have beautiful thoughts.

Remember the industrial districts, the mines, factories and docks. Recall the stranded lives of people, always on the border of poverty however rich they are: the courage and loyalty of the jeered-at clerks and petty business men—not in enduring the boredom, which they seldom feel, of their work—but of trying to construct, however misguidedly, homes which are happy or salvage what is good from them. Next what is found in life, "that strange, irregular rhythm," see the ungenerosity of modern literature: when it is vital, vital only with the rubber worm of hatred, not the dark blood of real hate, which still contains generosity, it is the product of a fine spirit. See the nigglers, the self-pitiers gnawing their bowels, the world-pitiers whose eyes are never dry: the pessimists rejecting all comfort under the sun, the optimists warming their bottoms before the fire of life without realising their trousers are alight.

We want writers to-day to whom England is fresh, which it always is for literature. They must see with courage and clear minds. Critically and with pride, they must feel the essential spirit of our race in their deep hearts. They must be men who do not cut themselves from their kind; must know rather the basic similarity of one man and another in desire and hope than revel in their own small difference of tastes.

To-day there is a split between the artist and his public. The fault is not entirely on the side of the public. It is caused partly by the decreased minimum of common knowledge due to the increase in specialist knowledge: but it is caused even more by the specialisation of literature. Shakespeare and Tolstoi appeal to people with small literary training as well as to men of culture. Not in the same way. But they appeal. The quality of great art is that it calls all people, those who know and those who don't. It is the measure of novelists to-day that since Lawrence there is no one who does.

BOOKS TO READ

Too many books about books are short cuts to knowledge; and the original, the prime factor, is omitted. But the purpose of criticism is not to give the reproduction of masterpieces, as we have photographs of pictures whose originals we cannot see. Criticism should contribute to the understanding of creative work, not supersede it.

The prefaces of Henry James are to my mind the finest profession of the scope and purpose of the novel; an amazing contrast to that author's own achievement. They, and especially the preface to *The Ivory Tower*, are of equal importance for novelists and their readers.

E. M. Forster's *Some Aspects of the Novel* and the simpler *Lamp and the Lute* by Bonamy Dobrée, are excellent for general purposes. Lewis's analysis of Joyce in *Time and Western Man* and Edmund Wilson's *Axel's Castle* are the best of the Joyce criticisms. For Lawrence I advise Lewis's *Paleface* and the much more elementary *Study of D. H. Lawrence* by Stephen Potter. Middleton Murry's *Son of Woman* is worth studying, provided that the reader constantly remembers that Murry himself is motivated psychologically. Lewis's studies of Hemingway and Faulkner in *Men Without Art* are good, the essay on Hemingway being the better of the two. For the Americans in general Granville J. Hicks's *The Great Tradition* is extremely interesting, but it must be remembered that his measure is not literary but Marxist. This, however, does not invalidate but sharpens his attack on Hemingway.

MUSIC TO-DAY

Edward Crankshaw

MUSIC TO-DAY

By Edward Crankshaw

I

THE complication of perfectly straightforward issues seems to be one of mankind's ineradicable impulses. Since it generally results in the question at issue being irrevocably lost to view one may take it that the habit is not due to a love of mental gymnastics but to an unconscious effort towards self-protection. The problem, though simple in its parts, is difficult of solution: the hare gets clean away, but chasing the rabbits scattered by its flight one may experience a pleasurable glow of purposeful activity. Among other current problems the familiar one of contemporary music and what it amounts to has been complicated almost out of existence. It has become so overlaid with hardy irrelevancies that it is already difficult to see the facts for the theories, or at any rate to distinguish between the two. Because of this, any earnest attempt to indicate the lie of the land must consist largely of an effort to clear it of irrelevant obstructions; in a short essay of this kind, indeed, there is little more that one can do.

One of the unnecessarily complicating factors is the belief, so old established and so crusted now that it is

often taken for fact, that there is among composers a royal line of succession; it is a belief analagous to the clear-cut evolutionary theory of earlier anthropologists that present-day man is the sublime product of uninterrupted development from the humble monkey. Instead of regarding the musical world as a republic, the temporary head of which, be he a Glück, a Bach, a Beethoven, a Wagner, is elected by the people on his own merits, we think of it too often as a hereditary monarchy with the son succeeding the father and carrying on from the point where he left off. There are few people to-day who would assert in cold blood that Beethoven, coming after Mozart, was *ipso facto* greater than his predecessor, who was limited by conventions overcome by Beethoven and by time; but the idea, though preposterous, was at one time widely current, and even to-day it colours and confuses the thoughts of many who if brought to the point would emphatically disown it.

This muddled notion of succession and development when applied to contemporary problems is itself responsible in a considerable measure for the two most frequent attitudes towards the music of the day, the despairing and the arrogantly exclusive. If persisted in it involves one in the forlorn and ridiculous task of trying to make a straight line touch all the points representing the work of those living composers who seem most worthy of notice. This plotting of the straight line, indeed, soon becomes an obsession and the primary aim of a critic's researches; and when, even

after playing unfairly by shifting the points nearer to
the line than is at all warrantable, one finds that if there
is to be a line at all it must be a zigzag, the disgusted
conclusion is reached that there is no hope in any of the
points, or, if one is arrogant, that the arbitrary point at
which the line has been started (it may or may not
have also been projected backwards into past time),
Schönberg, perhaps, Stravinski, Hindemith or Sibelius,
is the only one worth speaking of.

This sounds absurd enough, and is so in fact. It is
admittedly a severe simplification, a *reductio ad absurdum*
of what is actually an extremely vague and tortured
process; but fundamentally a great deal of criticism
consists of the attempt to draw such lines and getting
into a pet when they will not come straight. It is this
unconquerable masculine impulse which, as I have said,
is largely responsible for the common despair over the
arts in general and music in particular to-day. Things
are further complicated by the fact that the composers
themselves have turned self-conscious and joined the
critics in the immemorial game of cooked graph-
plotting.

The trouble is that we, that is to say those of us whose
main interest in life it is, are so given to thinking of
music as an end in itself, as the master of mankind
instead of one of its innumerable servants, that we have
endowed it with a body almost physical, the develop-
ment of which, suggested by one-sided contemplation
of the past, must be jealously watched and brought to
comply with certain preconceived notions. The fact

that the past itself, let alone the present, provides an overwhelming mass of evidence to refute the idea of succession and development (as distinct from a more general process of elaboration and spiritual trend) should, one would imagine, have kept this tendency under restraint. It has done nothing of the kind because musicians and the musically-minded are, as a body, the most one-sided and blinkered set of people in the world.

If one considers for a moment the sort of treatment which both the acknowledged masters of the past and those more ambiguous figures such as Berlioz, Schubert, Busoni and Mahler, have suffered and suffer still to-day at the hands of intolerant temperaments, it requires little imagination to realise that our contemporary figures, in all their variety and obscurity, uncanonised as yet, cannot possibly escape hard knocks from every side; nor in the excitement of the brawl is it easy to discover who are dead and who merely stunned.

Even when the canonised are in question it is the commonest thing to find otherwise intelligent musicians exalting one particular composer at the cost of the complete suppression of another with equal claims to greatness. For every man to have his own strong preferences is inevitable; but what can and must be objected to is the musicianly habit of denouncing all music save that of one's private idol. It is a strange state of mind which, believing Mozart supreme, feels called upon to deny all grace to Wagner. It is to suggest that the essence of music in the world is a strictly

limited quantity, that there is in all the world no more
attar than will fill one goblet to the brim. It is a strange
state of mind, but a common one in music; and the
adoration of the all-highest together with the denunci-
ation of those lacking in grace is carried on with a
fierce intensity of bigotry, a bitterness, almost, which
should have died out of Europe with the death of Mary
Stuart, or which at least should be limited to-day to
half-baked racial theorists.

A part of the same spirit is manifest in the intolerance
displayed by the musical towards the innumerable
excellent second-rate figures and the few ambiguous
figures with which the history of European musicians
is so thick. When one recalls the way in which men
like Mendelssohn, Schumann, Tschaikovski, Liszt, on
the one hand, and Schubert, Berlioz, Busoni, Mahler,
on the other, are continually being bullied almost out
of existence by this or that section of the musical public
it is evident that our own contemporaries are bound to
suffer even more thoroughly from the same nagging
spirit. The principle behind it all, as far as it can be
defined, is that no bread is better than half a loaf.
Unless a man is perfect he is worthless. Much of
contemporary criticism consists of a hysterical boosting
of selected saviours followed by a period of frenzied
mud-throwing when the discovery is made that they
are not perfect after all. It is a variation of the spirit
shown by savages who destroy their gods when no
answer is vouchsafed to prayer. It is a sort of perverted
idealism, that idealism of calf-love which leads to such

disaster when the madonna is found to be nothing but a human being. It is a mark of that eternal adolescence which, to generalise infernally, seems to characterise the musicianly mind. We do not find it to anything like the same extent in literature. The decision that either Charlotte Brontë or Jane Austen is the greater is not the signal for concerted mud-throwing at the other. Trollope may exist happily side by side with Tolstoi, and nobody reproaches Congreve for failing to "assimilate" Shakespeare. It may be, and probably is, due to the fact that a symphony takes up more space than a book. A book may live in peace and die in peace in one small corner of illimitable shelves; but music of the second-rank and music which appeals to only half the population has to be performed in concerts and allotted time which otherwise would go to music of the first rank, or music which appeals to the other half of the people; hence sensibilities continually scarred, hence bitterness.

With the cause, however, we are not concerned just now; it is the fact that is important. It explains the rushing from one idol to another. It explains the current prevalence of feet of clay. It helps to explain the confusion. Two composers who have suffered more than any others from this calf-of-gold hysteria are Richard Strauss and Igor Stravinski. Strauss was God, very much so, and when Strauss was discovered not to be God at all he was thrown down with an almighty crash amid denunciations louder than the earlier praises. I am not suggesting that Strauss protested against his deification; he does not seem to be that sort of person; but

human vanities should be left out of æsthetic assessment. All that matters is that Strauss has produced some remarkably able and interesting music, music which deserves to live in a quiet way for many years to come. The fact that he has also produced a mass of inferior work does not lessen the worth of the good. It is the same with Stravinski. He has certainly asked for rough treatment, but the "Sacre du Printemps" and "Les Noces" remain excellent and valuable works in spite of Stravinski. He has asked for it, but there is no reason why we should give it him. The police do not hang every man who confesses to the latest murder.

If we can give up our restless searching for a Pope and accept quite a number of contemporary composers as good in parts we should be a long way towards feeling less confused. By composing his Viola Concerto and "Belshazzar's Feast," Mr. William Walton laid himself under no moral obligation to compose a symphony to equal those works in mastery and originality; nor are there any composers in the past, even the completest geniuses at the most vital periods, who never fell from grace. That is not to suggest that Strauss, Stravinski, and Walton are anything but comparative weaklings; but what is pardonable in the bigger man should be doubly pardonable in the smaller.

II

If the contemporary confusion arises, as I believe, out of the muddled idea of succession and development,

it is worse confounded by the cry for a new form or new forms, a cry which is swelled by the composers themselves and which is as ambiguous as it is foolish, for nobody seems to know whether all that is meant is a new form, like the fugue or the sonata, or a new *system* which will itself contain new forms, of the kind that Schönberg has tried to give us. This cry, taking it for the moment unambiguously, seems to be founded on the notion that the symphony, and particularly the sonata form of the first movement of the classical symphony, is dead. It is said to have been perfected by Beethoven, and the reasoning is, apparently, that once a thing has been done perfectly it may never be done again and can be of no more use to succeeding composers. The magnificent use of the fugue in Beethoven's later works should, by the same reasoning, be condemned out of hand, for the fugue had been "perfected" by Bach a hundred years before.

The evidence of latter days is also disregarded. Brahms, by reason of his lateness the most glaring contradiction of the notion that sonata form is dead, is honourably excepted from the generalisation simply because he managed to infuse the rigid mould with something of a Schumannesque romanticism. In other words, his symphonies were different from Beethoven's symphonies, and he had something new to say which could be best expressed in the particular form he used. Anybody else who has something new to say and who instinctively finds his fullest expression in sonata form or the symphony as a whole has as much right to that

form as Beethoven had; just as Beethoven had as much right to the fugue as Bach. The curious notion that a form exists in its own right, is a mortal entity the days of which are numbered, becomes still more curious when we recall the use that Schubert made of the symphony and of the sonata. The fact that he was a part contemporary of Beethoven's is beside the point. If the symphony is dead now because of Beethoven's transcendent exploitation of it, it was as dead in Schubert's day as it is in ours. Yet Schubert took it and wrote at least one symphony and half a dozen piano sonatas of a greatness surpassed neither by Beethoven, nor Mozart, nor anybody else; and if another great genius arises with a spirit sufficiently organised and balanced for the antithetical system of sonata form to be its truest means of expression there will be more great symphonies. They will no more resemble the mature symphonies of Beethoven than the mature symphonies of Schubert did, but they will be "in" sonata form. A form is not a hollow mould waiting for genius to come and fill it; it does not exist except as a pattern of a finished work, and, as such, it is immortal. It seems possible that when Sibelius has finished his work this truism will be more widely appreciated than it is to-day. The fact that since Beethoven and Schubert there have been no symphonies to compare with theirs proves nothing at all save that those composers who have since expressed themselves primarily through the symphony are inferior, which is not to say that they are negligible, and that the general trend of the times was the romantic

one of pursuing individual emotions for their own sakes instead of trying to subdue and hammer all one's feelings into a balanced whole.

But, factual evidence apart (and there is no need to labour it), the cry for a new form is the most childish thing imaginable. People talk as though a form were a rigid, marketable commodity, a concrete entity, the acquisition of which will inspire the holder to turn everything he touches into music. So far as sonata form is concerned, the main thing required is the capacity to affirm. The great symphonists never cease from affirming. But when the tendency of an age is away from affirmation and towards exploration it has, as an age, little use for the forms most suited to affirmation, although there will always be exceptions, like Brahms, who are not interested in exploration as such. The greatest confusion has arisen because exploration of the spirit has been confused with exploration of technique. The great innovators of the past have wanted to say new things about the spirit, and their purpose has moulded and adapted their technique. The difference between Brahms and Schumann was simply that the one was impelled to unify what he already knew, making an illunimating whole greater than the sum of its parts, while the other was impelled to push forward disconnectedly with his explorations of the spirit.

There is only one way in which a new form can be born, and that is through the inner compulsion of an individual, who may, or may not, reflect the so-

called spirit of his age. An excellent example of this process is to hand in the work of Liszt, whom we may examine for a moment as an innovator, not for the intrinsic value of this music. Liszt was not interested in affirming; his main preoccupation was romantic striving. Romantic striving is not a matter of balanced development, but of narrative in time; and to this end the symphonic poem came into being, a form which enabled the composer to keep his motifs, symbolic of this, that, and the other, on the move throughout the composition. Liszt's invention of the symphonic poem no more proved that nothing further could be done with the symphony than the earlier adoption of sonata form proved that no more could be said in the fugue. It proved only one thing; that Liszt, an individual, had things to say for which the sonata was an unsuitable means of expression and that his impulse to say them was strong enough to mould itself a new form. For all we can tell, a new form will be born to-morrow, a new form as efficient and adaptable as sonata form itself, as all forms must be. But what would be gained by it? Nothing for certain but the originating composer, who would at least have great vitality and who might, though by no means necessarily, be a great artist. Apart from that there would be available a new scaffolding for third-rate composers who have nothing to say and do not mind how they say it to drape their empty rhetoric upon. These, indeed, are the only people who can legitimately cry out for a new form, the great third-rate, who are tired of saying nothing in

the same old way. No vital composer can demand it, for he will fashion his own, or adopt an old one to his end, and for us to demand it is sheer stupidity. If we must raise our voices, to call for a new genius would be more to the point. The form he employs will be of little account. It may be Beethoven's, adapted, or it may be Bach's, also adapted. It may be new altogether —what of it? We should be better employed in not crying out at all, but in making sure that we get the most out of what we already have.

<center>*III*</center>

To suggest that all self-conscious attempts to evolve a new form or a new idiom or system are valueless, are doomed as the traveller is doomed who puts the cart before the horse, is not to denounce experimenting altogether. During the last two or three decades there has been more blind experimenting (if one can call so extremely self-conscious a process blind) in all the arts than in the whole of their previous histories. Such a unanimity of mood cannot be ignored nor, however unsatisfactory they may seem, can the practitioners be slanged. Every epoch has its outstanding figures, its isolated geniuses who seem to owe next to nothing to the spirit of their age; but every age has some sort of a bias, and the majority of considerable artists as well as all the minor ones (those who are not content to repeat the past in watered numbers) reflect it. One does not have to be a specialist in modern music to know that

this age is an uncertain one, an age without standards, an age ridden by an hysterical, sentimental scepticism, an experimental age; one does not have to be a musician to realise this. On the other hand, a deaf and dumb hermit whose only contact with the life of the plains was a monthly supply of new scores would have as complete an idea of modern life, perhaps even a more correctly proportioned one, as we down here in the thick of it. All this uncertainty may be highly unsatisfactory, but if anybody must be blamed it is the mass of the people, the world as a whole, not merely the second-rate musicians, who happen to be articulate about what everybody else is feeling. Taking this uncertainty as a fact, which it is, one cannot blame the musicians, even if one is not particularly anxious to praise them. They are doing all they can, and although the intrinsic value of that from the concert promoter's point of view will probably prove negligible, the sparks that are flung up will have their uses.

The classic example, the most distinguished and the most dangerous, of the men driven by uncertainty into proclaiming their own infallibility, is Arnold Schönberg, perhaps the most important and influential figure in modern music. Schönberg is a great destroyer, taken by himself and his followers for a great constructor; but it is not until his pretensions as a composer of music of great intrinsic value are combated that his importance as a stimulating agent can be properly realised.

Schönberg has been above inventing new forms; he

has devoted his life not to perfecting a new form or evolving a new personal idiom, but to inventing a new system, a system, moreover, chiefly distinguished by the fact that it is a negation of all system as we understand the word. Atonality, based on the absolute equality of the twelve sounds of the octave, is more than a republic, it is a republic without a president; in it the millennium has come and one man's voice is as good as his neighbour's. And when one note is as good, as important as the next, as important and no more, the resultant chaos is as thorough as it would be were the twelve notes multiplied by a million and changed into men. If one considers for a moment the nature of music, its roots, and the various elaborations it has undergone, one can see very clearly the fundamental difference between the desired Schönbergian revolution and all the so-called revolutions throughout the past history of European music.

To be brief, to over-simplify, there was spontaneous song. In Western Europe the aboriginals expressed themselves in various cut and dried modes, different from the modes used by the Chinese, the Arabs or the Hottentots. First we sang, then we copied the singing voice on simple instruments. Rhythm was suggested by the dance: then the instruments were multiplied, perfected, and the songs elaborated to a most extraordinary degree, blended together in parallel, harmonised, rhythmically chopped about, distorted, beautified, generally elaborated out of all recognition to produce all kinds of music. And this elaboration of

166

song and simple dancing rhythm was instinctively pursued by every composer until in the twentieth century Arnold Schönberg broke away from instinct, retired to his study and worked out his system of atonality. His later compositions are not so much spontaneous creations, existing in their own right, as illustrations to a critical theory. When Mr. Prout wished to illustrate theories and laws of harmony and counterpart he quoted from Bach, Beethoven or Albrechtsberger; but Schönberg, wishing to illustrate his own megalomaniac meditations, had to compose his own examples. We find among contemporary artists of all kinds a curious tendency towards this kind of behaviour, but it has taken a musician to reduce the process to absurdity.

Schönberg, of course, is also a composer as well as a theorist. His early work was free from the least intellectual restraint. As an ardent disciple of Mahler, and thus indirectly of Wagner, he produced attenuated romantic effusions such as "Verklärte Nacht," the D. major Quartet, and the "Gurrelieder." These compositions exhibit the true Schönberg, and, as minor figures go, his true figure is by no means negligible; even works like "Pierrot Lunaire" and "Erwartung," products of the early stages of his mania, so clearly mirror the morbid perversities of a harassed spirit that their value is only limited by the narrowness of their appeal. The important thing is that Schönberg himself was acute enough to realise the small worth of his youthful aspirations—compared, that is, with the work of the

past masters; was acute enough to realise that no truly
universal music would be achieved by him in that par-
ticular style (or by anybody else); and was blind enough
to imagine that by taking thought he could turn himself
into a creative artist in the grand manner. All his value
to us and to music springs from the analytical side of
his nature; but his music, the product of his synthetic
side, is another matter altogether.

Theory is made for music, not music for theory;
music is made for man, not man for music. The utmost
an artist can legitimately demand from his contem-
porary public is an abandonment of prejudice, an attempt
at objectivity, and the will to struggle a little to assimilate
a new experience, or a familiar experience seen in a
new light. No composer has ever demanded more than
this; no composer, that is, until Schönberg, who asks
a great deal more. He asks us to disassociate our minds
completely from all familiar musical experience—
instead of to bring what we have already assimilated as
an aid to the comprehension of new things. He asks us
to desert this planet and take up quarters on a neigh-
bouring one on his own bare word, on the bare word
of a single, fallible human being, that we shall be all
the better for it. It is an impossible attitude. Faith may
move mountains, but it can also make fools of us all.
Regarded coolly, acceptance of Schönberg's attitude
amounts to submission to a spiritual dictatorship madly
exceeding in range, power and tyranny even the poli-
tical dictatorships of present-day Europe. A man may
not create a new world, though he may discover new

corners in existing ones, and new elements in the familiar earth and air. Schönberg, as a creative artist, too weak to explore neglected ground in the existing world of music, yet claims to have fashioned a new one. It is a claim bewildering in its presumption, its megalomania; and it is a pretty commentary on the contemporary state of mind that it has not long ago been indicted as such. Neither Monteverde nor Bach, Haydn, Berlioz or Wagner did anything but elaborate the existing *status quo* by working on particular aspects of it or by synthesising separate conceptions of it. Schönberg asks us to abandon the existing world and follow him into unknown territory, alleged by him to flow with milk and honey.

Since in this world there seems no place for certainty the possibility remains that Schönberg is a genius, a genius of a new order, the most colossal musical genius the world has ever known, the first specimen of a new type of humanity, *homo sapientissimus:* as different from *homo sapiens* as we from Mousterian man. . . . It is possible. And if this is so Mr. Schönberg need not feel hurt. He should be above all feeling. There is nothing at all to prevent him evacuating the land and waiting for the advance gang to follow him in fifty years time. He can while away the years by translating "Anna Livia Plurabella" into the tongues of angels.

It is possible. But if it is so none of us can tell to-day. Drastic self-uprootal is beyond the powers of the contemporary human being; we can do no more than adapt ourselves to new surroundings. It would seem a little

more possible if one were convinced that Schönberg had succeeded in uprooting himself as thoroughly as he would have us think. The evidence, which is his music, suggests that he has done nothing of the kind. He has severed the tap-root, but a thousand filaments and rootlets still attach him to the soil; and there he languishes in the bleaching sun crying sour grapes to his rather smug neighbours as they suck up nourishment from the familiar earth.

For Schönberg is still a romantic, still the tortured dreamer of the early compositions. He has shut his eyes to romanticism; he dreams of classic unity and balance, but in every nervous fibre of an exacerbated being he is the romantic of romantics. And in this new language which he invented in the hope that he was returning to the main springs of art deep, deep down, robust and clear, all he can do is repeat the dreams and thoughts of "Verklärte Nacht," all he can do is pay homage to Mahler, to Wagner, over and over again. He has not changed. It is as though a man, tired of his body, tired of its likeness to the bodies of his neighbours, were to stitch himself new clothes. He is very conspicuous, but his very conspicuousness emphasises the commonplaceness of his inevitable features; if one looks closely, that is; often enough the attention of the crowd is distracted from the features by the novelty of the garments, distracted too from the real original among them, the man in the hundred thousand whom no one notices, whose force of brow is hidden by a common bowler hat.

This is not, it is hardly necessary to say, an attack on novelty, *qua* novelty, though doubtless some will answer that all pioneers have been similarly disparaged. Think of Mozart, of Beethoven, of Wagner! I think of them. . . . The only reply is that all pioneers have *not* been similarly disparaged. Mozart was disliked because he was thought to be overloading a familiar form, because his music was too *chargé*; Beethoven was sometimes objected to on the same lines, and for freely adapting familiar forms; but before he died he was the idol of Vienna. Wagner did nothing at all but break violently and insistently various rules which had already been broken in the past, but more discreetly, while providing insufficient set arias for the principal baritones of the day. Wagner's unhappiness, which was profound, was due far more to his political opinions and to his incorrigible taste for silks, velvets, and other men's wives, than to the unpopularity of his music. Nor should it be forgotten that before he died Wagner persuaded the world to build him a theatre for the exclusive performance of his operas, and, having built it, to fill it. When I see a Dodecaphonarium erected to the glory of Schönberg I shall begin to wonder whether poor Hanslick has not risen from the dead under the name of the writer of this essay; but not before.

No, this is not an attack on novelty, as such. It is an attack on the idea that any one man can give birth to and elaborate an entirely new system of musical expression, which owes nothing at all to any hitherto exploited system, when all the evidence of the past indicates that

such a system of expression must arise spontaneously among the people and undergo elaboration through the centuries. It is an attack on the idea that harmony, rhythm, melody, counterpoint, are all self-contained entities instead of convenient labels for abstractions which do not exist outside a finished work. It is an attack on the idea that a fugue of Bach or a symphony of Beethoven consists only of these formal abstractions, thought of as entities—a particular kind of harmony associated with a particular kind of development, a particular kind of pattern. It is an attack on the idea that a new form, a new idiom, a new system can be thought into being instead of moulded unconsciously by new ideas clamouring for expression.

IV

Sonata form, which symbolised the classical impulse towards integration, is elastic enough, and Beethoven stretched it violently to contain his tremendous spirit. Several composers of varying merit have found themselves or imagine themselves at home in it between then and now, but the general tendency, as I have already suggested, was exploratory, and when you are exploring individual emotions as deeply as may be, when the cult of emotion becomes the end instead of the means to an end, you will obviously find a strictly limiting form, what one might almost call a judicial form, inimical. Throughout the nineteenth century the process of subtilisation went on. Emotions were

cultivated for their own sakes and technique was adapted to that end; the development of the orchestra was all part of the same process and accelerated matters enormously, though Schumann and Chopin discovered undreamt of possibilities in the pianoforte. Wagner made a titanic effort to synthesise all the new refinements, and succeeded. The process went on. There is no end to the refinement of the emotions until nothingness is reached. The process continued unchecked until Debussy. What Debussy with his early love of Wagner and his discovery of Moussorgski really did was to start breaking up the soaring, insubstantial fabric. By seizing hold of isolated words from the enormous vocabulary which the romantics had forged themselves for the expression of their all but inexpressible nostalgia he started a rapid process of disintegration. Colour had been brought into music almost unconsciously, and Debussy started playing with colour for its own sake. His eye was caught by the coloured windows of the fabric and he lost himself in the task of fashioning tiny fragments into exquisitely polished ornaments of clouded glass. Debussy played with colour for its own sake; Stravinski with rhythm; Bartok, disliking decay, hurried back to the unsapped virility of folk-song, taking with him a technical equipment out of all proportion to the task he had in mind; Delius, with prophetic insight, started a lament for the dead and the past with a harmonic freedom, a concentration on harmonic beauty, made possible by its death. Strauss, intoxicated by Wagner's orchestra,

and clever enough to improve it, scoured the centuries for scaffolding to festoon with his tonal fantasies. Schönberg, after a hasty tribute to the impressionistic vogue, realising the decay, too proud to be anything but universal, desperately aware that a first-class genius was needed to save a great art apparently perishing of anæmia, full of his holy mission, yet tormented by his own shortcomings, set himself to bring the great art back to first principles. He set about this with the passionate sincerity of an idealistic megalomaniac. He confused a spiritual process with an intellectual one. The similarity, the parallel, even, between the progress of Schönberg and James Joyce is a striking one, but Mr. Constant Lambert in his admirable book was the first to point it out. Nobody can deny, even those who regard "Work in Progress" as dogmatism run to seed, that Joyce, especially in "Ulysses," and in spite of the sentimentality which prevents that work from being a masterpiece, is perhaps the most important figure in contemporary literature and that his work has had as profound an influence on the novel as any single book in the history of our civilisation. But "Ulysses," though intended as a new form, actually does little but provide opportunities for the elaboration of existing forms. Joyce has reduced language to its component parts, and henceforward and for some time to come these component parts may be better comprehended for what they are, unobscured by the accumulated associations of tradition. Although a masterpiece of sorts, the importance of "Ulysses" is utterly disproportionate to

its intrinsic worth as a work of art, and in this it may be compared, as Mr. Lambert compares it, with Schönberg's work of the "Erwartung" and "Pierrot Lunaire" phase.

The mature works of Joyce and Schönberg are both monstrous practical essays in the disassociation of ideas, as preached by Remy de Gourmont. "There are two ways of thinking," says de Gourmont. "One can either accept current ideas and associations of ideas, just as they are, or else undertake, on one's own account, new associations, or, what is rarer, original disassociations. . . . It is a question either of inventing new relations between old ideas, old images, or of separating old ideas, old images, united by tradition, of considering them one by one, free to work them over and arrange an infinite number of new couples which a fresh operation will disunite once more, and so on till new ties, always doubtful and fragile, are formed." De Gourmont is speaking here of the transiency of philosophies; but his words may be applied to music without the slightest loss of relevancy.

The average musician of great talent or genius is primarily concerned with making new associations, although to some extent he must also disassociate. Schönberg and Joyce are primarily disassociaters, both appearing at a time when the main stems of music and of the novel had become almost completely obscured and sapped of their vitality by a multitudinous network of aspiring shoots, themselves bearing finer shoots, and those still finer. But because the complete

sceptic is the rarest creature on earth, because the driving force which is necessary before any man can surrender himself to an arduous and thankless task is essentially a romantic impulse, the disassociater, the analyst, Schönberg in fact, had to be a passionate romantic at heart, an inverted romantic, and allowed to believe that creation, not disintegration, was his might. What Schönberg believes (and nobody but himself can tell precisely what it is, though we may guess) is, however, of little account beside what he has done. He has done a great work and doubtless suffered deeply in the doing of it. It is in fairness to him alone that we should cease praising him as a composer and begin respecting him as a portent, for the more he is exalted as a synthetic musician the more catastrophic will be his fall when his compositions are seen for what they are. It is probably given to no man to shine equally in analysis and synthesis. The principle of the division of labour was discovered by destiny a billion years before it entered the head of man.

Schönberg's weakness, and also his strength—it is the same with Joyce—is that his is a one-track mind. He has pursued his task of disassociation with the blind ruthlessness of a fanatic doctrinaire. In his splitting up of associated ideas he has failed to see those associations which are arbitrary and those which are inevitable. Like Joyce, he has made himself unintelligible to his contemporaries by destroying not merely the arbitrary superstructure of music but the very foundations, the base, the common ground upon which all music meets;

by destroying tonality, the sheet-anchor of the tonic, he has destroyed the convention, apparently instinctive, which turns physical sounds into significant sound. In doing this he has passed from our comprehension; he is an artist who has robbed us of the key to his meaning. It may be answered that other musicians have been busy undermining tonality, and of course they have. As I see it there is nothing at all to prevent a composer lapsing into obscurity provided he uses atonality as a device, not as a system to be pursued for its own sake, desperately, through thick and thin. The undermining of tonality will probably prove to be one of the most important contributions to music that has ever been made. Above all it adds the expression of ambiguity to the composer's resources. But ambiguity, pursued for its own sake, as Schönberg pursues it and Joyce, is unsatisfying meat. One may take liberties, immense liberties; but the whole of their point is lost when they cease to be regarded as liberties and are thought of as duties. Schönberg, having done more than any other to undermine tonality and help musicians of the future to an easier, suppler, more expressive technique, has systemised his liberties into a hide-bound constitution.

There are signs already that his significance and insignificance are being realised. He himself seems in his latest music to be moving gropingly towards the light; and certainly, apart from his own school, the composers of the day are far removed from his immediate influence. Among those who are not, the most well known are von Webern, another doctrinaire after

the master's own heart, and Alban Berg, who is far from being a doctrinaire, who is indeed an instinctive composer and one who more than any other seems to have assimilated the valuable side of Schönberg's researches and to have rejected the dogma.

V

It seems a little strange to devote so large a part of an essay on current music to a man already in advanced middle-age. It is a pity that it should be necessary; but, as Mr. Lambert has pointed out, the day of the barricades is past; the revolutionary excitement was at its height before the War. Indeed, quite apart from the *enfants terribles*, the principal figures in modern music are all getting on in years or dead: the isolated figures like Busoni and Sibelius; the romantic impressionists like Debussy and Delius; the men who, starting in various ways, have made genuine and not insignificant efforts towards radical reassociation, like Bartok, Stravinski, van Dieren. Against them we may pit the composer of "Wozzeck," himself no chicken any more, and the heavenly child of the post-War era, Paul Hindemith. But if Hindemith is young in years he is ancient in outlook, heavy with the wisdom of the oldest profession in the world. The young men, with the exception of Hindemith, have offered us nothing at all to get excited about. The tremendous modernity of the machine-shop school is the palest of illusions: Mussolov can imitate a factory in full blast very well, but his

music is the poorest shadow of the real thing, like Academy paintings of rural scenes. Such work, in short, is the musical equivalent of the photographic school of painting and to be valued accordingly. The significant writing of the moment comes from Hindemith and Stravinski, and from a host of negligible pasticheurs and parodists whose work is worthless as music, but who are very tell-tale straws.

Schönberg self-consciously turned his back on romanticism, and now Hindemith demands the exclusion of all emotion from music and declares that composers should be able craftsmen, meeting the demand for their wares and nothing more. As for the emotions —Hindemith's notion is so naïvely ludicrous that it scarcely requires attention. He is, of course, confusing emotion, which is the basis of every work of art that the world has ever seen, with the romantic cult of emotion for its own sake. As for the supply-on-demand idea, apparently inspired by the fact that Bach wrote simply to supply his church with new music, that Haydn turned out symphonies and quartets for the amusement of the Esterhazys—Hindemith does not seem to realise that the contemporary demand for music operates under a very different guise from the demand of a hundred and fifty years ago, when the patronage system was still in force. Then music was called into being by private individuals who paid directly for it, either in cash or in kind; now the demand, less strong than ever before because less localised, is made by an amorphous mass of private individuals forming the concert-hall public and

paying impresarios to keep it entertained. Since both public and impresarios are unlearned in their tastes, it is up to the composer to do all he can to impose his own will on them.

But although the cult of excluding emotion may sound, and is, absurd, it has not sprung from nothing, and it seems to me to be highly symptomatic. If anything is at all evident to-day it is that (future holocausts permitting) music and all the other arts are in for a new spell of classicism. Classicism, in spite of Stravinski, does not mean imitating Bach and Mozart, nor, in spite of Hindemith, excluding emotion. It means a balanced and harmonious (not in the technical musical sense) synthesis of those ideas which may be expressed harmoniously, and a rejection of the rest. The greater the master, the less he will have to reject. The exploratory adventures of the romantics have provided the composer of the future with the means to express all manner of fine shades, and the general subtilisation of human understanding has brought into view all manner of new ideas or divisions and sub-divisions of ideas which require putting into perspective, a task which Sibelius in his isolation has already begun to-day. The romantic strivers and the romantic impressionists have dwelt lovingly and disproportionately on individual facets, magnifying them. It remains for the classical genius of the future to reveal the proportioned whole of which the multitudinous facets form the parts, to call order out of the chaos of individual impressions and vague perceptions. That is all that classicism amounts to; and any

attempt to make balanced patterns which does not use as its raw material the spiritual discoveries of the past hundred years is barren and forlorn.

As an analogy we may regard this generation's naïve preoccupation, essentially romantic, with the functions of the human body, the depths of the human mind, and the teachings of psychologists and sexologists. Already the time is passing when sex and complexes were the main topic of literature and conversation. The new ideas are in the process of assimilation, and soon an understanding of the subconscious mind and all the rest of the paraphernalia will no longer be cultivated for its own sake, will become a matter-of-fact part of our mental equipment, like an understanding of walking or the circulation of the blood. We shall, so far as ideas are concerned, have entered upon a new age of classicism, itself merely an epoch of consolidation, a taking-off ground for further flights into the unknown. But before this time is reached we shall probably have to pass through a stage of reaction against the tyranny of these new ideas, a stage when the mind will seem barren, uncreative and apathetic (that stage is with us now), when actually the business of assimilation is proceeding rapidly in unconsciousness.

And although Hindemith's notions as to the nature of classicism are as ridiculous as one can possibly imagine, and although Stravinski's efforts to subdue his splendid barbaric impressionism and "return to the past" are more than a little pathetic, it seems evident enough that the cause of it all is a preliminary itch towards balance

and poise and away from one-sided extension. Indeed, when Stravinski can refrain from artificially hurrying what must properly be an extremely gradual process, there is evidence in his own work of the germ of a real progress in the same direction—as witness "Les Noces." But, he, like Schönberg, is confusing a spiritual with an intellectual process.

We are left with a legion of small figures, most of them empty and derivative, but some, like Kodaly, Szymanovski, Kilpinen, Prokofiev, Honegger, Krenek, Ravel, engaged either in last minute re-association on the old lines or in attempting new syntheses in a small way; others like Bartok, van Dieren, Berg, engaged more fruitfully. And finally we are left with two full-sized figures, Busoni, who is dead and who was a law unto himself, as solitary and inexplicable as El Greco or van Gogh; and Sibelius.

Sibelius, whatever posterity's opinion of him may prove to be, is undoubtedly the greatest original of the age. He is an example, our only larger-than-life example, of the kind of musician I had in mind when speaking of the birth of new forms and the enrichment of old ones. There is nothing in the least bewildering in his technique, his idiom, his form, yet all three are individual enough to break the hearts of academicians, and all three are based on an unconscious synthesis of the new and the old.

His first two symphonies are Tschaikovski-esque, partly in feeling, partly in that the form employed is hardly suited to the nature of the thought; but his

impulse towards the unification of essentials has com-
pelled him gradually to reject uncontrolled aspiration.
A more serious matter was his yielding to the spell of
impressionism, and even to-day there are signs that the
war between the constructor and the impressionist in
him is still being waged. "Tapiola," for all its cohesion
and comprehensiveness, seems to me to be hardly
comparable with the greater symphonies in which the
chaos of a hundred years is fused with earlier elements,
subdued and given form. He is a lonely figure, indeed,
as Schubert was, but not an inexplicable one like
Berlioz. When the first half of the twentieth century
has become a memory it is safe to say that Sibelius will
be a salient part of that memory. He is the natural
creator, the unself-conscious artist, the musician whose
form is moulded by the music in him; the natural
creator, the man whose form is inseparable from its
content, the man to contrast with the other outstanding
figures of the last fifty years, who have been despairing
romantics like Mahler, or hypersensitive impressionists
like Delius, or the many artificers of new vessels to
contain old wine.

Unless an essay of this kind is to be a stuffed catalogue
of names and accomplishments it must necessarily deal
in generalisations; but the last thing to do is to take such
generalisations over-seriously. Generalisations do not
explain individuals; they merely suggest a point of
vantage from which a more or less extensive sector of
the panorama may be viewed. But where the affairs of
the mind are concerned the peak is rare which offers

an unobstructed view of every inch of the surrounding country, and it takes a genius to ascend it. The limited survey I have offered in these pages leaves a great deal out of account; whole tracts remain unindicated, both of the present and the immediate past—the release of national sentiments into the romantic stream, for instance, which did so much to broaden it and has been so important in the history of the last century of music; the infusions of new blood from the Moussorgskis, the César Francks, the Dvoráks, and the rest. And there is a mist which blurs defining lines and merges a hundred contrasting tints into a deceptive drab. It would be more satisfactory to deal with music, that is in individuals, instead of generalisations; but all I have done is to suggest a point of view from which the work of men not even mentioned in this essay may possibly be seen in a different light when the reader is faced with them again. Tendencies are overrated things, but they exist and must be recognised before all but the chosen few can be appreciated at their true worth. The chosen can look after themselves.

One thing, I think, is certain: music is not on the decline—music, that is, as a self-contained manifestation of a civilisation's culture. The civilisation itself may be declining, its culture with it, music with it; that may well be so: but the decline of a civilisation should not be visited on its artists. So long as our civilisation remains vital, so long as the common mind has anything to express, music, as the means of expression of one section of the articulate few, will survive and flourish.

But if the civilisation is to die, if there is nothing new to be expressed, if we have reached the end of our tether, music too will soon be dead, leaving behind its monuments for the inspiration and confusion of another age, for the awe and compassion too. The post-War preoccupation with pastiche and the faded finery of an earlier, vital classicism may prove to be the last stages of decadence; on the other hand it may be no more than a violent, graceless reaction from uncontrolled desire, the temporary sterilisation of desire preceding its balanced regulation. Pleasurable sensations, beneficial in themselves, if freely indulged in become obsessions, vices. It is not easy to progress directly from licence to moderation; it is easier, if less heroic, to turn at a stroke to strict asceticism, and from rigid self-denial to move easily to the stage of beneficial moderation; and so, by smooth stages, to licentiousness again. . . . The redeeming feature is that each age has its solitaries, its imponderables, its counterweights, who need not be supreme geniuses to exert a corrective influence. We have at least Sibelius.

BOOKS TO READ

Adolf Weissman. *The Problems of Modern Music. The Music of the Future.*
Cecil Gray. *A Survey of Contemporary Music. Sibelius.*
Constant Lambert. *Music Ho! A Study of Music in Decline.*
Guido Pannain. Modern Composers.
Gerald Abraham. *This Modern Stuff.*
Egon Wellesz. *Arnold Schönberg.*
E. J. Dent. *Ferrucio Busoni.*
Eaglefield-Hull. *A Dictionary of Modern Music and Musicians.*

THE THEATRE TO-DAY

Humphrey Jennings

THE THEATRE TO-DAY

By Humphrey Jennings

I

"What this school needs is co-operation; that means working with me."—*A Headmaster.*

AT the height of his triumph the returning Roman conqueror was invested with the robes and insignia of Jupiter and was identified by the crowd with the god himself: (Pompey as Jupiter). In the theatre Roscius *plays the part of* the conqueror (Roscius as Alexander) and at the moment of Tamburlaine's triumph in the theatre we have the series: Alleyn (the actor), Tamburlaine, Alexander, Jupiter:

> Where Belus, Ninus, and great Alexander
> Have rode in triumph triumphs Tamburlaine. . . .
> > Marlowe, *Tamburlaine*, II, 4181.

and

> Then in my coach like Saturnes royal son.
> Mounting his shining chariot gilt with fire,
> And drawn with princely Eagles through the path,
> Pav'd with bright Christall and enchac'd with starres,
> When all the Gods stand gazing in his pomp,
> So will I ride through Samarcanda streets. . . .
> > Marlowe, *Tamburlaine*, II, 4104.

189

When, in poetry, for example, in *The Progress of Poesy* (1754), the poet has substituted himself for his patron,[1] the actor substitutes himself for his part; that is, he is no longer identified with the hero by the audience: Mr. Garrick as Mr. Garrick as Macbeth, or (more complete) Mr. Kean as Mr. Kean as Richard II as God.[2] (The player scenes in *Hamlet* produce further perspectives: Burbage as Hamlet as an actor,[3] or Mr. Irving as Mr. Irving as Hamlet as an actor (or one of the children of the Chapel Royal[4]) as Æneas.) Again, when the poet substitutes himself for the King we get Alleyn as Richard II as Shakespeare. The rhetoric of Shakespeare's heroes at "moments of emotion" Mr. T. S. Eliot has already dealt with.[5] Add that at these moments—

> For God's sake let us sit upon the ground
> And tell sad stories of the death of Kings. . . .[6]

and

> Who can control his fate?[7]

the king or hero is literally changed into a poet, into the Poet.

[1] Yet oft before his infant eyes would run
Such forms, as glitter in the Muse's ray
With Orient hues, unborrowed of the Sun.
—Gray, *The Progress of Poesy*, 118.
[2] The breath of worldly men cannot depose
The deputy elected by the Lord.
—Shakespeare, *Richard II*, III, ii, 56.
[3] —This is one Lucianus, nephew to the King.
—You are as good as a chorus, my Lord.
—Shakespeare, *Hamlet*, III, ii, 238-9.
[4] In Marlowe's *Dido, Queen of Carthage*, the original of Hamlet's "Æneas' tale to Dido" (II, ii, 444).
[5] T. S. Eliot, in *Selected Essays*, Faber.
[6] *Richard II*, III, ii, 155-6.
[7] *Othello*, V, ii, 267.

By the nineteenth century these two metamorphoses, of the poet and the actor, have produced:

(a) Messrs. A, B, C, etc., in the parts of Mrs. Alving, her son, the maid, etc., all together making up an expression of Ibsen,[1] and

(b) Type-casting—Mr. Fishooks as Romeo as played by Mr. Fishooks,

leading finally to the film of Mr. Douglas Fairbanks' tour round the world in which we have Mr. Fairbanks as Mr. Fairbanks as Mr. Fairbanks, and where all possibility of drama ends.

The extreme displacement of the traditional central figure by Ibsen (continued in France by Roussel) has in England led to the assumption that one can be a playwright without being a poet. The immediate result has naturally been a "theatre renascence," a "new movement": "art"-theatredom: all methods of presenting or cloaking a new metamorphosis exalted in village-green drama, praise-god repertory, and other leagues, guilds, and love of the theatre-hoods: the metamorphosis of Jupiter into Pompey into Roscius into Crummles into The Producer, under whose leaden sceptre, etc. . . .

The producer is one of the great English group which includes parents, commanding officers, headmasters and magistrates, all of whom *cannot be answered back*. (The

[1] "In every new play I have aimed at my own spiritual emancipation and purification."—Ibsen.

mantle of Jupiter is on all of their shoulders.) The pro-
ducer is a lion, the roaring king of actors, scenic artists,
electrics, and of long dead authors: his opinion (opinion
not knowledge or certainty) is sacred and final. His-
torically he is the inevitable result of secondary educa-
tion: that is, he has been taught that one thing is better
than another, that anything can and should be improved.
He has *ideas*. His ideas come from his opinion and are
therefore not in any sense invention. They are dis-
tinguished by their arbitrariness, which is only natural
since they do not derive from any constant interior
source but from whatever the producer has happened
to notice or pick up in his educational rambles. The
current ideas of any art-producer simply date back to
his last ramble, which may have been ten minutes ago
(reading *Hours in the National Gallery* on his way to the
theatre) or years back, in which case it will by this time
have become a habit with him to refer back to it on
every occasion: so there will be the producer who
begins every conference on scenery with the question,
"Did you ever see a film called *The Cabinet of Dr.
Caligari?*"

His opinion is made up of these ideas and, as a wild
coachman to them, of the celebrated modern phantom,
"Unity." By a natural jumble (that is, proceeding
naturally from the miraculous circumstances of his
birth—above) he will claim, in lectures on "Producing
a Play," in "A Note" in his programme, and so on,
that the Producer is the person who gives to the other-
wise jarring work of the actors, designer, etc. that

Unity without which. . . . And so it is towards this Unity that the producer's passion for improvement (already mentioned) is directed.

Indeed the popularisation of æsthetic theories corresponds with the appearance of the producer and they are his self-justification. For they all depend on the same phantom Unity. Unity has become in poetry what loyalty is in the State: that is, the substitution of the poet for the king which should in fact represent the substitution of freedom for tyranny, has been disgustingly perverted by the culture-thirsty to provide a new tyranny in whose name Baudelaire and Rimbaud are declared to be traditional "after all," and thanks to which we can all snuggle under once more and forget.

But in the theatre before it became an "art" there simply was no producer. The play was written by the poet, acted by the actors, decorated by the designer, regulated by the manager and the stage-manager and so on. To have another guy hanging round "producing" is simply providing the widest possible opportunities for the local busybody. And so, apart, for example, from the infinitely painful rehearsals which become "talks on the theatre," you will find him dabbling with a little scene-paint immediately before the first-night curtain, altering lighting cues during the performance, and running round behind to annoy actors with notes on intonation. But Dionysius is not taken in.

The producer's - position is, of course, infinitely strengthened by the fact that most of the plays which he produces are "revivals": no horrid live author to

deal with, and a play which is known (in one circle or another) to be a "good" play, even to be a classic! The dreams of the adolescent producer gulping down a mixture of Arthur Rackham, Gordon Craig, and *A Midsummer Night's Dream* can be realised at last! And since the audience know the play already, continuity and intelligibility can be swept away for "treatment" to take their place; which is where the great "ideas" come in. And so it becomes possible to produce *Everyman* (such a beautiful play) with the flagellation-scene cut, and to spare "modern sensibility" the shocking sight of such maso . . . introducing at the same time exquisite mediæval tableaux constructed out of hessian and the company's electric light—to make up for it.

That is to say, the "Art theatre" is simply the producer's (Jupiter's) method of indulging in "self-expression." Being an "artist" he cannot of course sully his paws dealing with the "trade" theatre: so the extra money (don't imagine an art-theatre pays for itself) comes from benevolence, direct and indirect. Indirect benevolence: "When" (here the Higher Powers speak for themselves) "when the History of the English Theatre in the twentieth century comes to be written, no small place will have to be given to the boy- and girl-students working in Art- and Repertory-theatres. Like the chimney-sweeps of former ages they performed arduous tasks which have sometimes been thought to be too onerous for their years, but of which it may be said that their work gave them

valuable experience, allayed their too impulsive animal spirits, and developed their rational powers: in a word fitted them for life in their profession. They had the benefit of strict supervision from their superiors who at the same time allowed the enthusiasm of youth to have full scope in the long hours which theatre work demands. They were also often taken without a premium and as they improved were sometimes paid a small wage. Tribute also must be paid to the high-mindedness of the students' parents on whom in the end the burden of keeping their children in board, lodging, and clothing usually fell. But we are always to remember that the cause of Art was at the same time being constantly forwarded. . . ."

II

"England, Home, and Beauty."

Consider the opinions of Pepys, whom one would at least have expected to like "musicals," on *A Midsummer Night's Dream*,[1] and of Lamb, who is always supposed to have understood the Elizabethans so well, on *Tamburlaine*[2]; but Pepys and Lamb (being typical

[1] "To the King's theatre, where we saw *Midsummer's Night's Dream*, which I had never seen before, nor shall ever again, for it is the most insipid, ridiculous play that ever I saw in my life."

[2] "The lunes of Tamburlaine are perfect midsummer madness. Nebuchadnezzar's are mere modest pretensions compared with the thundering vaunts of the Scythian Shepherd. He comes in drawn by conquered Kings, and reproaches these *pampered jades of Asia* that they can *draw but twenty miles a day*. Till I saw this passage with my own eyes, I never believed it was anything more than a pleasant burlesque of mine ancient's. But I can assure my readers that it is soberly set down in a play which their ancestors took to be serious."

English theatre-goers) are among the favourite authors
of Alethea Campstool, who living as she does "within
17 minutes of Charing Cross" and having apparently
no household cares and endless three-and-sixpences
manages to see the matinées of *The Grey Cuckoo* (or
Heartsease or *March Winds* or . . .) any afternoon when
her sister, who runs a home-made tea-shop, is also free.
You will find them on their sixpenny folding seats
reading as I say Pepys or Lamb or one of the Mon-
taigne-and-water essayists of the present day, because
they love what Alethea calls "good" literature, and
"good" plays; with "sensitively drawn characterisa-
tions" and "entirely beautiful performances." They
find Tchekov "a little morbid, but then the world is
disillusioned nowadays, isn't it?" They also love
music: *Nymphs and Shepherds* is Agatha's favourite. Of
Shakespeare they prefer *As You Like It* and *The Merry
Wives.* But among authors of "good" plays they
remember particularly Euripides ("*Our* Euripides the
human"): happy is he who belongs to the Church of
England and the League of Nations Union: or alterna-
tively for those who are not regular churchgoers, the
difficulties of *The Bacchae* have long been explained
away as "glorious poetry" by Macaulay. In either case
the word "good" will cover the gaps and the English-
man's profound belief that Greek poetry and Italian
Art and the Bible[1] were all really produced by English-

[1] "This was the earliest manuscript of the New Testament in the world.
Was it not right that the Government should have the courage to say that
this was a thing which England ought to possess when it was for sale?"
Mr. Duff Cooper on The Sinai Codex in the House of Commons, July 31st,
1934 (reported in *The Times*).

men will be further deepened; and in turn further power will be given to the patron saint of speech days: the Christian militarist with a classical education.

Behind the performance of *Iphigenia* that the Camp-stool sisters so enjoyed are the ranged powers of Church, State, and University, of the Societies for this and the Associations for that—manifesting through correspondence columns and vouched for by banks—whose directors are also governors of schools, trustees of collections, organisers of charities . . . all, whether they are aware of it or not, using this performance of Euripides for their own ends—the solidification of their own interlocking positions: the "corporate life of the Nation" and what a body! And it is they who in their lives and actions ultimately define the word "good." In England rackets are rarely called rackets even by their victims because those who are running them are not aware (native imbecility) of the racket themselves: they only become aware if something is not running as smoothly as usual (what they call "unrest"). This curious blindness does not in any way lessen the effectiveness of the racket: on the contrary it makes it far more difficult to oppose.

Types of rackets: (*a*) park your car in a garage or get it punctured by the garage-hands (simple or American racket). (*b*) Reasonably similar is the speech day racket noticed above: in which, for example, there is a certain amount of money invested in India—in order to ensure dividends on this military control in India is necessary —in order to ensure military control officers are neces-

sary—in order to ensure the training of officers a brass hat distributes the prizes on speech day, and is doubly welcomed by staff and parents since after all they are paid out of those dividends. (*c*) But often substituted for the speech day racket is the Culture racket which bears directly on the theatre: in order to protect dividends as before, the utmost docility ("Citizenship") is desirable; this is procured by investing, through the opinions of apparently disinterested critics, professors, etc. (from whose translations the word "Citizenship" has already been borrowed) a Greek tragedy or whatever it may be with certain virtues (truth, beauty, goodness, invented by those critics or their forerunners), and which, on a moral plane make for "Citizenship," and by then contrasting the excellence (i.e. production of docility) of the Greek tragedy with the badness (since the critics have not invested it with the virtues) of whatever work is chosen as a foil. The audience is thus deluded into admiring and imitating the virtues and not considering the work itself at all. So that every Campstool who thinks that Euripides is so beautiful so good and so true (and who even has the illusion of discovering these virtues for herself) is playing into the hands of "safety-first"-ism in the simplest because obscurest way.

And Alethea herself (also unaware) uses the performance as a sacrifice to atone for her self-frustrated destiny: she says she has been to "something worth while." And the performers themselves will be all the more applauded because they are known through magazines

to lead beautiful home-lives (as distinct from ordinary theatre-folk) and to subscribe to the philosophy of "after all": the classics they will tell you have something the others haven't got, and when in later years they come to write the history of their stage life in a little thatched cottage in the country (hollyhocks and pewter and old French songs) they will remember that these performances were an inspiration to them and helped them to forget the Russian and German atrocities and so on. In that history also you will read how they took *The Grey Cuckoo* (or *Heartsease* or *March Winds* . . .) on tour to Canada, Australia, and South Africa, how the "Aussies" loved it, how the author of *Heartsease* had himself come down to the later rehearsals of it, how after all they are glad to have lived their lives giving the joy of the theatre to others and if life were to be lived over again. . . . So wide is the provinciality of the Theatre in the British Empire.

III

"They do but jest; poison in jest: no offence i' the world."—*Hamlet*

The "theatre which is a trade"—that is to say the ordinary theatre—is curiously parallel to the dress business, and the two are connected by the audience. Thus it is the shop-girls (very many from the dress business itself), their shoulders still faintly Schiaparelli-ish, who throng to see the picture-postcard star (who on

199

tour has his fan mail card-indexed, for next time) in a morning-coat song and dance show, and the leading lady attended to by a male chorus of newly-scrubbed shop-walkers. It is the rather "better class" wearers of the eternal "period dresses" who will adore anything about Old Vienna, the Tyrol, or beautified scraps of Tudor history, while Society itself in *original* models adorns those revues which begin to overlap the remnants of the Russian Ballet, and those chic first-nights where we all go to see each other, where the gallery applauds arrival of the theatre people in the stalls, and the stalls applaud the appearance of Society people on the stage, and all of which is in any case only preparatory to everybody's meeting afterwards for supper.

As a trade the theatre is no doubt worse run than the corresponding dress business at each "level."[1] At all "levels" the idea (like that of Estate Agents) is to present the perfect picture of the world in which the audience already fancies it moves. But here without appealing to Art or to Culture. Here the magic words are "good entertainment" and "good theatre."

The "entertainment-" and "theatre-rackets" are similarly run to the others, but if possible even less recognised as rackets, at any rate by the victims. Here the necessary opinions come not from professors but from theatrical critics, Sunday papers, Society magazines and general gossip columns. The criticisms are, of course, directed first by the momentary policy of the

[1] The incredible shortsightedness of people with money in the theatre is taken as known.

paper concerned, but also, inside the limited field dictated by the proprietor of the paper and his advertisers, it is in the simple use of the terms "entertainment" and "theatre" that another racket becomes possible.

(a) "Good entertainment": with these words the critic not only boosts any particular production he is told to, but also produces in his readers the required feeling that "after all" one goes to the theatre to be entertained and not to be instructed (an apposition dragged from the classics in order to support only one term of it) that there is nothing like a good laugh, that to have a sense of humour is to have a sense of God (that pulpit chestnut), that we are all good fellows here, and so on in series of deception and self-deception, to the conclusion that life on this right little tight little island is fine as it is, etc. (A conclusion resulting incidentally in their voting national, buying the canned goods advertised in the same paper, and so on.)

This exercise in debauchery is, of course, stimulated most strongly by the actual performance in question,[1] but it is also stimulated to some extent *every time* (see current circulation figures) that the term "good entertainment" is read in a paper. The term is primarily used by critics as a method of saying something for a show which is obviously pretty grim. Do not imagine that the public on going to a show labelled "good entertainment" will notice that it isn't even that. They

[1] Particularly by certain apparently innocent details, such as the introduction of an animal on to the stage, farmhouse windows with pretty check curtains, the endless butlers and references to cocktails.

have paid their money to be entertained and entertained they will be. Do not think that they are going to come home and tell everybody that they have been taken in by going to a poor play: vanity and pride alone won't allow that. They may get as far as scenting that something is not quite "up to" what they expected—and it is just here that the critics' words do their damnedest: the audience is able to explain anything and everything away to itself and friends by the grand covering remark, "Oh well, of course it isn't highbrow, I dare say, or this or that, but it's jolly good entertainment!"—and so the wheels spin.

They will have come home from the playwright's theatre: the theatre still pathetically used for masculine story-telling: stories of Life on the Ocean Wave, smart life, club life and country life, life behind scenes in big business: plays called *Old Mysore*, *Dead Men*, *At Heaven's Command*. . . . Meet the author of *Dead Men*. He lives abroad part of the year or writes plays on Mediterranean cruises. He is a quiet man, but usually manages to make friends with fellow-passengers who have noticed his slow walk round the deck and his curly pipe. He is so good too with the kiddies. He began life as a doctor or lawyer and in his London house he has a comfy study where he works, with club-chairs and water-colours and whisky and *Punch*, really very much like real doctors and lawyers: he likes dogs too, and golf and fishing: he works methodically from nine to twelve and from two to five, and believes hard work to be the only real kind of genius. But he is too well-bred to take his

plays completely seriously. He is in fact very *human*, very much like an ordinary man—there is nothing to be afraid of. Very much indeed—he positively *is* an ordinary man and his plays read and act like it also— and there is just that to be afraid of. (Apollo as Mr. Blank.) *His* plays more than any "art" productions are perfect "self-expression." The lives, mentalities and infinitely boring adventures of his characters are por- trayed by one who knows, since Mr. Blank knows about nothing else. Play-writing is a game: producing jolly good exciting stuff. How deadly the influence of his "stuff" can be he has just no idea; since it is in the assumptions he makes and not in any direct statement that the deadliness lies: in his and in his audience's satisfaction with a world composed of white bosses and Oh yes "emancipated" "niggers," of pretty girls and their young men in the Services: existences distributed between baronial halls (armour and decanters) lonely tarns and doctors' waiting-rooms. Of course it is only entertainment and I am taking the whole thing too seriously . . . that label again.

(*b*) "Good theatre": with these words the "theatrical profession" itself boosts up a job of work—acting, writing, producing or whatever it may be—which it knows very well to be outside its wishes. Meet an actor and ask him what show he is in and at any question of quality out comes the reply: "Oh! but it's terribly good theatre": pride again. It is also the only word of criticism an actor has because as a race they are easily the worst educated and least capable of *seeing* anything,

existent, even beating English *nature-mortistes* and coroners:

Il serait sans doute injuste de chercher parmi les artistes du jour des philosophes, des poètes et des savants; mais il serait légitime d'éxiger d'eux qu'ils s'intéressassent, un peu plus qu'ils ne font, à la religion, à la poésie et à la science. Hors de leurs ateliers que savent-ils? qu'aiment-ils? qu'expriment-ils? Or Eugène Delacroix était, en même temps qu'un peintre épris de son metier, un homme d'éducation générale, au contraire des autres artistes modernes qui, pour la plupart, ne sont guère que d'illustres ou d'obscurs rapins, de tristes spécialistes, vieux ou jeunes; de purs ouvriers, les uns sachant fabriquer des figures academiques, les autres des fruits, les autres des bestiaux. Eugène Delacroix aimait tout, savait tout peindre, et savait gouter tous les talents. C'était l'esprit le plus ouvert à toutes les notions et à toutes les impressions, le jouisseur le plus éclectique et le plus impartial.[1]

(The solitary serious "cultured" actress who reads D. H. Lawrence at rehearsals does not manage to be the least better actress for it.) Absolute professionals in apparently any business have a special fury which sweeps up a blinding dust into their own eyes. So a well-known Shakespearean actor will reply to his producer: "You know, old man, it's no good telling me what the lines mean because Shakespeare just means nothing to me whatever."

[1] Baudelaire *L'Œuvre et la vie D'Eugène Delacroix*, II, in *L'Art Romantique*.

Actors are principally unobservant and clumsy—they cannot open windows or undo knots or step down two steps instead of one: partly because they do not know how things are done and partly because for some reason it is an affront to expect them to do anything except move from position to position and of course, "act." (Try the carpet-scene in *Cæsar and Cleopatra*). Equally they are totally unaware of the simplest or commonest "stock responses": hence the success of the Marx Brothers. The audience is amazed to see actors who really appear to understand (i) ordinary human thoughts and actions, and (ii) who realise and use the difference between these and stock theatrical behaviour. (Remember Graucho's "You're a mother: you'll understand.") The audience is in fact so amazed and delighted that there is a sudden *danger* of them recognising these thoughts as their own, and so the Marx Brothers are camouflaged as "crazy week," just as Ibsen has been camouflaged as "sociological" and *Life's a Dream* as a "fantasy." And so (second abuse of the word) Sandy Powell singing *Underneath the Arches* is explained away as "entertainment for the masses" or a good substitute for slumming parties. If there does appear anyone on the English halls with something to say the audience has been so trained to regard him as "entertainment" only, and he has been so trained to regard his work as "theatre" only, and to be unaware of what it might be, that the possibilities of his touching anybody's *existence* (neither entertainment nor education) are snuffed right out. . . . Example of someone

getting away with and putting over a good proportion (say 50 per cent.) of what he really has to say: Eddie Cantor, who isn't an *actor*, or a *comedian*, or a *film star*: those are all *shapes* like ready-made suits, to look at: but Eddie on the contrary comes right *out*, at *you*: and literally alters behaviour.

IV

"Enslav'd, the Daughters of Albion weep; a trembling
 lamentation
 Upon their mountains; in their valleys, sighs toward
 America."—*Blake*.

Now I mention Eddie Cantor not to begin a film and theatre argument (anyway he comes from the stage and "good cinema" or not, his pictures show it) but because he has something England lost centuries ago and which America in general has still got (went there with the pilgrim fathers) and which Ireland has still got also.[1]

Since the seventeenth century, in England poetry and the theatre have gone in opposite directions: the poets producing rather cloudy attempts at play-writing: *Agrippina, Otho, The Cenci, Harold, The Dynasts*, while theatre-writers have managed to turn out some "perennial successes": *The Way of the World, She Stoops to Conquer, The School for Scandal, The Importance of being Earnest*, showing the possibilities of exploiting

[1] Read immediately Yeats's introduction to his selection of Spenser's poems.

oneself and of making one's fortune by writing for the English (and satisfying their stock ideas about the Irish being so paradoxical and so on) to several other Irishmen. But from before the seventeenth century the native Irish have been utterly unquellable. If the days when "Good Queen Bess" did her utmost to kill the wildness of Ireland, produced in despite of her[1] such English drama as there is, the days when Ireland finally freed herself from us, have produced an Irish theatre in which the work of three poets—Synge, Yeats, O'Casey (but especially Yeats)—is at least acted not for anybody's exploitation but with the poet actually in the position of King, and poetry realising free desires.[2] The handbooks of course already try to drag the "Irish School" into the history of English Drama. The work of these three poets has nothing to do with "English Literature" courses or drama schools or the rest of that junk, because it is something that nobody living has seen in England: poetry *in action*, and derived from the following series:

(a) Direct realisation of desires in war, conquest and the apotheosis of the conqueror, which was once the action of Kingship.

(b) "Imitation" of above through the medium of the theatre by the poet (his desires not free) of which the degeneration has already been traced.

[1] See her attempts to stop the playing of *Richard II*: read the life of Marlowe: Tamburlaine was a gangster.
[2] The reference, if you must have it, is Blake's *Garden of Love*:
And priests in black gowns were walking their rounds
And binding with briars my joys and desires.

(c) Realisation of free desires through the medium of words only: regal action of poetry (Rimbaud).

(d) Realisation of free desires through the medium of the theatre: poetry *in action*.

But don't hope that I am going to write a panegyric on the Irish theatre "to make up" for what I have said about the English one; so that it could be silently transferred from one to the other "because after all Dr. Yeats writes in English" or "because Ireland is still in the British Isles" or "will come back to the fold in the end" or any other such ambiguity. I mention the Irish theatre precisely because such *evasions* have already been made and because the Irish theatre retains the freedom ours has swamped in safety.

What is meant by "But especially Yeats"? In Yeats the revelation of wishes is less alloyed by circumstances (quaint Irish peasant stuff, theatrical conventions, etc.) and he is therefore more completely the poet-king and less the poet-subject than others. But at the same time his theatrical writing is less and not more *realisable* as techniques are at present, purely and simply because Yeats having got his poetry on to the stage has been cheated of *further* realisation. We arrive here at the supposed necessity (c. 1900) for a new theatre: meaning to Yeats (see his *Essays*) a new technique for the realisation of poetry in action. Now all the people responsible for the new techniquery (designers and so on) seized of course on the Celtic twilight (Tara's Halls and Green Erin) side of Yeats's poetry (and invented parallel

"blasted heath" and "Cotswold" and "Shakespeare's England" sides of Shakespeare—about as historical as James A. Fitzpatrick's delightful "Old Madrid") i.e., just those sides which are incapable of being further or fully realised in three dimensions, and proceeded to make a new "theatre art" ultimately leading to the merely disgusting Art-racket as described above.

Q. And what in heaven is this *realisation* stuff anyway? A. In *Horsefeathers* there was a scene where the frog in someone's throat was seriously searched for. In *King Lear* (III, vii) Regan says "Pluck out his eyes" (ordinarily equals "I would like to pluck his eyes out"): Gloster turns the wish into an image:

> Because I would not see thy cruel nails
> Pluck out his poor old eyes

the image leaps into poetry:

> The sea with such a storm as his bare head
> In hell-black night endured would have buoyed up
> And quench'd the stelled fires

and poetry into action: Gloster's *eyes are plucked out* and in full view of the audience and as terrifyingly as possible.

Again, every schoolmistress knows the line:

> To ride in triumph through Persepolis

and every producer with a large enough stage can bring on a horse or a camel (cf. Crummles: "My chaise-pony goes on in *Timour the Tartar*.") But the stage direction in *Tamburlaine* which amazed Lamb so much is this:

Tamburlaine drawn in his chariot by Trebizon and Soria with bittes in their mouthes, reines in his left hand, in his right hand a whip, with which he scourgeth them.

Marlowe did not invent this: Sesostris (Rameses II) was said to have been drawn thus by captive kings (see *Diodorus Siculus*). In life this was a piece of Egyptian megalomania (Rameses is to men as men are to horses); but on the stage Tamburlaine and the Kings are still actors all the time, and so this action so far from being a pre-arranged piece of vulgarity and outrageousness (as Lamb thought it was, and as the original action of Rameses was) is completely *inside* the medium of the theatre (actors), as horses and camels are not.

This is not only poetry in action but also metaphor in action and the *solidification* of imagery. "But," you should complain, "precisely in Yeats the imagery is least of all solidifiable." Yep; and this just *owing* to the gerlorious new theatre art failing (in simple courage among other things) to produce any means of solidification, even plain borrowings from the circus like Cocteau's. The conflict of twilightery and solidification is in fact the purported "subject" of several of Yeats's later poems: *Ego Dominus Tuus*, for example. Read also (I am not going to quote) the long arguments of Forgael and Aibric in *The Shadowy Waters*. In this play there are the two following stage directions:

The deck of an ancient ship. At the right of the stage is the mast with a large square sail hiding a great deal of the sky and sea on that side. . . .

and

Voices and the clashing of swords are heard from the other ship, which cannot be seen because of the sail.

This "other ship" which has come alongside remains completely unreal: and I am perfectly aware that as things are it is even meant to be unreal and to present simply a starting point for the audience's wretched imagination, which is not imagination at all but only the raking up of one stock mood or another. So that criticism apart, *The Shadowy Waters*, for example, presents poetry *on the stage* but not *realised through the medium of the theatre*. Without any passion for the Baroque it may one day be discovered that the scenic machines of the Italian theatre (including ships which came on to the stage) had some *reason* behind them. Even the completely provincial Inigo Jones produced in England definite and active scenery which had an influence on the imagery of seventeenth-century poetry. And Yeats's imagery is twilightish because the theatre he was working in aimed at twilights, in turn because his poetry was full of them.

V

—Or heap the shrine of Luxury and Pride
With incense kindled at the Muse's flame.
 —*Gray*.

But now, now that a nation of busybodies like the English is positively invited to telephone the police

when they see anything that they consider *queer* going, on, now that we buy art-petrol, and National-mark the fruits of Neptune, what place has so vulgar (so vulgar because so free) a thing as a poet in England,[1] let alone for him to be a dramatist or an actor (for actors and dancers have been poets)? The eighteenth-century Italian Ballet, the Russian Imperial Ballet, and the short, passionate, black and chestnut existence of pre-War Paris all met in Nijinsky; of whom we have still some photographs as made-up for *Spectre de la Rose*: and the story of him sitting for Rodin. But now, late even in pettiness, it is England's turn to make charming nineteenth-century tableaux, of which the following might be the history:

(1) Lautrec painting a Café-Concert in the 'nineties includes some dancers and the lights and boards of the stage.

(2) The picture presents in the directest possible way the "vulgarest possible" existence of the time in absolute *hatred* of Art and Connoisseurs and Rue La Boétie-ism, and of public romantic perspectives.

(3) The picture is now (1934) exhibited at a select exhibition to an adoring audience of Art-*Lovers*, Connoisseurs, and wives of financiers, who have already made a romantic perspective running back to the 'nineties and to Lautrec in particular.

(4) In the wash of this crowd (and ultimately depend-

[1] So I have heard an English Art critic complain that Picasso's colour is sometimes rather vulgar! In case anyone still believes England has treated her poets well, there is a passage on this subject in Moore's life of Byron.

ing on them for existence) are "young people" who are running a "Ballet" (as if Sonnie Hale had not superbly made even the word unbearable).
(5) In their baths the next morning they suddenly have a *wonderful* idea: Why not make a Ballet of Lautrec's picture. . . .

There are still certain things in England that have just not been culturised; examples: beer ads., steam railways, Woolworths, clairvoyantes (the backs of playing-cards having been adorned with "good" patterns lately, someone wanted the faces beautified also). When the life has been finally veneered out of these it really will be the end.

I am aware that this continued defence of the poet is regarded as very dilettante by the now politically minded English. Art must now be social and useful. Alas! we have been all over that ground only such a very short time ago and in the theatre too. But Fabianism and Bernard Shaw and the social dramas of Mr. Granville Barker are already so unreadable—simply from sheer dullness—that it is difficult to work up any enthusiasm for a yet another political drama. Mr. Shaw's little tricks for becoming the "greatest living playwright" were described by Coleridge as long ago as 1817:

. . . the whole secret of the modern Jacobinical drama and of its popularity, consists in the confusion and subversion of the natural order of things in their causes and effects: namely, in the excitement of surprise by

representing the qualities of liberality, refined feeling, and a nice sense of honour, (those things rather which pass amongst us for such) in persons and in classes where experience teaches us least to expect them; and by rewarding with all the sympathies which are the due of virtue, those criminals whom law, reason, and religion have excommunicated from our esteem.

Biographia Literaria: II, 193.

Compare with this description the "Russian" opening of *Heartbreak House:* the romanticising of Doolittle in *Pygmalion,* the sentimentalising of the English priest in *Saint Joan.* The work of Ibsen from which the work of Mr. Shaw is supposed to descend (and who was the "figure behind" the drama-movement of the 1900's) is neither "social drama," nor politics, nor "Art," nor "entertainment," but from it any or all of these can be and have been extracted. The spectacle of the great "Socialist" playwright paying super-tax is not so remarkable after all, since the tax is on what the English public have agreed to pay Mr. Shaw for giving them harmless mouthfuls of a politico-philosophical mixture (Ibsen and water) marked "dangerous" (but that is part of the plan) with which to put off the terrible moment of Existence a little further.

England hasn't got It and doesn't want to have: she is deadly afraid: she wraps herself up in every kind of blanket—Art, Culture, Entertainment—against the explosion of the terrible bomb. Her capacity for turning any fragments or news of foreign passions (themselves explosions) which may have strayed into this country

into blankets is really astonishing:[1] that is what she wanted from this article. But the bomb, dear Englishmen, is inside and not outside—you need a different type of blanket—but there, Freud is already labelled "Foreign," "Scientific," "Interesting,"[2] and it's no good talking. The English have certainly got the theatre they want (even including me: I don't want it altered or "improved": I am simply describing it and its surroundings): and also, to use their own phrase, the theatre "they deserve."

"But, but, but . . ." you cry. . . . Of course you hoped I was going to come forward with heavyweight pronouncements on the value ("value!") of the Irish theatre or of Meyerhold or Strobach or Pirandello or Mr. James Bridie or "mime" or wherever else you happen to think the "future of the theatre" lies. Now all such labelling with adhesive values is simply a method of avoiding the consequences of attack from the work in question and of utilising it thus weakened to confirm satisfaction with habitual behaviour. And this satisfaction is all the pleasanter when the labelling is done for one. You had expected no doubt that I was going to do the old conjuring trick: that I had a new theatre connected in some vague way with "modern art" and "suntrap houses" howling with rebirth in my pocket.

For a short period at the end of the sixteenth century and at the beginning of the seventeenth several English-

[1] She is even managing to use Communism as one.
[2] And the paintings of Dali "Pathology."

men used "the theatre" as they found it, for their own purposes of poetry and analysis of behaviour—*connaissance*—we have no word for it—naturally. That these may still be constructed by Englishmen there seems just a possibility, but that they can or will use the theatre as a means is hardly possible since in one way or another it is precisely against these things (seeing in them its own downfall) that the present theatre's activity is directed (if one can use the word "directed" of cottonwool). Nor (*here the speaker addressed himself more particularly to those who were or were about to become parents*) do I see any likelihood of the motives behind this activity altering in any relevant way.

THE CINEMA TO-DAY

John Grierson

THE CINEMA TO-DAY

By John Grierson

A N artist in this art of cinema may whistle for the
means of production. A camera costs a thousand
pounds, a sound-recording outfit three times as much,
and the brute cost of every second of picture shot
is sixpence. Add the cost of actors, of technicians, of
the thousand-and-one technical processes which come
between the conception and the finished film, and the
price of production is already a matter of high finance.
A poet may prosper on pennies. A film director, even
a bad director, must deal in thousands. Six thousand
or so will make a quickie to meet the English quota
laws. With sixty thousand one is reaching to the
Chu Chin Chows. The more garish efforts of the
Napoleonic de Mille cost one hundred and sixty.
Ben Hur at more than a million and *Hell's Angels* at
nearly a million are weird exceptions, but they hap-
pened. The cost of a film ranges between the price of a
hospital and the estimated cost of clearing the slums of
Southwark.

The most interesting point about these huge pro-
duction costs is that they can be recovered. *Ben Hur*
made money. *Hell's Angels* failed to justify the crazy
extravagance of its making, but only by a trifling forty

thousand pounds. This fact must be realised, and, with it, the one consideration which controls the cinema and dictates its relation to the artist: that a film is capable of infinite reproduction and infinite exhibition. It can cross boundaries and hold an audience of millions. The world's cinema audience is 250 millions a week, each and all of these myriads paying his yen or rupee or shilling or quarter for the privilege. The last Chaplin was seen by fifteen millions in this country alone. Where the prize of popularity is so gigantic, considerations of art and public service must, of course, be secondary. The film people are business men and by all law of commerce, their spiritual researches are confined to those common factors of human appeal which ensure the rattle of ten or twenty or fifty million sixpences across the world. In this respect they pursue the same principles as Woolworth and Ford. They have rationalised the hopes-and-dreams business: a more plainly dangerous development, if entered lightly into, than all other rationalisation whatsoever.

There are, among the common factors of human appeal, higher factors like humour and religion. There are the lower common factors of sentimentality and sensationalism. In the practical issue, nothing is quite so diffident as a million dollars. There is a certainty about the lower factors which the higher cannot pretend. Who—particularly a financier—can recognise the genuine prophet from the fake? Cinema has, on the whole, lost so much on its mistakes of prophecy that its simpler instinct is to avoid all prophecy together.

Humour it has held to, and faithfully. Epic—in twenty years or so—it has learned to distinguish from melodrama. These, in their blessed combination of simplicity and depth, have a sure record in commercial cinema: comedy in particular. They represent the two points at which wide human appeal may also have the quality of depth. And, so far from breaking through the economic law, it has been proved by Chaplins and Covered Wagons that they even more generously fulfil it. Simple inspiration, as priests and medicine men once discovered, was always a better box office bet than simple entertainment.

But there, in comedy and epic, is the limit. Great cameramen contribute their superb craftsmanship, great story-tellers their invention, great art directors their splendour of decor, and the patience and skill which build even the average film are miracles to wonder over; but, at centre, in the heart and theme of the commercial film the financial consideration rules. It is a consideration of largest possible audiences and widest possible appeal. Sometimes, in comedy and epic, the result is in its simple way splendid. Nearly always the technical splendours of cinema loom gigantically over trivial and contemptible issues.

Only, therefore, in comedy, in epic, in occasional idyll does the commercial cinema touch the world of art, and is cinema possible for the artist. And epic and idyll being near to the problems of prophecy (note for example the difficulties of Robert Flaherty), comedy is of these the surest ground. Chaplin, Disney, Laurel

221

and Hardy and the Marx Brothers are the only relatively footloose artists in cinema to-day. They are, in fact, free up to the point of satire. There, comedy merges with those deeper considerations of which finance must necessarily be sensitive. Footloose they are, these comedians, till in a moment of more considered fancy the Marx Brothers decide to play ducks and drakes with the banking system, Walt Disney with the American constitution, and Laurel and Hardy with the N.R.A.

Epic too can have its way if it is as rough-shod as *The Covered Wagon*, as sentimental for the *status quo* as *Cavalcade*, as heroic in the face of hunger as *Nanook*. Heaven defend it if, as once happened in Griffith's *Isn't Life Wonderful*, the hunger is not of Eskimos but of ourselves. Perhaps it is that people do not want to see the world in its more sordid aspects, and that the law of widest appeal does not permit consideration of either our follies or our sorrows. Certain it is that the magnates of cinema will deplore the deviation. Theirs the dream of shop-girl and counter-clerk, and exclusively they pursue it. The films of our modern society are set among braveries too detached for questioning. The surroundings vary, and they sometimes reach to the mills and factories and hospitals and telephone exchanges of common life. They even reach back to include the more solid pageantries of history. But seldom is it that a grave or present issue is struck. Industry and history might assuredly bring to dramatic point those matters which more nearly concern us.

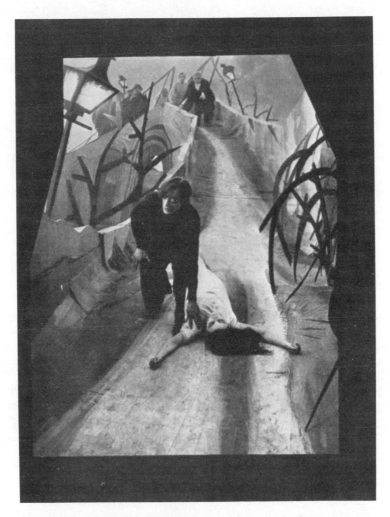

From Robert Wiene's THE CABINET OF DOCTOR CALIGARI, made in 1919, with expressionist settings by Walther Röhrig, Walther Reimann and Hermann Warm.

In film they do not, because the financiers dare not. These backgrounds are façades only for an article which—though in comedy and epic it may not be trifling—is invariably safe.

This is not to convict the film producers of a great wrong. Like other business men, they serve their creed and ensure their profit and, on the whole, they do it very well. In one sense even, the financier might regard himself as a public benefactor. In an age when the faiths, the loyalties and the purposes have been more than usually undermined, mental fatigue—or is it spiritual fatigue—represents a large factor in everyday experience. Our cinema magnate does no more than exploit the occasion. He also, more or less frankly, is a dope pedlar.

This, then, is the atmosphere in which the maker of films is held, however noble his purpose or deep his inspiration. He is in a closed circle from which he can only by a rare failure of the system escape. It is a threefold circle. The financier-producer will prevent him going deep lest he becomes either difficult or dangerous. But beyond the producer lies the renter, the salesman, who, skilled only in selling dope, is unfitted for stimulants. If the film deviates in any way he will either curse it as a changeling or, in an effort to translate it into his own salesman terms, deceive and disappoint exhibitor and public alike. In this way *Moana* was mis-sold as "the Love Life of a South Sea Syren." The exhibitor is the third circle. He is by nature and circumstance more nervous than either pro-

ducer or renter. He could, of course, combine the capacities of teacher and showman, as Phil Hyams sometimes brilliantly does at the Elephant and Castle. He could, by articulating unusual virtues in a film, introduce them to the public. He could thereby create a more discriminating and critical public. But the exhibitor follows, like his brothers, the line of least resistance. The more imaginative points of showmanship are not for him when the brazen methods of ballyhoo are so patently effective. He is, he will say in self-defence, "in the entertainment business" or, sometimes, "in the entertainment catering business." Entertainment may be as rich as inspiration, but being a complacent fellow in his world of sensational superlatives, it is difficult to convince him. Of the great exhibitors in England only Hyams and Jarrett seem to appreciate the distinction. Jarrett, though pretending every toughery, has done more than anyone for the documentary film.

The wise directors will accept these conditions from the beginning. Production money, renting facilities, theatre screens, with the qualifications I have noted, are held against any divergence from the common law. His stuff must be popular stuff and as popular as possible. It must also be immediately popular, for the film business does not allow of those long term policies and belated recognitions so common to art. A film is out and away and in again in twelve months, and the publicity which is so necessary to wide and sensational success promotes a sally rather than a circulation. The

system does not allow of that slow penetration which is the safeguard of the painter and the poet.

In spite of all this, the system does sometimes fail and unexpected things come through. The fit of scepticism which overtook Germany after the War had the effect of encouraging a seriousness of outlook which was altogether novel in the commercial world. Theatres and studios combined in the contemplation of Fate, and the cinema had its only period of tragedy. *Caligari, Destiny, The Joyless Street, The Grey House,* were the great films of this period. They were humourless and sombre but they were imaginatively done. They added power to cinema and celebrity to directors. Hollywood almost immediately acquired the celebrity. Murnau, Pommer, Jannings, Pola Negri, Lubitch went over but, subjected to the brighter air of Hollywood and the wider insistence of its international market, their skill was quickly chained to the normal round. The system, as it continuously does with able aliens, absorbed them or broke them. After a struggle Pommer returned to Europe, but could not rebuild the tradition he had deserted. He is now back in Hollywood again. Murnau also struggled and in a last attempt at escape produced, with Flaherty, *Tabu*: too late, perhaps, for the expensive and shallow outlook of the studios had caught him. Lubitch discovered a genius for comedy and was wholeheartedly absorbed. The rule obtains whether it is the artist or only his story that passes to the commercial atmosphere. Like the Celtic warriors, "when they go into the West they seldom come back."

The other exceptions are individual ones. Occasionally a director has money enough to back his own venture. Distribution will be lacking: but he can in the meantime have his fling. Occasionally a director is able to convince or deceive a producer into doing something more solid than usual. Occasionally, the publicity value attaching to a great reputation may overcome commercial scruples. In these categories come certain deviations of Fairbanks, King Vidor, D. W. Griffith, Von Sternberg and Jean Renoir and responsible versions of H. G. Wells and Eugene O'Neill and Bernard Shaw. Sometimes, again, the personal toughery or insistence of a director has managed a deeper result than was contemplated or wanted. In this category are some of the films of Von Stroheim, the best films of Von Sternberg, Flaherty's *Moana*, Dryer's *Jeanne d'Arc* and some of the best of King Vidor and D. W. Griffith. But even the toughs do not last long. These men have done much for cinema and Griffith is the greatest master cinema has produced, but only Sternberg has any assurance of continuity. He is the golden producer of the golden Dietrich. As a parting shot from his retirement Griffith has announced that one line of Shakespeare's poetry is worth all that the cinema ever produced.

To be absorbed or eliminated is the only choice in the commercial cinema, for it has the virtue of singleness of purpose. It has no ambition to specialise for specialised audiences. It has no reason to exploit the artist for the individual or creative quality of his inspiration. It is a big racket, they say, and you must

From LA PASSION DE JEANNE D'ARC, 1927-28.

play it big: which is to say that you must play it good
and wide and common to the exclusion of all height
and handsomeness. Within its lights and limits the
commercial cinema is right. The artist is an economic
fool who confuses financial dealings with patronage and
exploitation with understanding.

Commercial cinema, being the monstrous undiscip-
lined force it is, has done a great deal of harm. It has
also done a great deal of simple good. Even in the
world of sentimentality and sensationalism its narrative
is racy, its wit is keen, and its types have more honest
human gusto than their brothers and sisters of the stage
and popular novel. The vast array of thwarted talent
so expresses itself. If cinema has not debunked the
greater evils of society it has very successfully debunked
some of the lesser ones. It has given many salutary
lessons in critical citizenship, for it has taught people to
question authority, realise the trickeries that may parade
in the name of Justice, and recognise that graft may sit
in the highest places. It has taught the common people
to take account of themselves in their common manners,
if not in their common rights. It has taught the world
to dress better, look better, and, to some extent, behave
better. It may not have added to the wisdom of the
world but it has at least de-yokelised it. These are only
some of the gifts of the commercial cinema. There is
also the gift of beautiful women, of the fresh air of the
Westerns, of much fine setting and brilliant decor. The
skill and polish of its presentation, though only the
professional may judge it properly, are a continuing

delight. They may even exercise a continuing discipline.

The stars are not so easily included in the benefits of cinema. They are our version of the mythological figures who have at all times expressed the desires of primitive peoples. Here, as always, the figures of the imagination maintain the will. But to say so is to discover that other side of the cinema picture which is not so beautiful. For loss and lack of other mythology the millions are very deeply bound to their stars: not only in the matter of their dress and bearing but also in the ends they seek. On this criterion the stars are a queer lot. The recent enquiries of the Payne Trust in America have discovered some interesting analyses in this connection, and I take the following excerpts more or less solidly from Mr. Forman's summing up of their findings. Thirty-three per cent. of the heroines, thirty-four per cent. of the villains, sixty-three per cent. of the villainesses in one hundred and fifteen pictures—all these eminent protagonists—are either wealthy or ultra-wealthy. The poor run only to five per cent. The largest classification for all characters combined is *no occupation*. *Commercial* comes next with ninety characters. *Occupation unknown* comes next with eighty. The gangsters, bootleggers, smugglers, thieves, bandits, blackmailers and prostitutes follow, also with eighty. *Theatrical, servants, high society*, the luxury trades in fact, follow, as one might imagine, the gangsters, the thieves and the bandits. These together account for six hundred and forty of a total character list of eight

hundred and eighty-three. The remaining quarter of this crazily assorted population is scattered among many callings, notable in that common labour is not included in them at all. A few agricultural labourers exist, but only to decorate the Westerns. Mr. Forman adds: "Were the population of the United States, the population of the world itself, so arranged and distributed, there would be no farming, no manufacturing, almost no industry, no vital statistics (except murders), no economic problems and no economics."

Dr. Dale contributes an even more entertaining analysis of *goals*. In his hundred and fifteen pictures, the heroes are responsible for thirteen good sound murders, the villains and villainesses for thirty. Heroines have only one to their credit. Altogether fifty-four murders are committed, to say nothing of fifty-nine cases of mere assault and battery. Thirty-six hold-ups are staged and twenty-one kidnappings, numerous other crimes scattering. The total score is remarkable. Forty-three crimes are attempted, four hundred and six are actually committed. And taking an analysis of forty pictures in which fifty-seven criminals are responsible for sixty-two crimes, it appears that of the fifty-seven only three were arrested and held, four were arrested and released, four others were arrested but escaped, seven were arrested and the punishment applied, twenty-four were punished by extra-legal methods. In seventeen cases the punishment was accidental. Fifteen criminals went wholly unpunished.

"The goals in the lives of these baseless ruthless

people," says Mr. Forman, "are often as tawdry as themselves. Of the social goals, the higher goals of mankind, the numbers are very small." They are indeed, when one realises that seventy-five to eighty per cent. of the films deal more or less exclusively with sex and crime. Of the sixteen "goals" figuring most frequently, *performance of duty* comes a miserable eighth in the order of merit. All the others are strictly personal. *Love* in its various forms is first, second, fourth, fifth, sixth, with *illicit love* quietly solid at tenth. "Shoddy goals," says Mr. Forman, "pursued frequently by highly objectionable human beings." It is difficult not to agree, though economic estimate is, on the whole, more fruitful than moral indignation.

Out of this welter of influences for good and evil it is possible occasionally to isolate a dramatic film which is just a good honest film in itself—with spirit enough to dodge sociological criticism. The gangster films *Quick Millions* and *Beast of a City* were well done. So were the newspaper stories *Hi! Nellie, Five Star Final* and *Front Page.* So were the convict films *I was a Fugitive* and *Twenty Thousand Years in Sing Sing.* So was the back-stage story *Forty-Second Street.* They have invention and gusto in the high degree we generally associate with Edgar Wallace. And this is as much as a wise critic will expect of the dramatic film. One recent film of the line did break through to subtler qualities. This was *Three-Cornered Moon.* It appeared humbly as a second feature at the Plaza and its deviation was plainly mistrusted, but it made a fine affair of family

affection and said something quietly of the American depression. Among the sentimental romances there was *Ekstase*, not a film of the line but a freak of quality from Czechoslovakia. The commercial cinemas refused it. Sentimental romance does, however, vary a little. By dint of great directorial ambition (or is "artistic" the word?) the sad, sad saccharine of *Seventh Heaven* becomes the sad, sad saccharine of *The Constant Nymph*. Here the object of the affection is no longer the rich young man next door: he is the poor young artist in the garret over the way. So the mind of the movies moves laboriously to higher things.

The creative reputations built on such foundations are, to say the least, slimly based. In great generosity the critics have made names for Milestone, Roland Brown, Mamoulian and others. They are great and skilled craftsmen certainly, but nothing of them remains at the midriff after a twelve month. Here perhaps the critics, finding no depth of theme for their consideration, have made a grave and continuing mistake. They have equated a mere skill of presentation with the creative will itself. So doing, they have perverted criticism and misled at least one generation of willing youths into false appreciation. The only critic in England who has taken the proper measure of the movies is Mr. St. John Ervine. By blasting it for its shallowness he, by implication, defends a cinema which may yet—who knows—be measured to the adult mind. But it is the cinema-conscious and the cinema-critical who rise howling at his word. Our body of criticism

is largely to blame. It is consciously or subconsciously influenced by the paid advertisement and the flattering hospitality of the trade. It is, consciously or subconsciously, affected by the continuing dearth of critical subject matter. The observation of technical skill is the only decent gambit available to a disheartening, sycophantic, and largely contemptible pursuit.

Outside the world of drama there are, of course, better things. There are the idylls, the epics and the comedies. Each has had its own particular problems and troubles: financial in the case of idylls, as one might expect in a genre so near to poetry, technical in the case of comedy and epic, because of the complications of sound. The great idyll of the period has been *Man of Aran*, and I *précise* its story for its bearing on the economic arguments I have laid. Flaherty came to England at the invitation of the old E.M.B. Film Unit, not of the cinema trade at all. He had done nothing in cinema since his co-operation with Murnau on *Tabu*: a film which was financed and made outside the commercial circle. Through the persistent efforts of Cedric Belfrage and Angus McPhail he passed to Gaumont-British, to be given *carte blanche* on the Aran Islands. This was altogether a freak happening in commercial cinema and entirely due to the supporting courage of Michael Balcon and McPhail at G.-B. They had even to conceal the film from their financiers, for I found myself giving one of them his first information regarding it three months after the film had started. He was furious.

After two years the film came along. It was not altogether the film some of us expected. It made sensation of the sea, it restored shark hunting to the Arans to give the film a high-spot, and Flaherty's genius for the observation of simple people in their simple manners was not, we felt, exercised to the full. But as a simple account of human dignity and bravery through the years, the film was a fine affair. There remained only the selling of it in a world inclined to be alien. Flaherty himself had to take up the necessary barn-storming tactics. He went through the country making personal appearances. Aran Islanders in home-spun and tam-o'-shanters attended with him and spoke at luncheons given to local Mayors. Flaherty's life story appeared in a Sunday newspaper and copies of it were handed out by cinema attendants dressed in fisherman's jerseys marked "Man of Aran." The champagne flowed and the critics raved. In the Edgware Road a now excited crowd tried to cut locks of hair from Tiger King the hero and Maggie Durrane, the heroine—a lovely creature—went on tour of Selfridges under the *Daily Express*, to discuss silk stockings and the modern woman. So far as England was concerned the method worked. Salesman and exhibitor alike were driven into acquiescence and the English commercial cinema's only work of art was ballyhooed into appreciation. Without Flaherty behind it storming, raging, praying and publicising, heaven knows what would have happened. The fate of the film in Paris is a fair guide. There the pessimism or inertia or stupidity of the

commercial agent made all the difference. In a country more instructed than England in documentary, where *Nanook* and *Moana*, the other great films of Flaherty, have been running for twelve and eight years respectively, the commercial people cut down the film and billed it below the line as a subsidiary feature.

The cinema magnates, as I have noted, have been good to comedy, and so has the medium. It was, from the beginning, kind to the masks of clowns; its space and its movement gave the stage tumblers a more generous outlet; editing and trick work, from *précising* the throwing of pies, came to encourage a new ingenuity of comic event. The coming of sound was something of a disaster for the silent comedians like Chaplin, Keaton, Langdon, Griffith and Lloyd. The realism of the spoken word destroyed the more distant atmosphere in which the silent art created them, and none of them has had the ingenuity to develop a use of sound which would preserve the ancient quality of their mask and ballet. A recent Cavalcanti film *Pett and Pott* shows how this could effectively be done by formalising the sound and making it contribute to the mute (*a*) in comedy of music, (*b*) in comedy of sound image and (*c*) in comedy of asynchronism; but the studios have failed to experiment. Intoxicated by the novelty and ease of the spoken word they have not perhaps thought the old comedy of mask worth saving, and the mummers have not known how to save themselves. Their art is, for the moment, declining. The palm is passing to a new band of wisecrack comedians who, like the Marx Brothers,

W. C. Fields, Schnozzle Durante, Burns and Allen, make as great a preciosity of talking as their predecessors did of silence. Laurel and Hardy do not depend quite so much on talk and the peculiar style of their comedy has allowed them to make a more effective use of sound. They are clumsy, they are destructive, they are in essence noisy people; the world of sound is theirs to crash and tumble over. By making sound an integral factor in their mumming, they have tumbled on a first creative use of sound.

Out of the thousand possibilities of sound synchronisation a world of sound must be created, as refined in abstraction as the old silent art, if great figures like Chaplin are to come again. It is no accident that of all the comedy workers of the new regime the most attractive, by far, is the cartoonist Disney. The nature of his material forced upon him something like the right solution. Making his sound strip first and working his animated figures in distortion and counterpoint to the beat of the sound he has begun to discover those ingenious combinations which will carry on the true tradition of film comedy.

Epic, too, has had its setback since the coming of sound. There has been *Cimarron* to succeed *The Iron Horse* and *The Covered Wagon*, but nothing like the same continuity of great outdoor themes, in which continents were crossed, jungles penetrated and cities and nations built. There has been the technical difficulty that outdoor sound with its manifold of background noise has been difficult to register, but apart from this there

has not been the same will to create in outdoor worlds as in silent days. The commercial cinema has come more than ever indoors to imitate in dialogue and confinement the charade of the theatre. The personal human story is more easily told in sound than it was in silence. Silence drove it inevitably to wider horizons, to issues of storm and flood, to large physical happenings. Silence could hardly avoid epic and sound can. Just as silence created its own tempo'd form and its own sense of distance, the new medium might present a deeply counterpointed consideration of great event. The voices of crowds and nations could be cross-sectioned; complex happening could be dramatised by the *montage* of sound and voice, and by the many possibilities there are of combining, by sound, present fact with distant bearings. As I write, an experimentalist is crossing a chorus of market cries and a rigmarole of international commerce with a religious scene in Buddhist Ceylon. Lost in the ease of dialogue, the studios will have none of this.

Man of Aran if we accept it as near to epic, is a silent, not a sound film: a silent film to which a background ribbon of sound has added nothing but atmosphere. Its story is a visual story. Its effects are achieved by the tempo'd technique built up by the Russian silent films. The sound script does not jump into the narrative to play the part it might easily do in building up the issue. In *Man of Aran* perhaps it was not necessary. In films of wider range it is plainly foolish to avoid the powers which lie ready to hand. Where a film combines in

significance the highlights of a nation's history there is much which an imaginative use of sound cutting and sound orchestration might do. Of *Cimarron* one can only remember the rumble of wagons, the chatter of crowds, the beat of horses' hoofs, and some dialogue of personal story: unimportant, uncreative noises all of them, which did nothing to build the body of cinema epic. Whatever horizons were crossed cinema itself stayed halting at home. This neglect of the creative element of the new cinema proves, if proof were necessary, that if the deeper purpose is not there it is not likely that the medium will be deeply discovered.

Outside these fields of popular cinema—of which this all too qualified result can be expected—there has grown up, within recent years another more independent cinema. I do not mean here the *avant garde* cinema which for a while flourished in France and has raised its head wherever family fortune and youthful enthusiasm have allowed it. The French *avant garde* with René Clair (the early René Clair of the *Italian Straw Hat*) Cavalcanti, Epstein and Jean Renoir, made its dash for liberty by exploiting its friends. Working on a shoe string it created its own little distribution and theatre system. It built its own faithful audience at the Ursulines and the Vieux Colombier. All the requisites of an independent cinema were there indeed except principle, and the loyalty which goes with principle. In fact, the moment the business men of the group made money they invested it in popular films and abandoned art and audience alike. The *avant garde* movement blew

up because its directors were economic innocents and, until they go to Hollywood, film directors only too often are. It blew up because the tie which bound the director and his agents was not the creative one they imagined. In a dilettante sense it may have been, but it had no social basis which could withstand commercial temptation.

Something more solidly founded than the *avant garde* cinema there has been, and that is the propagandist cinema. With the failure of the French movement, it became evident in at least one quarter that, if an independent cinema was to become possible, some other economic basis than the entertainment world and other than private philanthropy had to be discovered. Education was first considered but being the poor, neglected, unimaginative world it is, was quickly discarded. The choice of propaganda was inevitable. It has been responsible for odd periodic excursions into cinema in a hundred centres. The Canadian Government has a large film bureau which produces films for its departments. Government departments in the United States, France, Germany and Italy have their annual issue of films on agriculture, health and industrial process. The vaults of great industrial houses are packed with the more or less pathetic efforts of commercial film companies (shooting at so much a foot) to make their processes and products exciting. But only in England—I except Russia—was propaganda deliberately exploited for the greater opportunity it presented to cinematic art, and made the basis of a school of

cinema. This was at the Empire Marketing Board, under Sir Stephen Tallents, who is possibly the most imaginative and far-seeing of the masters of propaganda in England to-day: certainly the only one who has considered how, and how deeply, propaganda may serve the State. He has maintained with John Stuart Mill that "it is the artist alone in whose hands truth becomes impressive and a living principle of action."

If you are to bring alive—this was the E.M.B. phrase—the material of commerce and industry, the new bewildering world of invention and science and the modern complex of human relationship; if you are to make citizenship in our vast new world imaginative and, therefore, possible, cinema is, on the face of it, a powerful weapon. But when the material of event has not yet been brought to imaginative form, research into new cinematic method is necessary. The example of the studios was not good enough, for it demonstrated little respect for common fact and less for common achievement. Its cameras and its technique had not prowled into this world of worker, organiser and discoverer. What was wanted was a cinema capable of building its art from subject matter essentially alien to the studio mind. On the bare evidence of Ruttman's *Berlin*, Cavalcanti's *Rien que les Heures*, and with a side-glance at the Russians, the E.M.B. dived into what it called "Documentary": giving a freedom to its directors never recorded before in cinema. Indeed it is a curious comment on our art that the only freedom given to directors since has also

been by propaganda groups: by Shell, the B.B.C., the Ministry of Labour, the Ceylon Government, the Gas Light and Coke Co., and by certain shipping, creosoting and radio firms on the Continent. It is, of course, a relative freedom only, for propaganda has its own ideological limits. This, however, can be said for it: the freshness and even the difficulty of its material drives the director to new forms and rich perspectives.

Out of this world has come the work of Ruttman, Joris Ivens, Jean Lods, Basil Wright, Paul Rotha, Arthur Elton, Stuart Legg and Evelyn Spice. Save Ruttman, they are all young people, not one of them thirty. They are all masters of camera and, more importantly, masters of *montage*. They have all learned how to make ordinary things stand up with a new interest, and make fine sequence of what, on the face of it, was plain event. They have begun to bring their observation of the world under their nose to an issue. Their documentary is not the idyllic documentary of Flaherty with its emphasis of man against the sky, but a documentary of industrial and social function, where man is more likely to be in the bowels of the earth.

Whatever the difference of their still developing styles —symphonic in Ruttman, Ivens, Wright and Rotha, analytic in Elton and Legg and dialectical as yet in none of them—they have one achievement in common. They have taken the discursive cinema of the news reels, the scenics and the interests, and given it shape; and they have done it with material which the commercial cinema has avoided. They have not yet learned how

to combine the lucid—and even academic—estimate of event in the body of imaginative work, but they are coming slowly nearer to the growing points of their social material. Wright with his film of Ceylon, Legg with his B.B.C. and Rotha with his new ship-building film, may presently have something more solid and mature to bring forward.

The relationship between the artist and the themes of the community, so far from binding the artist has opened new horizons for it. The documentary of work and workers has found endless possibilities stretching out before it: reaching not perhaps as its forbears did to halcyon horizons but by the nearest hole in the road to engineering master-works, and by the nearest vegetable store to the epics of scientific agriculture. And where there is so much occasion for observing the qualities of mankind, the human factor must be increasingly commanded. As though to demonstrate how in this seemingly sober world the mainspring of creation lies, it is remarkable how much quicker in the up-take this relatively small group has been in the exploitation of the new sound medium. The G.P.O. Film Unit which has succeeded the E.M.B. Film Unit, is the only experimental centre in Europe. Where the artist is not pursuing entertainment but purpose, not art but theme, the technique is energised inevitably by the size and scope of the occasion. How much further it reaches, and will reach, than the studio leap-frog of impotent and self-conscious art! Its instructional factor is, in a curious way, the final factor.

This near relationship to purpose and theme is even more plainly evidenced by the great Russian directors. They too were begun in propaganda and were made by it: in the size of their story and the power of their style. One cannot do less when recording a world revolution than develop a tempo to take it. But the more interesting story of the Russian film does not begin till after *Potemkin* and *The End of St. Petersberg*. These early films with their tales of war and sudden death provided relatively easy material, and did not diverge greatly in melodrama from the example of D. W. Griffith. There was the brighter cinematic style; there was the important creation of crowd character; but the whole effect was hectic and, in the last resort, romantic. In the first period of revolution the artists had not yet got down, like their neighbours, to themes of honest work; and it is remarkable how, after the first flush of exciting cinema, the Russian talent faded. Relating cinema to the less melodramatic problems of reconstruction was plainly a different matter.

Eisenstein set himself to tell the story of the Russian peasants, and had to discover wicked poisoning kulaks to make a case for co-operatives. He took three years to make a mull of *The General Line*. The truth was that he came to his subject from the outside and did not sufficiently appreciate either the peasants or their problems. Turin, more luckily, had the shooting of the Turkestan—Siberian railway: where the specious and romantic appeal of drought and desert storm could give colour to his story. *Turk—Sib* gave every impres-

From ARSENAL, Dovschenko's film of Rebellion in the Ukraine, 1929.

sion of building a railway but the approach was again too detached to appreciate just how precisely or humanly it was built. H. G. Wells very properly remarked that its epileptic way of doing things was too much for him. Dovschenko missed his footing in the same way as Eisenstein. He only incidentally and crudely treated the question of peasant organisation in *Earth*, by melodramatically associating it with the personal villainies of an individual kulak. And, as Flaherty might have done, he ran the film into a song of the seasons: so beautifully that only the dialecticians noticed his avoidance. Vertov, coming nearer to the problem, used every camera exhibitionism to tell in *Enthusiasm* how wonderful the worker's life was. But the heroic angle of his vision of workmen always failed to observe what the men were doing. Altogether, the Russian directors have been slow in coming to earth. Great artists they are, but alien for the most part to the material they are set. Only in Ermler's first crude *Stump of an Empire:* in his more mature *Counterplan:* and in *Men and Jobs*—where the central issue in Russia of giving industrial skill to a peasant community is the dramatic issue of the film— does the future seem assured. Eisenstein, after Parisian adventuring in *Romance Sentimentale* (a description of the moods of a female pianist) and further wanderings in the exotic atmospheres of Hollywood and Mexico, is still planning a successor to *October*. Pudovkin's *Deserter* has not yet, like *Men and Jobs*, found those common issues in which alone the work of that great artist can develop.

Pudovkin reveals more than any of the Russian directors the trouble which has recently faced them. Lacking a strong political head, he has blundered into the most curious and revealing mess which Russia ever sent us—a film called *A Simple Case*. It was clearly Pudovkin's intention to demonstrate how the revolutionary mind had faltered as it came to grips with the life of reconstruction. But this theme is based on a trivial personal story in which a Soviet soldier runs off with a vamp. The story, in other words, is not nearly large enough for the issue and, with heavy weather over nothing, the films fails. Not all Pudovkin's beautiful symbolic images of death and resurrection can save it. *Deserter* followed *A Simple Case*. It is also a personal story: of a German worker who deserted the class war in Hamburg for the ease of workers' emancipation in Russia. He finds in Russia, as one might expect, that the real thing is back on his own home front. The film is greatly spread; there are marchings and counter marchings, riots and revolutions in the grand manner; there is a scene in a Russian factory where the dead line for the completion of a giant generator is frantically kept. Indeed, one may only observe of Pudovkin at this stage, that it is the foulest folly in industrial practice to keep any such dead line frantically. And his own recourse to Hamburg and the pyrotechnics of sudden death, when accurate industrial observation was open to him on his own doorstep, is the very desertion he is describing.

It is a commonplace of modern teaching that even

with revolution, revolution has only begun. The Russian film directors do not seem to have appreciated the significance of this, for it would lead them to subject matter which, for the moment, they appear to avoid: to the common problems of everyday economic life and to the common—even instructional—solutions of them. But Russian directors are too bound up—too æsthetically vain—in what they call their "play films" to contribute to Russia's instructional cinema. They have, indeed, suffered greatly from the freedom given to artists in a first uncritical moment of revolutionary enthusiasm, for they have tended to isolate themselves more and more in private impression and private performance. As much as any bourgeois counterpart, they have given themselves the airs and ribbons of art. This has been possible because the first five-year plan and the second have been too busy with essential services to get round to cinema. For the future, one may leave them safely to the consideration of the Central Committee. One's impression is that when some of the art and all the bohemian self-indulgence has been knocked out of them, the Russian cinema will fulfil its high promise of five years ago. It is bound to, for only its present romantic perspective prevents it coming to grips with the swift and deeply detailed issues around it. The revolutionary will must certainly "liquidate," as they put it, this romantic perspective.

Of our own future there are two things to say, and the first has to do with sound. The habit is to consider sound-film as in some sense a progress on the silent form.

What has happened of course is that the cheaper and easier uses of the silent film have been succeeded by the cheaper and easier uses of the sound film. There has been as yet no succession to the mature use of silent cinema which slowly developed in Griffith, Sennett, Eisenstein, Pudovkin, in the great German school, in the French *avant garde*, and in the documentaries of Flaherty and Ruttman. We have added sound and, in the process, have lost a great deal of our sense of visual form. We use sound to mouth a story from one more or less insignificant situation to another. We use music for atmosphere and sometimes to give tempo to our event. Our crowds roar and our carriages rumble. The shadows of our screen make noises now, and it is true that, at their best, they might be Shakespearean noises; but that is not to say we are thinking sound-film and properly using it. For sound-film is not simply an opportunity of doing what straight plays and magic lantern lectures have already done: it is, in its own right, an opportunity for something individual and different, and imaginatively so. A brief consideration of its physical nature will indicate this. The sound, like the mute, is visually registered on a strip of film. Like the images of the mute, the different stretches of sound can be cut up with scissors and joined by paste in any order one pleases. Any sound stretch can be laid over another and added to it. So natural sound, music, recital, dialogue can be orchestrated to the will of the artist; and his orchestrations may be in any relation he selects to the images which run alongside. A statue of the

Buddha may be associated with religious music or with the sound of wireless signals relating to tea and international markets, or with some word spoken from a Buddhist gospel. An orator's speech can be variously associated with (*a*) its own noise, (*b*) a jazz band playing "I Can't Give You Anything But Love, Baby," (*c*) the dictation of the secretary who determined its rhetoric, (*d*) a heavenly choir of female voices, (*e*) the applause or execration of a fifty-thousand crowd rolling up in carefully shaped waves, (*f*) any sound the artist cares to draw on the side of the film. A succession of G's or K's, for example, might make a remarkable and revealing accompaniment. The point is that one may add almost anything one chooses to an image or to a sequence of images; for there is, in sound film, a power of selection which is denied the stage. With these immense powers available, it is fairly clear that the synchronised dialogue with which we are universally afflicted represents a crude use of the new medium, hardly better than the B.B.C.'s reproductive use of the microphone. What must come is a conception of the sound-film as a new and distinct art with a genius of its own; to be slowly discovered as the silent art of cinema had begun to be discovered. The fine abstraction of that art we have lost among the chattering voices. In the weird perspectives of sound film we shall find it again.

And regarding the future, there is this second point to make: that the cinema will divide and specialise and the more ambitious parts of it will break—as much as may be—from the stranglehold of commercial interests.

Cinema is neither an art nor an entertainment: it is a form of publication, and may publish in a hundred diffcrent ways for a hundred different audiences. There is education to serve; there is the new civic education which is emerging from the world of publicity and propaganda; there is the new critical audience of the film circles, the film societies and the specialised theatres. All these fields are outside the commercial cinema.

Of these, the most important field by far is propaganda. The circles devoted to the art of cinema mean well and they will help to articulate the development of technique, but the conscious pursuit of art carries with it, in periods of public difficulty, a certain shallowness of outlook. The surface values are not appreciated in relation to the material they serve, for there is avoidance of the central issues involved in the material. We need not look to the film societies for fundamentals. They will continue to be bright about trivialities of tempo and other technique, and their pleasant Sunday afternoons will continue to be innocuous. The "grim and desperate education" of propaganda is another matter. It comes more and more to grips with the questions of public life and public importance, and cinema, serving it, reflects a certain solidity of approach. The facts are simple enough. In a world too complex for the educational methods of public speech and public writing, there is a growing need for more imaginative and widespread media of public address. Cinema has begun to serve propaganda and will increasingly do so. It will be in demand. It will be asked to create appreciation of

From Fritz Lang's "M." 1932.

public services and public purposes. It will be asked from a hundred quarters to create a more imaginative and considered citizenship. It will be asked, too, inevitably, to serve the narrower viewpoints of political or other party propaganda. But where there are wide fields, the participation of the artist can be various. As I see it, the future of the cinema may not be in the cinema at all. It may even come humbly in the guise of propaganda and shamelessly in the guise of uplift and education. It may creep in quietly by way of the Y.M.C.A.'s, the church halls and other citadels of suburban improvement. This is the future for the art of cinema, for in the commercial cinema there is no future worth serving. It represents the only economic basis on which the artist may expect to perform. Two possibilities there are which qualify this conclusion. The theatres, now so abandoned in their commercial anarchy, would, under any measure of national control, be forced to larger considerations than they at present entertain. And the coming of television will bring a consideration of cinema as liberal at least as the B.B.C.'s present consideration of music. In these respects, the future is bright enough. But even under a controlled cinema and a televised cinema, it will still be wise for the artist to organise his independence: going direct to public service and public uplift for his material and his economy. There lies his best opportunity—and therefore his freedom.

BOOKS TO READ

Paul Rotha. *The Film Till Now. Celluloid.*
C. A. Lejeune. *Cinema.*
Rudolph Arnheim. *Film.*
V. I. Pudovkin. *Film Technique* (with two chapters on the theory of sound).
Gilbert Selbes. *An Hour with the Movies and the Talkies.*
Henry James Forman. *Our Movie Made Children.*

ARCHITECTURE TO-DAY

John Summerson

ARCHITECTURE TO-DAY

By John Summerson

I. Problem and Attitude

THE word "problem," rhetorically applicable to the painter's or musician's approach to his work, carries a literal meaning where architecture is concerned. In painting, as well as in music, sculpture and poetry, the tension between "problem" and solution is delicate, imperceptible, like that between two parachutes linked in mid-air. But the architect's problem exists outside himself; it is pinned down at certain points to conditions which can be specified. The painter's problem changes as the solution grows; the architect's does so only in part, and its fundamentals remain fixed.

The problem brings the architect into existence; and the architect brings to the problem an attitude, growing out of the infinite complexity of feelings and assumptions which are the sap of the social growth of which his own mind is part.

The architect's education is the adjustment of this attitude in relation to that of his own and that of the previous generation. In this way he becomes part of a "movement" and unites his faith to a general attitude which proceeds and strengthens by a process of give and take.

In writing about contemporary architecture it is, essentially, both a problem and an attitude towards it which must be analysed, and we must be clear that the attitude is never precisely the outcome of the problem in hand but of the solutions of immediately preceding problems; also we must remember that the attitude to a great extent affects the formulation of the problem: the two are only separable in arbitrary fashion, for the sake of discussion.

Growing as it does out of *past* solutions, the attitude is primarily concerned with building *forms*, i.e., with results, rather than with methods. This means that if the problem changes suddenly, the new solutions tend at first to be superficially similar to the old ones; this has often happened, notably in the case of early motor-cars which resembled horse vehicles, and of steel-frame buildings, dressed to resemble stone ones. To-day this time-lag between problem and attitude is shortening; the shortening process has been proceeding for the last thirty years; but for critical purposes we must remind ourselves that hypothetically it does—and must always—exist.

The time-lag between problem and attitude must always exist; but if we discuss the problem and the attitude separately, as I propose to do, we must remember all the time that each is constantly governed to some extent by the other, and that they interact in harmony with the broader currents of feeling around them.

Before proceeding further I want to establish certain data; their importance will be seen later on. They concern machines and building technique.

II. *Machinery and the Vessel of Power*

The last century witnessed a rapid change in scientific and economic conditions. That is a commonplace; and it is not until we follow particular threads in the story that we see precisely what this change was. For our purpose a sudden acceleration in the development of technics is the outstanding event and it is essential that we should know with some precision at the outset the nature of this event.

What is the machine and when did it arrive? There were machines in the eighteenth century and long before. There were clocks and watches, mills, looms, spinning-wheels and elaborate farm contrivances, yet the idea of the machine as we conceive it did not exist. Why not? Because all these things were "common-sense" machines. A man of ordinary intelligence could grasp the functions of a mill simply by watching one, and a few men together, with comparatively simple tools and materials, could construct one. Even the early steam-engines were still common-sense machines to most people, and the electric telegraph was probably the first important application of science to escape into a separate, non-common-sense category in the educated mind. After that, each new invention was more complex and baffling than the last and, what was more important, inventions were departmentalised; a lifetime of ingenuity might be spent on a single detail of a locomotive, and "machinery" came to mean a mass of wheels, axles, gears, eccentrics, belts, cylinders and so forth, all accur-

255

ately co-ordinated but ugly, amorphous and understandable only by engineers. Thus the well-defined idea of *machines* was merged in the bigger, vague idea of *machinery*.

Machinery was the black monster which roused anxiety and disgust in sensitive Victorians and childish wonder in their tougher contemporaries. Nobody saw much beauty in machinery for there was little to see; beauty implies order. And it is worth remembering that even Ruskin, who professed a dislike of machinery, was susceptible to the pulsing rhythm of the steam-engine. The machinery of the mid-nineteenth century was no longer simple common-sense machinery like the inventions of Stephenson and Congreve; on the other hand it had none of the *apparent* simplicity which was to come later. It was complicated, clumsy, noisy, without immediately comprehensible order or shapeliness.

Now after about 1880, theory and its application to practice made great advances. The internal combustion engine developed; Daimler's 1886 engine was an outstanding achievement, and the following year saw the construction of the first Daimler-engined car. The turbine, formed like a gigantic volute, was evolved by Parsons between 1884 and 1897. The Diesel engine was patented in 1892. The generation of electricity on a big scale dates from the introduction of turbo-generators about 1903. These inventions brought with them a new compactness. An engine was no longer a striving monster spurting steam and smoke, but a purring essence

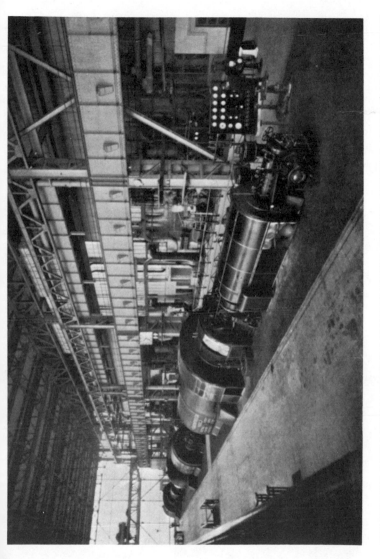

THE TURBINE ROOM AT THE DUNSTON-ON-TYNE POWER STATION, SHOWING THREE 70,000 H.P. TURBO-GENERATOR SETS. This picture is not a "stunt" photograph and shows nothing "streamlined" for effect; it is therefore a fair illustration of the half-emergence of visual order in engineering forms. The lattice girder and naked pipe-work in the background still suggest the clumsiness of an earlier phase in technological evolution.

enclosed within a vessel; and the vessel took to itself a shape not absolutely governed by the exigencies of its contents. The vessel might be the bonnet of a car or, later, the fusilage of an aeroplane, or more intimately part of the machine, like the casing of a turbine; but it had a coherent, simple, memorable shape; the passage from the common-sense machine of the eighteenth century to the "vessel of power" of the twentieth was complete—or, if not complete (for it is still going on) at least recognisable.[1]

III. *The Problem: Materials and Planning*

Meanwhile building science developed also, and if we omit the "architectural" part of the story we can draw a close parallel. In the early 1800's there was the common-sense engineering of men like Telford and Brunel, and just as early engine-builders cast Doric mouldings on parts of their steam-engines so Telford reflected the outlook of his time in trivial romanticism like the castellated pylons at Conway. Many architects were engineers of the common-sense type. John Nash was almost as able an engineer as Rennie; he built the Pavilion domes on cast-iron framing, used patent composition for his flat roofs and constructed the biggest sewer of his day.

With the coming of the Gothic Revival modern

[1] Since this was written Mr. Lewis Mumford's admirable book *Technics and Civilisation* has appeared. The distinctions I have drawn between the three phases of the machine's history are admirably elucidated by Mr. Mumford, who calls them the eotechnic, palæotechnic and neotechnic phases.

building science was transferred to the hands of architects who earned a somewhat despised livelihood designing such places as factories, warehouses, engine-sheds and public lavatories. Their aim was to give certain accommodation as cheaply and substantially as possible; unfortunately, they knew just enough about cornices and mullions not to let their client down if he wanted to make a show, which, alas, he often did. Patent materials came on the market, usually in the guise of substitutes for something more costly. Mass-production blundered onwards. Cast-iron manufacturers produced stupendous catalogues of decorative iron-work embracing everything from jubilee clocks to urinals. In 1858 Bessemer perfected his steel process and in due course steel became indispensable for commercial buildings owing to the desirable elimination of columns, and subsequently, especially in America, whole buildings were supported on steel frames, though to the relief of architects educated under Norman Shaw or Bodley it was found essential to cover the steel with fire-proof material.

No Victorian architect can be blamed for failing to see imaginative possibilities in the new materials. The mixture of solid walling, steel girders, terra-cotta and plate glass which formed the "practical man's" resources in 1800–70 constituted no new and coherent starting point and was as little stimulating as the blundering progress of a paddle-boat, or the clattering mechanism of a steam-roller.

It was not till reinforced concrete was introduced

that building science made a triumphant contribution to technology. Just as mechanical engineering resolved the Victorian discords by evolving smooth, consistent "vessels of power" in the shape of such things as motors and turbines, so building science evolved the suave, highly-synthesised rectilinearity of reinforced concrete.

Reinforced concrete conceals the real facts of its composition just as the bonnet of a car conceals the motor. Outwardly a reinforced concrete beam is as simple as one of the lintels of Stonehenge or the bressummer of a Gothic house. But a section reveals the steel rods, disposed in a way exactly calculated to cancel the strain which would otherwise break the concrete. There is no common-sense coherence about their disposition. To anyone unfamiliar with the elements of structural theory the section of a concrete roof-principal (see Plate I), with massive clusters of rods embedded at various points, would appear quite arbitrary, and as meaningless as an astronomical diagram; the intuitive apprehension of function is completely baffled.

The simplest reinforced lintel possesses a measure of the same complexity, the same highly-developed degree of technique as a complex roof-principal; exact calculation and exact control of the strength of steel and concrete are folded compactly within the simple geometry of its exterior.

Now I do not want to suggest that reinforced concrete construction dominates the contemporary situation in architecture; it does not. Neither has it been directly

responsible for new formal developments of real importance; there is little it can do which cannot be done with combinations of steel sections, or even brick or stone combined with steel. On the other hand, reinforced concrete typifies the metamorphosis of the problem as a problem of means, of materials; that is to say, the dissolution of the old standards of timber, stone and brick, and the creation of new ones originating in chemistry and mathematics. Thus building, no longer a process of piling up from foundations, stone by stone, brick by brick, becomes either a pouring into moulds, or a setting up of previously constructed units, as one sets up a cardboard model.

All synthetic materials embody to some extent the notion of condensed technique, of complexity within simplicity. And synthetic materials rule the contemporary problem in so far as it is regarded as a problem of means.

A problem is a matter of means and ends. We have been dealing with the means. Now for the ends, which need not detain us long. It is hardly necessary to state how questions of accommodation have changed in the last century. The whole process is directly related to the economic movements of the period. One can follow it along different lines. Domestic architecture shows the Edwardian apogee of the country mansion and its subsequent decline, the development of the flat-dwelling, the country villa, and subsequently the week-end cottage; the multiplication of slums by the building of semi-slums, and the chequered progress of slum-

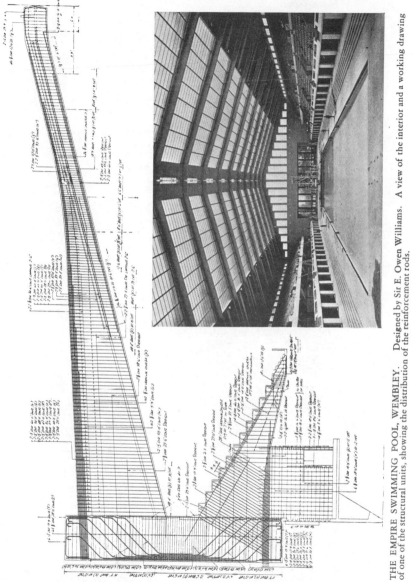

THE EMPIRE SWIMMING POOL, WEMBLEY. Designed by Sir E. Owen Williams. A view of the interior and a working drawing of one of the structural units, showing the distribution of the reinforcement rods.

clearance and re-housing chiefly by private initiative. Commercial architecture shows the rise of the office block built by one firm for its own glory, but partly let off to others less ambitious; and the total elimination of solid walling on the ground floor of shop premises. Public buildings like town halls show a decline from the old communal status to that of mere public offices; churches show a similar decline in social-symbolical importance.

IV. Attitudes: Pyramidal Emphasis to Counterpoint

The history of nineteenth-century architecture may be presented as the history of changing attitudes, some banished before they were half-formed, others formed without ever having established sufficient contacts with reality to warrant their survival. One might sub-divide each attitude, for argument's sake, into an attitude (i) to building forms, (ii) to the problem itself. Such a division is arbitrary but useful.

(i) Attitudes to the problem.

From the seventeenth century till towards the end of the nineteenth, the architect's problem was conceived to have two aspects: convenience and ornament; the architect as an artist and as a gentleman was only concerned with the latter, though he exposed himself to ridicule if he ignored the former. Pugin and Ruskin battered at this fallacy, though they were themselves victims of it and it was never exploded till our own

time, when circumstances made the false duality too obvious to be ignored.

In the eighteenth century this point of view was natural enough. Building tradition proceeded steadily in the hands of artisans; the town house had a constant arrangement of rooms and the country house was a variable harmony of rectangles, squares, octagons and circles. The architect's function was to give the traditional solutions a superior kind of order and, by means of a carefully acquired technique, to contrive a subtle, exact distribution of emphasis. The problem looked after itself.

The Gothic Revival shook this attitude and so far as churches were concerned to some extent replaced it. But the Gothic Revival worked in a little world of its own and its attitudes shaped themselves only with relation to that world. Pugin believed that the mediæval church represented a grander, more satisfying way of building than the brick and plaster churches of his own day, and behind all his passionate nonsense about "pointed or Christian" methods, was a fine sense of the need for identifying "ornament" with "convenience," of closing up the widening gap between form and content. After him, Butterfield, Street, Burges and a few others pursued similar ideals within the same narrow limits, revealing in their work undeniable power and sensibility.

But the gap between "ornament" and "convenience" did not close and the Revivalists, whose ideas about planning hinged on mediæval colleges and eight-roomed vicarages were incapable of dealing with the

contemporary problem when it was forced on their attention. During the fiasco of the Law Courts competition it was seriously suggested that two architects should work in partnership, one to provide the plan, the other the *architecture*.

All this while, hospitals, asylums, hotels, railway stations, office buildings, public baths, sewage farms, schools, universities and working-class dwellings were being built; the architects, mostly second-raters lacking stylistic expertise, planned by fitting room to room, seeing the problem still only as contrivance plus architecture. Where a clean solution emerged it was usually by some benighted architect (like Mr. Cubitt of King's Cross or Mr. Robins of the Bloomsbury Model Dwellings) who was so far behind the times as not even to attempt any style-mongering on the elevations.

In the 'eighties and 'nineties the secular problems of architecture asserted themselves forcibly and at last regained the attention of architects of intelligence. In England, domestic planning entered on developments which were important not only for this country but for the whole future of European architecture. Perhaps for the first time, the problem was conceived to have an imaginative significance *in its own right*. The searchlight of imaginative analysis began to shift from the sum total of old solutions to the actual problem. Here was a revolution. Almost immediately the trappings of "the styles" began to fall away, though the ultimate process of disintegration was very long delayed, particularly in the planning of architecture other than

263

domestic. And England was soon to drop behind. In the years after the War there was a sudden hardening up, a reaction against the liberation of the problem, and progress in architecture was, for a time, confined to countries on the Continent. To these we shall come later.

(ii) *Attitudes to Building Forms.*

The eighteenth century attitude to architectural form might be interpreted as the disposal of pyramidal emphasis. The centre with wings was the typical Palladian composition, the axial points being further emphasised with pediments and portico; later on, the pyramid was whittled away and emphasis was suggested rather than expressed, but even the frail scheme of emphasis in the three-window villa of the Regency is pyramidal by implication.

This view of architectural form, the established successor to the long-forgotten mediæval view, became so deeply rooted that in time it was considered to be the inevitable and only rational one. It held its own, in the background, all through the nineteenth century; the Gothic Revivalists wrenched themselves away from it, but (except in churches) found no satisfactory substitute. Waterhouse, the only one of them who was much concerned with big secular buildings almost invariably capitulated to symmetry; Street, at the Law Courts, contrived an asymmetry which was artificial and meaningless.

The only alternative to pyramidal emphasis was the Picturesque, which, born of eighteenth-century roman-

ticism, was rigorously reformed by the Revivalists. The "irregular villas" of Thomson and the "fermes ornées" of Goodwin, had pursued asymmetry as an affectation; the Revivalists preferred to sanction it as the outcome of practical considerations; and in domestic architecture they began to find it very useful.

Unquestionably the greatest figure in English (perhaps in European) architecture of the latter half of the nineteenth century was Richard Norman Shaw (1831–1912). As a young man he was an earnest upholder of "Early French" Revivalism, but he, more than anyone, hastened the dissolution of the Revival and the development of "free Gothic" or equally "free" Tudor and the experimental brick manner known (misleadingly) as "Queen Anne." Under these new conditions (1870 onwards) house planning discovered a new flexibility; "purity of style" gave place to eclecticism, accompanied by a new interest in materials, previously fostered by William Morris and his architect Philip Webb (The Red House, 1859—60). Shaw was a very slick artist, constantly moving from one field of brilliant experiment to another. He planned (so I have been told by those who knew him) quickly and easily. His compositions are powerful, florid, redundant, overflowing with invention. His silhouettes are bold and irregular, crowned, as a rule, with soaring brick chimneys. Here pyramidal emphasis has disintegrated completely, and in its place a new logic becomes faintly discernible; this new logic we shall call counterpoint.

The emergence of counterpoint is the great event in

the immediate historical background of the modern attitude to architectural form. I have borrowed the word from music, though I do not wish to imply any analogy with musical development. Counterpoint, ordered intricacy with a dynamic rather than static coherence, seems to me to find a place in the modern attitude not only to architecture but to the other arts and many things besides; counterpoint not necessarily as an end in itself (which it is, I suggest, in many contemporary pictures and W. M. Dudok's architecture) but as a common idiom of form.

In architecture, counterpoint emerged from the picturesque. The line of an eaves running into a vertical chimney stack; the quick rhythm of a timbered upper storey against the slow punctuation of windows in brickwork; the contrast of textures—tile-hanging, roughcast, brick, stone; all these, the contrivances of the picturesque, gradually suggested a new kind of coherence, and the clearer the suggestions became, the faster the tyranny of styles dissolved.

I have mentioned Norman Shaw as the leading figure of his time, as if there were no architects outside England working in the same direction; but of course there were. There were Cuypers in Holland and Clason in Sweden and, best of all, Nyrop in Denmark, all working in more or less national idioms and all owing something, one suspects, to the unique Gothic upheaval in England and more particularly to the writings of Ruskin.

Shaw is a useful landmark. Lutyens's New Delhi and Scott's Liverpool Cathedral are his direct offspring; but

more important are the indirect descendants like Voysey, Mackintosh and Walton, with their contemporaries and evolutionary parallels on the Continent.

C. F. A. Voysey (b. 1857) who emphasised certain important tendencies in Shaw's work, designed in simpler terms than his predecessors. His houses are neither as elaborate nor as large as Shaw's; his plans are cleaner, more concise; his detail is confined to the simplest mouldings and accentuations; his interiors have the gentle orderliness of pictures by de Hoogh. Their excellence is not in a full mastery and control of form but in the sincerity of the attitude towards the problem.

From Voysey's influence sprang the achievement of Charles Rennie Mackintosh (1869–1928) who of late years has been discovered as the father of modern architecture. But he was not a very great architect; he had the essential weakness of all *fin de siècle* experimentalism and may ultimately be remembered chiefly as a member of the group of agreeable domestic architects among whom Sir Robert Lorimer, C. R. Ashbee and George Walton were principal performers. His celebrated Glasgow Art School (1896) with its dramatic simplifications and quaint detail, merely restates in brilliant *art nouveau* jargon the position already established by his predecessors.

While Mackintosh worked in Glasgow, Otto Wagner (1841–1918) worked in Vienna, where the nineteenth century provided, not the hectic Gothic background of Pugin and Ruskin but an established academic tradition. Wagner's work was directed towards rendering classic-

ism flexible; he never got further than loosening the old tight-laced formulas and reassembling them with novel rhythmic arrangements, which were, however, always in the tradition of pyramidal rather than contrapuntal emphasis.

Another architect working in Vienna in the early 1900's was Adolph Loos (1870–1933) who seems to have been one of the very first architects to bring a thorough-going materialism into his attitude. Exactly how and why he came to do so it is difficult to determine. At the time he built his incredibly austere and functional terrace-houses at the Heuberg suburb of Vienna he cannot have been instigated by the stress of economic conditions or overwhelmed by machine-worship. His attitude probably grew partly from a sense of revolt from the quest of "a new style" and partly, as Mr. P. Morton Shand has suggested in a recent article, from a rediscovery of eighteenth-century standardisation as seen in the English town house of that period.

After Loos we come to Behrens, who was born in 1868 and whose career is, so to speak, the historical backbone of architecture in the present century. England begins to drop out of the story; France, inextricably bound up in an academicism embracing every foible from *neo-grec* to *art nouveau*, contributes nothing intrinsically new; Holland and the Scandinavian countries pursue the easy course of national sentiment and arts and crafts.

Behrens started as a painter and when he turned to architecture he attached himself to the *jugend-stil* move-

ment, flourishing under J. M. Olbrich at Darmstadt. The critical years of his development were between 1900 and 1910, during which period his attitude moulded itself in relation to what was now becoming an important factor in the formation of attitudes, the machine; and Behrens's interest in the machine received its greatest stimulus when he was appointed, in 1908, to be architectural adviser to the A.E.G., the principal German electrical manufacturing company. In this capacity of formal arbiter he designed the first standardised arc-lamps ever made, as well as motor-coaches for electric trains, and many buildings, including the famous Turbine Erecting Shop (1909).

To say that Behrens, or anybody, discovered the proper relationship of buildings and machines would be misleading. But perhaps Behrens was the first to notice that the contrapuntal economy emerging from old conceptions of building forms was finding a remarkably close counterpart in the new shapes which had been evolved by engineers. It became apparent that the machine could be relied upon to provide a norm; architecture, sailing aimlessly upon notions of style, could once more be anchored to reality.

Before the War Behrens designed many buildings to enclose machines and it was reasonable that such buildings should partake to some extent of a machine character, just like the enclosing bonnet of a motor. Nevertheless, he did not merge the concepts of machine and architecture, and his buildings always have a strong classical understanding about them. In the matter of

technique he has always fought for a thoroughly scientific approach; standardisation and pre-fabrication occupied his attention as early as 1912, and in 1918 he advocated a far-reaching use of machinery both in the production of materials and in their assembly on the site.

The direction of "functionalism" is towards a thing which Behrens never attempted, the merging of the concepts of machine and architecture. Le Corbusier's name is chiefly associated with this, but his work is in a special category to which we shall come presently and it is Walter Gropius (b. 1883) who has principally contributed to the disintegration of the "architectural," or rather "literary" concept of building. According to Mr. Shand, Gropius's famous factory at Alfeld (1911) was "perhaps the first purely functional modern building" and his later Bauhaus at Dessau (1925) is a development on similar lines.

V. Spatial Counterpoint

Gropius stands for the final phase in that important aspect of the growth of modern architecture, *the dissolution of the wall:* a process which owed so much to the genius of Frank Lloyd Wright. Even now, to most people, a building is essentially "four walls and a roof" with holes in the walls to admit light and air; yet there is no reason why a building (particularly a factory) should not be a positive reversal of this: four windows, instead of walls, with opaque patches wherever privacy or darkness are needed. At the Bauhaus, vast sheets of

window, constructed independently of the floors, replace solid walling. The weight of the structure is

concentrated at points, not distributed along continuous foundations. Thus a final blow is dealt to pyramidal emphasis; not only has static symmetry dissolved into dynamic counterpoint but the architect's *point of control* is no longer at ground level but in mid-air. The contemporary architect's idiom may be described as *spatial counterpoint.* Contrapuntal architecture would not be a bad designation for the whole drift of authentic modernism, since it obviously excludes the denuded academicism which tries to keep abreast of the times by an ingenious technique of omission. Nothing demonstrates the contrapuntal attitude more aptly

Axonometric drawing of an apartment house with roof-garden. *By* L. H. DE KONINCK.

271

than the isometric and axonometric drawings which modern architects habitually use to illustrate their buildings. These diagrams show the building as an organism, a three-dimensional unity in space, and it is not a mere coincidence that these geometrical projections on paper sometimes resemble the abstractions of modern painters.

VI. The Contemporary Situation

Ten years ago the architectural outlook was uncertain and complicated; never before had there been such diversity of outlook. To-day this is no longer so. In 1925 almost every European country was working in some private idiom of its own; now most of these idioms are being discarded. In 1925, for instance, Swedish romanticism was being watched as something of great potential power, instead of as what it is, a mere second flowering of what Norman Shaw and Martin Nyrop planted and reared in the 1890's. Seen in proper perspective, Ostberg's work (principally the Stockholm Town Hall) belongs, with that of Sir Edwin Lutyens and Sir Giles Gilbert Scott, to a branch development which will not grow any further. It has borne fruit; New Delhi, for instance, is a triumphant personal conquest of classical technique, a marvel of insight and control.

Another important thing in 1925 was the brick-faced architecture of Fritz Höger and others in North Germany, with its pronounced vertical lines and vigorous

ornament. German architects elsewhere were responsible for a pleasant form of "denuded academicism," neat and exquisitely proportioned; this, I believe, finds favour again under the swastika.

In France, the Perret brothers were producing their revolutionary reinforced-concrete interpretations of the Beaux Arts tradition, Mallet-Stephens combined geometry and jazz and le Corbusier was just becoming famous. In Holland, Dudok was doing good work at Hilversum, but elsewhere in that country indifferent architecture was being overlaid with complicated brickwork of excessive vulgarity.

England and America, somewhat aloof from all these tendencies, continued to encourage "commercial classic," and even "free Gothic" appeared to have a future. Modernism oozed in slowly. Adelaide House, near London Bridge, was regarded in 1925 as a nice clean modern building, in spite of the glaring contradiction between the sensational vertical lines of the Portland stone façades and the horizontal truths of brick and plate-glass at the back. The first authentic building in the new manner was Crawford's building in Holborn. by Frederick Etchells, 1927.

To-day there emerges from all these conflicting attitudes one which is gaining acknowledged universality both in Europe and America; it is this attitude which we have tried to define in the course of exploring its background and origin.

An account of the contemporary situation is bound to be largely a matter of names; and since names mean

little without a whole anthology of illustrations I will cut the list as short as possible. One feels bound to put Walter Gropius at the head of it. His descent is from that very great man Behrens (who, by the way, is still alive and at work). His conception of the architect's place in modern society has made him a great teacher as well as a great architect and the influence of the Bauhaus (the school at Dessau which he founded) fighting for a healthy relationship between architecture and machine and against crystallisation into dogma and fashion, is bound to be lasting, even in the face of reactionary prejudice.

Other notable Germans are Heinrich Lauterbach and the firm of Luckhardt and Anker. Erich Mendelssohn, whose picturesque novelties in reinforced concrete startled the world ten years ago, now follows an orthodox direction with great competence and resource.

W. M. Dudok is the leading architect in contemporary Holland. He shares the superficiality of the modern Dutch school as a whole, with its affection for the less edifying aspects of the achievement of Frank Lloyd Wright. One feels that he has never been attracted by the finer potentialities of the modern problem and his latest buildings exhibit a somewhat smug elaboration of the contrapuntal idea. More interesting is the work of Brinkman and Van der Vlugt, authors of the magnificent Van Nelle tea factory at Rotterdam, a structure whose outer "walls" are almost entirely of glass.

The work of Alvar Aalto, a Finn, reflects the new Scandinavian outlook in its sternest aspect, though for

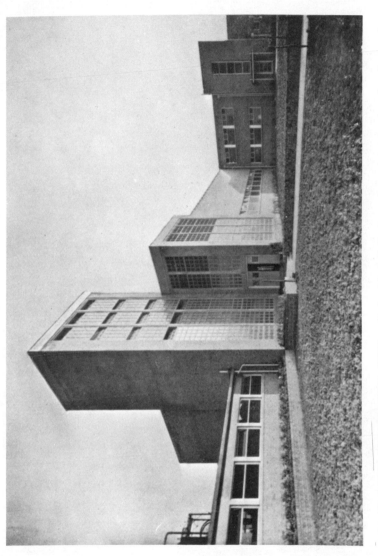

PITHEAD BATHS, BETTESHANGER, KENT. Designed by J. H. Forshaw. A complex programme of requirements has been carefully analysed and the elements assembled into an interesting counterpoint of masses and lines. Note a vestige of older concepts of design in the small decorative porch on the right.

all its formal puritanism it is romantic. The same could be said of Gunnar Asplund, the Swede, who has arrived at orthodoxy by way of an intelligent devotion to the period of Sir John Soane.

France's most notable orthodox modernist is André Lurçat, whose communist schools at Villejuif have recently brought him into prominence. Lurçat is almost isolated in his own country, for French architects are somewhat reluctant to part with their extremely flexible tradition of academic planning.

Czechoslovakia might fairly be regarded as the country where the best modern work is now being done. Corbusier's influence has been active here; and Mies van der Rohe, in his Tugendhat Haus, Brünn, has taken an important step in the exploration of the relationship between architecture and the space it confines. The firm of Havlicek and Honzik has also done some remarkable three-dimensional planning.

Italy, true to her tradition of rhetoric, steadfastly ignores foreign influence. Sant' Elia, an architect who might have been a world-influence, was killed in the War, and to-day Rome glories in the fascist academics of Piacentini.

In England, it is slowly being discovered that modern architecture is not a question of jazz, and architects whose loyalties are bound up with the new Continental tradition are beginning to find employment, in spite of prejudice against "modernismus" and "the packing-case style." The thoroughly intelligent works of Wells Coates, Maxwell Fry, R. A. Duncan, and a few

others are helping to form an attitude which has the paramount merit of objectivity. A tendency for young architects to keep in touch with each other in their exploration of technique may perhaps be ascribed to the far-reaching influence of Gropius and the Bauhaus.

There remains one outstanding architect whom we have not discussed. The works and writings of le Corbusier have created more stir than those of any architect since the War and he is certainly of the greatest importance.

Le Corbusier's real name is Charles Edouard Jeanneret; he is a French Swiss, practising in Paris, and was born in 1887. Starting as a painter, he eventually became a pupil of Behrens and subsequently of Perret (1911). His early work shows Perret's academic influence; there are even pilasters and cornices. After the War his ideas crystallised quickly, following on the development of a new attitude to building forms. In 1919 he published *Vers une Architecture:* a not very likable combination of smart journalism and genuinely perceptive writing. His writings do not explain his works, nor his works his writings; in fact, they do each other considerable harm. But purely as an architect, Corbusier has achieved something which distinguishes him from all others. I shall return to this later on; for the moment I want to sketch in rough outline the workings of architecture as a visual art.

VII. Form and Function

The immediate future of architecture will, I imagine, be concerned with the question, to what extent can, or

should, a building be a machine? Standardisation and pre-fabrication are problems which are already working themselves out. Will the time come when the motor-car and the block of flats are merely different regions of the same scope? I believe that it will, but in a way altogether different to our groping anticipations.

It must be remembered, in considering this question, that the majority of buildings have no single, immediate purpose. A house, for instance, is to keep out the rain, but it is not an enlarged umbrella; it is to contain people, but it is not a packing-case for human beings (as an auditorium is, in a sense). A house is simply *enclosed space*, space partitioned off for a variety of reasons. The architect's efforts are not, like the engineer's, concentrated upon a single end.

Thus, the architect's code of form, not being subject to a constant, enveloping pressure of expediency, starts from the basis of space subdivided in simple ratios. Architecture is still primarily the organisation of simple geometric forms; cubes, cylinders, pyramids, spheres and cones. But it is more than this, for architecture only begins when these geometric elements are employed with reference to function; and by way of elucidating this relationship of form and function as clearly and concisely as possible I propose taking a concrete example, something as simple and elementary as an upright cylinder. So as to have the picture clearly in our minds, let us suppose our cylinder fifty feet high, with a diameter of ten feet.

The cylinder stands in a deserted place; it is devoid of

any marks or inscriptions; it has, let us say, a smooth grey surface and its material and method of construction are indeterminate. By virtue of its size and regularity of form, its proportions and its position with relation to the horizontal, it has a certain formal significance; its regularity constitutes the rhythmic stimulus fundamental to all architecture—repetitive rhythm either implied (as in this cylinder) or expressed (as in the ripples of a fluted cylinder); its proportions, together with its relationship to the ground, carry an empathetic significance and set up remote and complex psychological reverberations.

But this cylinder is not necessarily a building (though our experience may lead us to class it instantly as architecture). It is not properly a building until we know (or obtain some acceptable substitute for knowledge) how it is constructed and what it is for. What the cylinder has already communicated to us is too crude, too elementary, to do anything but stimulate our emotional susceptibilities. But once we are given a hint of its purpose (that the cylinder was raised, let us say, to be a landmark from the sea) and a hint concerning its construction (that it is of brick or stone covered with cement) enough has been added to the visual facts to resolve the expectations aroused at the first ignorant encounter.

Parenthetically let us note that knowledge concerning the method of construction is of minor, if not negligible, importance, though it is difficult to say to what extent its importance has been diminished by our recently acquired familiarity with synthetic materials and fluid construction.

Now elaborate the cylinder by the insertion of a door

at the base and a ring of windows at the top. These add complexity, and new formal relations are created. But what is more important is that the *cylinder* becomes a *tower*. That is to say, by reference to immediately available experience, we conclude that the opening at the base is for people to pass through and the openings at the top are for people to look through and, likewise by automatic reference to experience, we assume the existence of a stair or lift.

In the transference from the concept "cylinder-with-holes-in-it" to the concept "tower" we have a precise demonstration of the relation of form to content in architecture.

The cylinder was an elementary case: the formal relations involved did not offer that degree of complexity which might (if not too obviously related to function) rivet our attention to the formal interest of the structure at the expense of the form-and-content interest. And I doubt whether the most highly organised architectonic structure could do so, for the simple reason that architecture, being an affair of solid geometry, lacks the capacity of *immediate communication* (e.g., by brush or pen line) which painting and sculpture possess in the highest degree.

The communicative process in architecture may, on the basis of what we have just considered, be tabulated like this:

(i) Geometric stimulus;
(ii) Empathetic recognition;
(iii) Functional recognition.

These appear to form a basis not, of course, indivisible, of the mechanism of our reactions to architecture.

VIII. Towards Style

"Style" is formed and moves within the psychological currents which are so elusive to thought, but which are the core of history. It is impossible to generalise about "origins" of style. It seems inevitable that a certain complexity of interest must always be maintained in the arts; this complexity never arises in the same way and the three sequential factors tabulated above are constantly being differently stressed.

Style in architecture is, of course, ultimately a matter of the unconscious associations developing round structural forms. The starting point is the recognition of sets of formal-structural relationships as an architectural "language." Then this language is used as a partial substitute for architecture in the elementary sense; the substitution is not necessarily an overlay of structure with pseudo-structural ornament (that comes later) but a detachment and reattachment of perceptions. At the point of reattachment comes a tendency to elaborate and modulate structural components, to preserve the complexity of interest by substituting an intricate code of expression for expression by sheer statement.

Ancient beam-and-lintel architectures exemplify this process over and over again, though it is very difficult to find monuments which show the process in operation

(proving perhaps that the process is a comparatively rapid transition). One can only deduce it from developed manifestations.

The further elaboration of style often proceeds to the complete detachment of the architectural "language" from its functional background. It is at this moment that structural units in their characteristic relationships (column and beam, for instance, in the classical gamut) are used as a secondary means of expression. Two columns and a pediment, for instance, are reproduced in miniature round a door or window opening. In the first instance this is an intensely dramatic juxtaposition. The door or window is dramatised by being thrust suddenly into a new scale, a new arena of relationships. But it is not long before the process, by repetition, loses intensity; the miniature columns and gable round the opening become a mere decorative adjunct, a *cliché*.

A parallel with language may be suggested. Such expressions as "the brow of a hill" or a "burden of sorrow" must once have possessed great intensity of meaning, *poetic* meaning, which is now blunted through familiarity; the expressions have become incorporated in general usage, much as the columns and pediment surrounding a window were incorprated into the general usage of architecture. This reference to language will explain why I have drifted so far into what may seem to be purely historical considerations. For just as a contemporary poet is, I imagine, deeply concerned with the natural history of language, his own use of words reproducing in epitome a remote and more or less

hypothetical historical process, so, I feel, contemporary architecture is constantly reproducing the characteristics of a phase (a hypothetical phase) lying at the root of architectural history.

IX. Le Corbusier

This brings me back to a consideration of the work of one modern architect, le Corbusier. His achievement consists largely in having undone and reconstructed the mass of associations built up round our conceptions of building-forms. Not a vestige of *cliché* remains in his designs; not a single accepted complex of association remains undissolved. Every shape, every rhythm is reselected under the innocent judgment of intuition. And all the time his ostensible pursuit is machine efficiency, though it must be admitted that a careful reading of his books does not reveal him as the materialist which he is sometimes represented to be.

The machine, scientific building, mass-production, these are le Corbusier's anchors to the world of commonsense, while he explores the underworld of form. His taste is exquisite, as unerring as Paul Klee's, an artist with whom he has definite affinities.

The villa de Monzie at Garches, a characteristic house by le Corbusier, was built in 1927. (See opposite). A study of the plan (the understanding of which requires only five minutes concentration from the most backward layman), reveals the extreme flexibility of le Corbusier's handling. The house is constructed on a

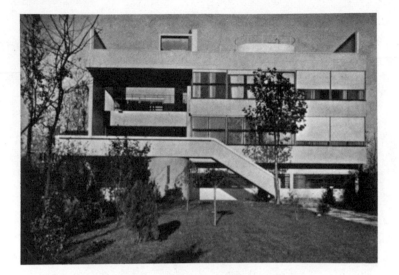

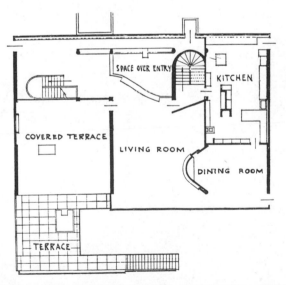

PHOTOGRAPH AND FIRST FLOOR PLAN OF THE VILLA MONZIE AT GARCHES. Architects : le Corbusier and Jeanneret, 1927. Reinforced concrete frame ; walls and partitions of hollow concrete blocks. Roof and floors of hollow tiles.

reinforced concrete frame and the whole weight comes on a set of posts with isolated foundations (the posts are partly hidden in the walls, but can be distinguished here and there on the plan). There is no "walling" in the conventional sense; the rest of the plan is simply a light partitioning of space partly by glass and partly by thin concrete. The covered terrace (the big blank hollow on the left of the photograph) shows how completely the architect has broken with the "four-walls-and-a-roof" notion of a house; internal and external space embrace each other. None of the supporting elements are visible from the exterior and the architecture seems to have crystallised rather than grown; there is no feeling of it having been built upwards from the ground; it might just as well have been begun from the top and built downwards.

The influence of a building such as this (chiefly through drawings and photographs) is very great. The relationships, recognised as fundamentally valid, become part of the experience of countless other architects. That is how style grows.

Reverting to our analysis of the communicative process (page 279) it would be true to say that whereas the majority of architects accept a more or less superficial code of communication, le Corbusier adjusts his conception of architecture most minutely to the real exigencies of the process. His approach to design is thus more intense and concentrated, and therefore of keener æsthetic interest, than that of any other contemporary architect.

X. *Machine Nonsense*

A detestation of the word "style" is characteristic of the modern architect, although the nature and movement of style has never been so nakedly apparent as now. The reason is, no doubt, to be found in a well-justified revulsion of feeling against the use of stylistic trappings (original or borrowed) as the badge of a clique; one recalls the futility of "middle-pointed" squabbles in the 'fifties and the vanities of "jugendstil" and "art nouveau."

Style is never static; it is always changing. It is the fault of history-books, written by people with no sense of history, that we talk of "*a* style," an ugly and fundamentally meaningless convention.

But the modern denial of style is part of a tendency which, for the present, at any rate, is necessary; it is a tendency to see architecture in proper and exact relation to science and sociology. The biological functions of architecture must be felt and understood; that is the essential belief of the modern movement.

Herein lies an obvious danger. Art Nonsense is quickly being replaced by Machine Nonsense. A spurious faith in the dizzy ramifications of synthesis appeals strongly to people with weak sensibility and a passion for propaganda. The "science of living" is a very fine catch-word and it is enthralling to visualise the whole material setting of life as one perpetual fugue of calm, humane efficiency. But, after all, the implications of such a belief do not carry one very far. Man

will not discover anything greater than his own imperfection simply by organising his surroundings with exquisite stream-lined neatness.

It is a very good thing that arm-chairs should combine comfort and elegance with simplicity; that clocks should have clear black strokes in place of confusing Roman numerals; that cooks should have "streamlined" kitchens; and that public lavatories and underground trains should be trim and unpretentious. And it is proper that these things should be considered as merging into architecture; but it ought to be possible (and in time it must be) to take their rightness as a matter of course. Meanwhile, there is the danger of trying to drive the whole of architecture down to the level of the stream-lined kitchen. This tendency will not come from such men as Corbusier, but it may easily receive support from misunderstanding and misinterpretation of their works.

A more finely adjusted attitude will, perhaps, emerge eventually from the present one, conditioned, as it is, by a sudden, vertiginous recognition of a new textural unity in living conditions, a new diapason of style. Everything depends ultimately on the shifts of the social structure and its economic basis. It is possible that architecture may return to the communal anonymity which characterised it in the Middle Ages and which is recognisable in the engineering achievements of to-day (one never thinks of a liner or an engine as personal works of artists). Certainly there will be a partial movement in this direction, corresponding with the

establishment of proper ties between architecture and mass-production; but I do not believe such a movement will embrace the whole destiny of the art. However completely the foundations of architecture as we know it may dissolve any new superstructure is bound by its very nature, to be subject to the same psychological thrusts, the same "will to form" as the "free" arts of music and painting. Architecture and Machine as we understand the terms, cannot become identifiable; but the passage from one to the other, now so feeble, constricted and clogged with half-discarded beliefs will become strong, clear and inevitable.

XI. *The Outlook*

The future of architecture is part of the future of society; to speculate upon it as anything else would be waste of time. If any directional activity can be detected it is a process of dissolution. Old concepts of architecture—concepts which have hardly changed since the Renaissance—are dissolving; and the faster they dissolve the more clearly are the social and economic implications of the art revealed. An architect who craves philosophic sanction for his attitude can only reach it through an understanding of the society of which he forms part, and if such an understanding lands him in a political camp, as it probably will, he must make the best of it. But architecture is an exacting profession and there is plenty to do without chasing abstract problems to their logical solutions.

Meanwhile what are architects doing? Most of them are trying to match an ill-matured, unbalanced, groping attitude against a problem which is complex, unco-ordinated and constantly shifting. Most architects do not think; those who do, either establish themselves in secure personal isolation or throw in their lot with the orthodox modernists.

The sheer hopelessness of practically all architecture being built in this country is a matter I do not propose to consider. People often talk as if it were the personal fault of the architects concerned, whereas it is their, and our, misfortune (chiefly ours). The architect has to do his work whether he is a thinker and an artist with something to say or whether he is not. When the age into which he is born provides him with no tradition, no scaffolding on which to build his faith, he can only achieve excellence by framing his own scaffolding. This a few men have done in the last hundred years and the sad echoes of their achievements have been called "tradition."

The best that can be said for architecture to-day is that an attitude is forming which is so fundamentally honest that it will not combat its own inevitable metamorphoses. It is not a recipe for masterpieces and seeks sanction in no historical analogy. It builds its faith upon understanding and analysis of its own age. It is an attitude concerned more with present problems than past results.

BOOKS TO READ

Le Corbusier. *Vers une Architecture.* Translated by F. Etchells as
 Towards a new Architecture.
Josef Frank. *Architektur als Symbol.* Intelligent and constructive
 criticism of modern attitudes.
R. MacGrath. *Twentieth Century Houses.* A thorough, well-
 balanced survey.
G. A. Platz. *Baukunst der Gegenwart.* An international picture
 book with valuable introductory essay. *Wohnraume der
 Gegenwart.* A companion to the above.
P. Morton Shand. A series of retrospective articles on domestic
 architecture of the last century, in the *Architectural Review,*
 July 1934—March 1935.
F. Lloyd Wright. *In the Cause of Architecture.*
F. R. S. Yorke. *The Modern House.*
Walter Gropius. *The New Architecture and the Bauhaus.*
Lewis Mumford. *Technics and Civilisation.*

INDEX

A

Aalto, Alvar, 274
"Abstraction," 71, 72 ff., 83; and
 Half-Abstraction, 75, 76, 83
Abstraction-Création group, the, 87,
 94
Active Anthology (Pound), 36, 39
Actors, narrowness, etc., of, 204, 205
Adelaide House, London, 273
Æsthetics, essentials in, 26
Agrippina, 206
Alaska Eskimos, dance masks of, 90
Albrechtsberger, 167
Aldington, Richard, 39
Aldridge, John, 105
Alexanderplatz (Döbelin), 143
Alfeld, factory at, 270
Alice in Wonderland, 10
A.E.G., the, 269
Alleyn, 189, 190
Alliteration, 54
Altamira paintings, the, 79; the bison,
 82, 106
American fiction, 140 ff.
American films, 220, 225–6, 228–9,
 230–1
American racket, 197
Ancient Mariner, The (Coleridge), 63
Anna Karenina (Tolstoi), 116, 134
"Anna Livia Plurabella," 169
Antic Hay (A. Huxley), 135
Apes of God, The (Wyndham Lewis),
 130, 132
Appleton House, 38
Arab music, 166
Aran Islands, film of, 232–3
Architect, the, problem of 253 ff.
Architects, Continental, 266, 267
Architecture To-day, 253 ff.; atti-
 tudes, changing, history of,
 261 ff.; civic, 261; commer-
 cial, 261; communicative pro-
 cess in, 279, 283; contem-
 porary situation of, 272 ff.;

contrapuntal, 265 ff., 271;
 definition of, 277; domestic,
 260–1; ecclesiastical, 261;
 eighteenth century, 262; form
 and function in, 276 ff.; future
 of, 276–7, 286–7; style in,
 280 ff.
Arcos Raid, the, 121
Ariel poems by Eliot, 62
Aristotle, 26, 58, 66
Arlen, Michael, 117
Arp, Tauber, 104
Art, geometric, 76, 77, 79, 80, 104
Art, Is it? 71 ff.
Art and Mathematics (Hélion), 94
Art and phantasy, 6; prehistoric,
 76 ff.; Puritanism in, 84, 85;
 purpose of, 113
Art language, 106 ff.
Art theatres, 194–5
"Art Concret" group, 94
Artist, the, in History, 2; as Neuro-
 tic, 3; and Public, split
 between, 148
Artists, Continental, 84 ff, 106 ff.
As You Like It, 196
Ash Wednesday (Eliot), 62
Ashbee, C. R., 267
Asplund, Gunnar, 275
Assonance, 53
Atheism, 119
Atonality, 166, 167, 177
Auden, W. H., 1, 43, 44, 45, 51, 53,
 54, 56, 57, 58, 59, 60, 61, 63
Aurignacian sculpture, 79, 80
Austen, Jane, 158
Australian aboriginal art, 80, 90
Austria, 121
Azilian art, 80–1, 93

B

Babbitt, Irving, 129
Bacchae, The, 196

INDEX

INDEX